T0166512

BAD BOY
NIETZSCHE!

and Other Plays

BAD BOY NIETZSCHE!

and Other Plays

Richard Foreman

THEATRE COMMUNICATIONS GROUP
NEW YORK
2007

Bad Boy Nietzsche! and Other Plays is published by Theatre Communications Group, Inc., 520 Eighth Avenue, 24th Floor, New York, NY 10018-4156.

This publication is made possible in part with public funds from the New York State Council on the Arts, a State Agency.

TCG books are exclusively distributed to the book trade by Consortium Book Sales and Distribution, 1045 Westgate Dr., St. Paul, MN 55114.

Library of Congress Cataloging-in-Publication Data

Foreman, Richard.
Bad boy Nietzsche and other plays / Richard Foreman.—1st ed.
p. cm.
ISBN 978-1-55936-257-3
I. Title.
PS3556.O7225B34 2007
812'.54—dc22
2007015452

Cover and book design and composition by Lisa Govan
Cover photo by Paula Court

First Edition, October 2007

Contents

Preface

As I do with all my published texts, I urge anyone who stages one of these plays in the future to ignore the elaborate stage directions printed in this book, which provide a historical record of my own productions of each play.

I suggest that each director re-conceive these texts and create a staging that elaborates on his or her own private vision of whatever world these texts seem to suggest.

Bad Boy Nietzsche!

PRODUCTION HISTORY

Bad Boy Nietzsche! Produced by the Ontological-Hysteric Theater at the Ontological at St. Mark's Theater, New York City. January–April 2000. Written, directed and designed by Richard Foreman.

NIETZSCHE	Gary Wilmes
THE CHILD	Sarah Louise Lilley
THE DANGEROUS MAN	Kevin Hurley
THE BEAUTIFUL WOMAN	Juliana Francis Kelly
SCHOLARS	Brian Bickerstaff, Marc Lesser, David Lloyd Rabig, Josh Stark

The perspective offered by this play—about a philosopher who preached "perspectivism"—is from within the seeds of his own madness, which we choose to hypothesize as having been present not only in later years, when he flew to embrace a horse being beaten on the streets of Turino, but also in healthier years (and may we all productively touch such hidden madness!), fueling the fire of his epoch-shattering philosophy and, in effect, turning everything provocatively upside down (as if he were walking upside down on the other side of the world—in China—as this play fantasizes!).

Nietzsche himself was a kind and gentle man, celibate most of his life, who turned against his friend Richard Wagner's anti-Semitism and, during crucial years, worshipped a wise and powerful woman who esteemed him above all others, while refusing to add him to her long list of lovers. The following lines, included in the play, are taken from Nietzsche's poems and letters—doodles on the margins of his philosophy—which nevertheless reveal secret fears and obsessions:

My dear friend. After you discover me, you find me. The difficulty is now to lose me.

The divine art is flying—to great heights, from which one throws what is oppressive into the ocean, into the depths of the ocean.

I write on table, write on wall / with foolish heart a foolish scrawl. / You say—the hands of fools deface the table and the wall / erase it all! / I try to help the best I can / I wield a sponge, as you recall / but when the cleaning up is done / let's see this super sage emit / upon the walls, sagacious shit!

The one thing necessary / is to keep pen in motion, over the paper. / The pen scribbles? / I say to hell with that. / And I say no / to belief systems of all kinds. / Am I condemned to scrawl? / Boldly I dip it into the well / and with thick strokes / my writing flows / so full and broad / So what if it's illegible / Who reads the stuff I write?

Oh why is she so clever now, and so refined? / On her account a man's now out of his mind. / His head was good before he took this whirl. / He lost his head to the aforesaid girl!

—I do not love my neighbor near / but wish he / were high up and far away. / How else could he become my guiding star?

—Lest your happiness oppress us / cloak yourself in devilish tresses / Devilish wit and devilish dresses, / all in vain! Her eyes express / her angelic saintliness.

Was I ill? Have I got well? But those are well who have forgotten!

The stage is a large dark room, with faded painted targets covering the walls like wallpaper. In addition, skulls and pillows are tacked up on the walls as decorative motifs. All over the painted walls runs scrawled, illegible writing, in chalk—as if a deteriorating Nietzsche had allowed his scribbling to escape from his notebooks and cover the walls as his feverishly productive mind overpowered his self-control.

Half of the rear wall of the room is missing, replaced by a series of vertical planes lined up one behind the other, each succeeding plane getting higher as they recede into the distance, all painted a reflective black, as if they were the planes of a stylized black ocean. Above the ocean is a decorated arch, beneath which a red sun, framed by dark wings and festooned with skulls, rises over the ocean's horizon. In the shadows stage right sits a large cabinet with a protruding cannon. Pillowed benches line the walls of the room. Angling down from above the audience are two twelve-foot-long metal probes. Their rods, padded at one end like a swab, arrive at the front edge of the stage, tilting downward, with the padded end at chest height.

The floor is coral pink, in shocking contrast to the dark walls, and at intervals on the walls and floor, large block letters spell out fragments of words.

The name "Friedrich Nietzsche," in three-dimensional script, floats over the stage, as do many lamps.

Loops of music are heard in the background. They change continually, but are ever-present throughout the play—sometimes childlike, sometimes military and overpowering.

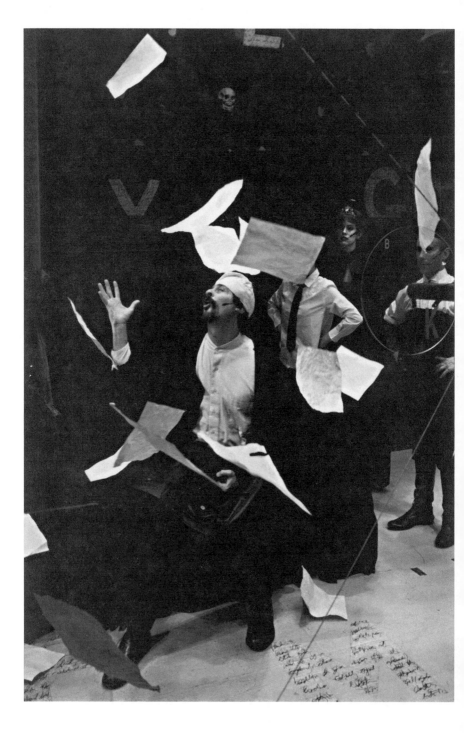

Nietzsche, dressed in a long black frock coat, wearing a sleeping cap with a tassel and carrying a stuffed briefcase, ambles onstage. He does a funny little march, his head bobbing slightly from side to side. He seems to have already descended into a kind of madness. Throughout the play he does bits of a stumbling dance, or rubs his hands together and rolls his eyes, always speaking in a voice that keeps cracking and making irrational swoops and dives. As he enters, he cocks his head and repeats, "Guess . . . Guess . . ." in a childlike singsong voice to no one in particular.

The Child appears at the side—a young girl with rosy cheeks, dressed as a boy in a white shirt and tie, with a child's cap cocked at an angle.

NIETZSCHE: Guess . . .

THE CHILD: You look very different from the way I imagined you, Mr. Nietzsche—

NIETZSCHE: Guess!

THE CHILD: I HAVE read bits and pieces of things you write, Mr. Nietzsche—so I imagined you big and strong, with eyes on fire . . .

(Nietzsche looks about distractedly as the Child advances into the room, hands on hips.)

Is it possible—maybe you aren't the real Mr. Nietzsche?

NIETZSCHE: Guess! . . .

THE CHILD *(Pointing to a stuffed toy horse hanging from the ceiling)*: Let's make a test. Suppose I climb up toward that little horse hanging from the ceiling, and start beating it and beating it and beating it—would you protect that poor little horse, Mr. Nietzsche?

NIETZSCHE: Guess!

(The Dangerous Man appears through a door, hair cropped short in military fashion. His cruel beady eyes, jutting chin and storm trooper boots are in sharp contrast to the kilt he wears up over his chest as a kind of feminine kilt-bra.)

THE DANGEROUS MAN: No guesses.

NIETZSCHE: Guess.

THE DANGEROUS MAN: No guesses for me, thank you.

NIETZSCHE *(Opening his briefcase)*: Right this minute, guess what I'm experiencing.

(He throws fistfuls of paper into the air. Four Scholars in black caps appear as the papers float to the floor. They gather the papers and bring them to Nietzsche, but he pushes them away. He rises and thrusts his chest against one of the probes, emitting a cry of pain.)

THE DANGEROUS MAN: I really don't want to know about this, Mr. Nietzsche.

NIETZSCHE: Stage fright.

THE DANGEROUS MAN: Jesus Christ—stage fright!

NIETZSCHE *(Turning away, stumbling a bit over his own feet)*: What's that beautiful music?

THE CHILD: Is this really you, Mr. Nietzsche?

NIETZSCHE: Oh—I'm a wonderful dancer.

(He dances in a heavy-footed way, holding the hands of the Child, as the Scholars cross the room and point at the dangling stuffed horse.)

THE DANGEROUS MAN: Oh, I bet this is gonna be special.

(The Child pulls the Dangerous Man to see the horse. He pulls away with a lurch.)

NIETZSCHE: Let's face it. Nobody likes being chained to the wall by somebody else's imagination.

(The Scholars carry a white screen onstage behind Nietzsche, to frame his body. He holds it behind him with two outstretched hands.)

Please! Wipe me out!

THE DANGEROUS MAN: I'd do it if I could, Mr. Nietzsche.

NIETZSCHE: You can do it. I want things said to me—that will be very disturbing—not to other people of course, but to myself in par-

ticular. *(Whirls, still holding the screen behind him)* I want things said to me that will cut into me like a knife. In that hope, I want everybody's collaboration.

THE CHILD: Why should we collaborate with you, Mr. Nietzsche? A: We do not trust you, and B: We do not like you.

NIETZSCHE: Really? You don't like me?

(The Scholars manipulate the screen so it flies over his head and comes down in front of him.)

Tell me why you don't like me.

THE CHILD: Well, first of all, we don't know you well enough to have definite opinions.

NIETZSCHE: OK, don't try to know me better than you know me right this minute. OK? *(Puts his chest against a probe and spreads his arms)* Just sustain this same level of hostility for no particular reason, because I need to experience this kind of pressure. Remember—I'll pay very well.

THE DANGEROUS MAN: Hey! Let me think about this. *(Exits)*

THE CHILD *(Steps forward with cake and a single candle)*: Hey. Is your mind really on fire, Mr. Nietzsche? *(Nietzsche rolls his eyes in delight)* Is this candle for you? Do you like candles?

NIETZSCHE *(Licking his lips)*: In fact, what I like is cake. *(Goes for the cake, stumbles and falls onto a bench. The alert Scholars are already there to support him with pillows)*

THE CHILD: OK. The cake's for you too.

NIETZSCHE: I don't deserve it, I suppose . . .

THE CHILD: Right.

NIETZSCHE: Right. Look at me carefully. I'm an everyday person, in fact.

THE CHILD: Not really. I think your mind is on fire, Mr. Nietzsche.

NIETZSCHE *(Struggling up from the bench)*: No. There is no fire inside me.

THE CHILD: Then how do you manage to capture my attention, Mr. Nietzsche?

NIETZSCHE *(Throwing himself against a probe, with a groan)*: Yes. Yes! . . . Yes! I accept that!

(A knock is heard, and a Faraway Voice calls: "It's open, Fritz!")

Hello? *(Looks about the room, then stumbles to throw himself against another probe)* Yes! I accept that!

THE CHILD *(As the Scholars line up behind him)*: Then how do you manage to capture my attention, Mr. Nietzsche?

NIETZSCHE: Please, be very careful.

(He falls backward and the Scholars push him back onto the probe as the Dangerous Man enters with a second cake.)

THE CHILD: Why should I be careful, Mr. Nietzsche?

NIETZSCHE: It could be that I am dangerous in my passivity.

THE DANGEROUS MAN: See?

(He shoves the cake at Nietzsche, who stumbles away with a giggle of shock.)

Your passivity is something very intense after all, Mr. Nietzsche.

NIETZSCHE: Perhaps.

THE CHILD: No—maybe! That's what the word "perhaps" really means, really it does. Am I right?

THE DANGEROUS MAN: You're right.

THE CHILD: But, in fact, I want nothing more to do with you, Mr. Nietzsche.

THE DANGEROUS MAN: She's right, of course.

THE CHILD: Knock knock! Mr. Nietzsche.

NIETZSCHE: Knock knock? Is somebody talking to me?

THE DANGEROUS MAN: Hey—. Nobody said nothing.

(The music rises as a wall, decorated much like the others, slides in to hide the room behind. Nietzsche runs to it and runs his hands over its surface.)

NIETZSCHE: No, somebody who is outside is trying to get inside.

(The wall slides out, revealing four giant, egg-shaped heads, six feet tall, with faces painted in the center, rocking back and forth. They whisper in falsetto: "Peek a boo!")

My dear friends. After you discover me, you find me.

(The Egg Heads say: "Oww-ee!")

The difficulty is now to lose me, Friedrich Nietzsche.

(He marches clumsily across the front of the stage as the wall slides in front of the Egg Heads and then immediately slides off again, revealing an empty room. At the top of the ocean, framed against the red sun, a Beautiful Woman with naked breasts appears, wearing an occult crown and holding two disks painted with symbols. The music is very loud.)

THE DANGEROUS MAN *(Shouting over the music and indicating the Beautiful Woman, above)*: Who is that woman up there?

NIETZSCHE *(Prancing about the stage)*: Well, this is a person who claims she is unable to live without me.

THE DANGEROUS MAN *(Jumping onto a bench to see the Beautiful Woman better)*: You?

NIETZSCHE: This is what she secretly tells me!

THE DANGEROUS MAN: You?

NIETZSCHE: Not that I believe this is true!

THE DANGEROUS MAN: Really?

NIETZSCHE: Do I believe this is true!

THE DANGEROUS MAN: Well? Do you believe it?

NIETZSCHE: Yes.

THE DANGEROUS MAN *(Throws his leg up against the wall; he is frightening and semi-erotic)*: Yes, is it?

(Nietzsche jumps back in terror.)

Then whatever happens, you'll never move from this spot.

NIETZSCHE: Perhaps—perhaps not. Perhaps, perhaps not—

THE DANGEROUS MAN: I don't understand your hesitation.

NIETZSCHE: No. There is no hesitation. *(Shouts loudly)* This is Paradise, after all!

(The Dangerous Man slaps his face. The Beautiful Woman screams then disappears.)

THE DANGEROUS MAN: This doesn't look like Paradise, does it now?

NIETZSCHE: Wrong. Feet, placed firmly on the floor—

THE DANGEROUS MAN: Pick up your feet when you walk.

NIETZSCHE: This is Paradise.

THE BEAUTIFUL WOMAN (*Whispering as she peeps around a corner*): Paradise.

NIETZSCHE: The oh-so-poignant torso, twisting slightly to suggest— unimaginable directions.

THE BEAUTIFUL WOMAN (*Whispering as she peeps around a corner*): Paradise.

NIETZSCHE: A certain dizziness entering history by accident.

THE DANGEROUS MAN: I don't get it, obviously.

(*The Scholars enter with sheets of paper and a giant-sized pencil. Nietzsche laughs and grabs the pencil, holding it over his head with both hands. The Scholars hold the sheets against the walls, and Nietzsche tries to write on the paper with his giant pencil.*)

NIETZSCHE:

 Here I am, doing my thing in Paradise.
 —I write on paper, write on wall
 With foolish heart a foolish scrawl.
 You say—the hands of fools
 Deface the table and the wall—
 Erase it all! Erase it!

(*The pencil falls to the floor with a loud crash.*)

 I try to help the best I can
 I wield a sponge, as you recall
 But when the cleaning up is done
 Let's see this super sage emit
 Upon the walls, sagacious shit!

(*The Scholars begin beating Nietzsche with whips, as a Voice intones: "Pleased to meet you! Pleased to meet you!"*)

THE DANGEROUS MAN: Jesus Christ—I heard one bad boy, i.e., Bad Boy Nietzsche, using the word "Paradise"—but this does not look like Paradise the way I imagined it.

NIETZSCHE *(Pushing away the Scholars)*: Wrong.

THE DANGEROUS MAN: What's wrong about it?

NIETZSCHE: Here I am. Doing my thing, in a place that looks very much like Paradise.

THE DANGEROUS MAN: If Mr. Nietzsche says so, then I guess this is really Paradise.

NIETZSCHE: Here is a list of potent items.

(The items start being passed over the walls that simulate the ocean.)

A crown.

THE CHILD *(Carrying a stuffed toy horse with a crown on its head)*: Oh yes, here's a really nice crown.

NIETZSCHE: A drum.

THE CHILD: Here comes a big drum.

NIETZSCHE *(Holding up his hand)*: Hand.

THE CHILD *(As the Scholars hold up their hands)*: But there are so many hands available, Mr. Nietzsche. How can we choose just one?

NIETZSCHE: Blindfold! Blindfold!

THE DANGEROUS MAN *(As the Scholars cover Nietzsche and the Dangerous Man's eyes)*: Under the circumstances, a blindfold— *(He slaps Nietzsche, who grabs a chair to defend himself)* —might be appropriate.

NIETZSCHE: Knife.

THE DANGEROUS MAN: OK.

NIETZSCHE: Is a chair appropriate?

THE DANGEROUS MAN: Chair. Very appropriate.

THE CHILD: Maybe you favor physical objects over people, Mr. Nietzsche.

(The big bass drum that has been passed over the wall has tubes coming out of it, with funnels on the ends of the tubes, wide end outward. As the music rises, Nietzsche sniffs at a funnel, then holds it to his chest. The Dangerous Man hits the drum, and Nietzsche staggers back as the thud pounds against his heart.)

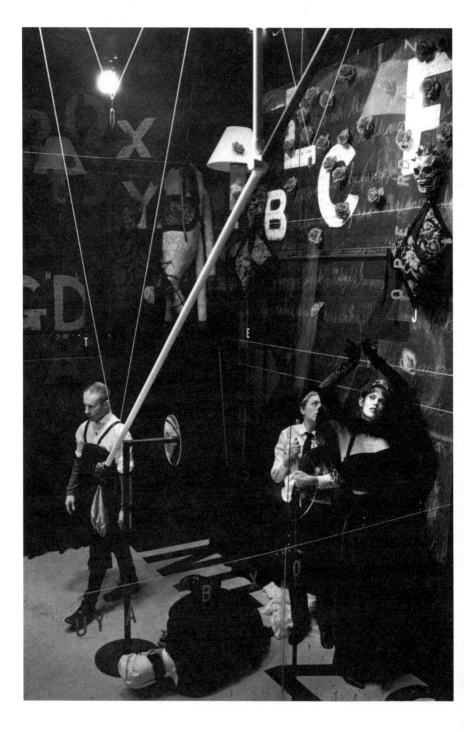

NIETZSCHE: Maybe that hurts people, but that's OK. Because I do not favor people. No—not people—but what's inside people. *(Again he allows the Child to place a tube on his chest. The Dangerous Man hits the drum and Nietzsche staggers)* Again and again. Shaking things to their very foundations. My iron fist. My feet like fire. My knife like a terrible kiss. *(Pretends to stab himself, and a Scholar brings a bloody rag with which Nietzsche tries to clean his hands)* Stabbing oneself—hands covered with blood—

THE BEAUTIFUL WOMAN *(A white shawl over her shoulders)*: Beautiful white wings. *(Spreads her arms to extend the shawl like wings)* Red blood falling from the eyes.

NIETZSCHE *(Wrapping himself in her shawl)*: That which is oppressive to me, all that I hurl into the depths. Once and for all.

THE BEAUTIFUL WOMAN: Wings.

NIETZSCHE: Yes! Wings! The divine art is flying—to great heights from which one throws what is oppressive into the depths of the ocean! *(Skulls appear in the ocean, and Falsetto Voices cry: "Peek a boo." Nietzsche sings out in falsetto)* Shipwreck! *(A little boat appears at the top of the ocean)* I throw myself into that ocean—Shipwreck! I do throw myself into that terrible ocean! *(Dances, stumbling)*

THE DANGEROUS MAN: Not much of a dancer, are you Mr. Nietzsche?

THE BEAUTIFUL WOMAN: A better dancer than a singer, maybe.

THE CHILD *(With a cymbal and drumstick)*: OK, everybody start dancing! *(Hits the cymbal)* And again! And again!

(A large cutout puppet slides in from the side, so big it has to bend at the waist to fit beneath the ceiling. It slowly kicks its leg as it advances. It is, perhaps, the God of Shipwrecks. All start screaming and clawing the walls as the music becomes deafening and the boat heaves violently.

They fall to the floor as the lights fade to black, and a Deep Voice is heard proclaiming: "Shipwreck, shipwreck."

The lights return and the Child is seen alone, staring at the little boat on the top of the ocean.)

He thought he saw a giant boat
Beneath a silver moon.

He looked again and saw it was
His lonely living room.

He thought he saw the sailors
Throwing bread crumbs toward the sea.
He looked again and saw
A giant fish is eating me!

ALL *(As they claw the walls)*: Help! Help! Help!

NIETZSCHE *(Slowly collapsing to the floor)*: Ow! A splinter, my finger . . .

THE DANGEROUS MAN *(Pulling Nietzsche's briefcase out from beneath a bench)*: Hey— Look what I found. This is for you, Mr. Nietzsche. *(Nietzsche reaches for it, but the Dangerous Man pulls it away and runs to the wall)* OK. Let me correct myself—Mr. "Bad Boy" Nietzsche.

NIETZSCHE: What's in the briefcase?

THE DANGEROUS MAN: Jesus Christ—I don't know.

NIETZSCHE: Open it.

THE DANGEROUS MAN: Oh, come on now—are you afraid to open it?

NIETZSCHE *(Dances slowly toward the briefcase, then grabs it away from the Dangerous Man)*: Fools have known all along—

THE DANGEROUS MAN: What fools?

(Nietzsche takes papers out of the briefcase and throws them up to the sky. As they flutter down, the Scholars run in with sticks that have grabber claws on the end. They each seize a piece of paper with a grabber and extend it toward Nietzsche.)

NIETZSCHE: The one thing necessary—

THE DANGEROUS MAN: Yes?

NIETZSCHE: Is to keep—pen in motion—over the paper. The pen scribbles—?

(The grabbers move pieces of paper against the walls, and Nietzsche snatches at the papers and stuffs them in the mouth of the cannon protruding from the side cabinet as he continues.)

I say to hell with that. "Well, to hell with that." And I say "no" to belief systems of all kinds.

THE DANGEROUS MAN: Don't do that, Mr. Nietzsche.

NIETZSCHE *(Stuffs the papers in the cannon with a big cannon stuffer, which he then uses to try to write in bold strokes on the walls of the room)*: With thick strokes my writing flows so full and broad. So what if it's illegible? Ow! *(Loses his balance and falls to the floor)* Who reads the stuff I write? Ow! I hurt my shoulder.

THE BEAUTIFUL WOMAN *(Standing over Nietzsche, who rubs his sore shoulder)*: I think Mr. Nietzsche had an accident.

THE DANGEROUS MAN: There's not much we can do about accidents. They happen.

THE CHILD: We could get medical help.

THE BEAUTIFUL WOMAN: Is your shoulder really that bad? Are you a Bad Bad Boy?

NIETZSCHE *(Crawling up onto a bench)*: It still hurts, but not so much. I don't think it's broken.

THE BEAUTIFUL WOMAN: Oh—it's not broken.

NIETZSCHE *(Thinks, then holds out his hand)*: But I hurt my hand.

THE BEAUTIFUL WOMAN: Oh? Your HAND?

NIETZSCHE: My writing hand.

THE DANGEROUS MAN: Then your scribbling days are over, right?

THE CHILD: What's wrong, Mr. Nietzsche?

(She giggles, then all run offstage.
Nietzsche turns around, then slowly comes down and shows his hand to the audience.)

NIETZSCHE *(Quietly)*: Once upon a time I tried writing a letter to a beloved friend, using my left hand, but the letter was unreadable, of course—not because of its content, which came from my heart—but using my left hand I could only partially control the formation of letter after letter after letter! *(Tries to write on the walls, but again—falls)* Ow! I hurt my left hand!

(The Child enters with a big loaf of bread, with a large knife stuck in the center. The others follow.)

I better use my right hand to cut some slices from this holy bread which enters my life like an unexpected guest.

THE DANGEROUS MAN: Your right hand? You mean your writing hand, Mr. Nietzsche?

NIETZSCHE *(Holding the bread)*: Have some slices of this holy bread which trembles in expectation.

THE DANGEROUS MAN: That looks like normal bread to me, Mr. Nietzsche.

NIETZSCHE: There are valuable jewels in this bread.

THE DANGEROUS MAN: What did you say?

NIETZSCHE: This bread is very unusual. You eat it—you grow bigger. Your body becomes strong and your head—double—

THE DANGEROUS MAN: Is that really desirable? Such a big head?

NIETZSCHE: There are jewels—ow! *(He trips and falls on a bench)* —Valuable jewels in this holy bread.

THE BEAUTIFUL WOMAN *(Posing against a white screen)*: I heard him say something unusual.

THE DANGEROUS MAN: So did we all.

THE BEAUTIFUL WOMAN: He said—there are "Jews" in this bread.

NIETZSCHE: No, no, you misunderstand me. There are jewels, valuable jewels in this bread.

THE BEAUTIFUL WOMAN: I would not eat this bread if there were Jews in this bread. *(Slowly advances and takes the bread from Nietzsche. She turns toward the audience and puts her hand on the knife)* You understand why I say that? Jews—I do not eat Jews. You better make me believe there are no Jews in this bread, because, my dear Fritz— *(Lifts the knife out of the bread)* —if there are Jews in this bread, then I will put not even the tiniest morsel of this bread in my mouth. But on the other hand— *(Lifts the knife higher. A siren is heard, and she swoons to the floor. Then she slowly rises to her knees)* —if I am certain there are no Jews in this bread, then I will open my mouth and allow a few tiny crumbs of bread to enter my own, sweet— *(Licks the edge of the knife)*

NIETZSCHE: I do not move.

THE BEAUTIFUL WOMAN: If you don't move, you're in trouble, Mr. Nietzsche.

NIETZSCHE: I hope to prove to you, however, that I do not bake Jews in this bread. So please. Feed me some of my own bread. *(She holds the knife to his mouth)* I would never eat bread baked with Jews inside. Because to do so would be to hurt, terribly . . .

THE BEAUTIFUL WOMAN: Let's find out.

NIETZSCHE *(Licks the knife)*: What I have in my stomach now. —No Jews in there!—only—jewels baked in my bread, now in my stomach. *(Suddenly holds his stomach in pain, tumbling to the floor, as the Scholars beat him)* Oww! Can you possibly understand how painful to me to have sharp jewels inside one's stomach?

THE BEAUTIFUL WOMAN *(Still kneeling on the floor)*: I am imagining that.

NIETZSCHE: You tell me what it feels like in the imagination.

THE BEAUTIFUL WOMAN: It would be very painful.

NIETZSCHE: Yes! It is!

THE BEAUTIFUL WOMAN: Like broken glass—

NIETZSCHE: Yes! It is!

THE BEAUTIFUL WOMAN *(As a small target passes in front of her eyes)*: Or long splinters, driven into the hands, or into the feet. Or eyes wide open—

NIETZSCHE *(Cowering at the wall)*: Please stop—

THE BEAUTIFUL WOMAN: Staring straight into the sun, which is probably the most painful thing I can think of—splinters going into my eyes!

(They all scream as the target leaves her eyes and the lights brighten.)

VOICE *(Over loud music)*: Eyes eyes eyes!—

(A Phallic Serpent rises from the ocean, then sinks down again.)

NIETZSCHE: Where is my Chinese horse? Where is my Chinese horse?

THE DANGEROUS MAN *(Overlapping)*: What the hell are you talking about? I don't understand you, Mr. Nietzsche.

(Nietzsche falls to his knees.)

THE BEAUTIFUL WOMAN: My God—here is a voice we dare not allow to speak directly because— *(Puts her hands on Nietzsche's brow)* —the madness of this voice is infectious, and if one hears this voice speaking directly for itself, one is intoxicated by such speaking, one leaps from high windows, one plunges into wide

rivers—from the power of whose turbulence—no escape seems possible.

THE CHILD (*Prancing in the ocean, singing*): I know where that voice is coming from—I know where this voice is coming from—

(*The Scholars bring on two stuffed horses, which they throw back and forth. Nietzsche grabs one of the horses and dances with it affectionately. A Voice is heard over the music:*)

VOICE: Here is a man—here is a man, here is a man who simply cannot opt out of his own self-destructive motives—who listens to himself only.

(*One horse is wrenched from Nietzsche's grasp, and he runs for the other, but that second one is thrown past him—he grabs for it but ends up clutching only his own body. He advances to the probe, throws himself against it and sings:*)

NIETZSCHE: Where is my Chinese horse? Where is my Chinese horse?

(*A wild dance follows. One of the horses is placed on Nietzsche's back, and he prances around the stage as the Child hits her cymbals and the lights fade to black.*
When the lights come up, the Dangerous Man is at the side of the stage dressed in a bloody apron and feathered hat, holding a tray of raw meat. Nietzsche slumps, exhausted, on a bench, embracing his horse.)

VOICE: Here is a man.

THE DANGEROUS MAN: Hard to believe, Friedrich Nietzsche, philosopher of power—the missing years of sweet, gentle, Bad Boy Nietzsche—years in the desert, in the lonely mountains of China—unknown years in lonely rooms in Chinese rooming houses— (*Drops the tray to the floor with a loud crash*) —visited in secret—by the ghosts of wise men seeking power—ghosts of ancient China.

THE CHILD (*Bending over the tray*): Where is my Chinese horse?

NIETZSCHE (*Rising, hugging his horse*): This is my Chinese horse.

THE DANGEROUS MAN: Chinese or no Chinese, that doesn't mean shit to me.

(A crash of Chinese cymbals. The Beautiful Woman, with bare breasts, appears above the ocean.)

THE BEAUTIFUL WOMAN: I can relate to this, please—I too am banished to some nether region, where the best I can do is to try understanding the goddamn rules on this particular shithouse planet—

THE DANGEROUS MAN: Sorry about this, Mr. Nietzsche.

THE BEAUTIFUL WOMAN *(Disappearing)*: That bastard is NEVER sorry!!

THE DANGEROUS MAN: Hey!—spiritual self-laceration is not to my taste.

NIETZSCHE *(In his own world, hugging his horse)*: Nobody sees my Chinese horse. Nobody sees my Chinese horse. Nobody sees my Chinese horse.

(The Child bounces up and down on a second horse as the Scholars dance around her. The Dangerous Man reenters carrying a ceremonial red Chinese wagon wheel.)

THE CHILD: Is it not true that to pursue and sing whatever one truly desires inside each moment as it passes—this is to pursue—incoherence in fact—

THE DANGEROUS MAN *(Overlapping)*: Chinese whores and horses! Chinese horses and whores!

THE CHILD AND THE DANGEROUS MAN: True! True! True! True!

THE BEAUTIFUL WOMAN *(Reappearing, fully dressed, as things quiet down)*: Mr. Nietzsche is a man who sees the darkness where other people think there is a light still shining.

THE DANGEROUS MAN: That doesn't mean shit to this tough Chinaman!

THE BEAUTIFUL WOMAN *(Crossing to cast a spell on Nietzsche)*: Shitheads of the entire world. Do you really believe that Mr. Nietzsche's purpose here on earth is to bring light into places where up till now there has been darkness?

NIETZSCHE *(Sings, cuddling his horse in a corner)*: Nobody sees my Chinese horse.

THE CHILD *(Lifting a whip)*: You've never even been to China, you bad bad bad boy.

NIETZSCHE: Whip me, sir, and you whip my horse. *(She whips)* Whip my horse, sir—and I, also, suffer those same blows. Remember—I'll pay you very well.

THE CHILD *(Backing away; singing)*: Jews in my bread . . . *(Falls over a horse, cries out, and then recovers)* I have wonderful—Jews in my bread.

THE DANGEROUS MAN: This does not look like China, you crazy man!

NIETZSCHE: Maybe not . . . but—I'm on my way.

(A tone sounds as the giant shipwreck puppet slides in again. This time, dangling from his fingers, there is a blackboard on which are written magical Hebrew letters. A pair of legs rises feetfirst from the ocean, and, between the two legs, the Phallic Serpent. Nietzsche grabs the whip and starts beating at the waves, rather ineffectively. A Voice sings out: "Hello! Hello! Hello!"

Nietzsche drops the whip and tries to erase the kabbalistic letters on the blackboard as the lights fade to black.

In the darkness a Deep Voice says: "Remember," and Nietzsche cries out: "Hello!" Then the lights return, the puppet is gone, and Nietzsche sits alone on a bench. A moment later, a big snake with a human hand instead of a head jumps up from the ocean and plops onto the bench next to Nietzsche, with its tail still hidden, invisible inside the ocean.

The Child is heard crying, and then appears onstage, struggling step by step, supported by two crutches that are too big for her.)

(Running back and forth nervously; to the Child) Don't cry . . . don't cry . . .

(More and more of the snake's body pours over the edge of the ocean wall. As the Child continues sobbing, the Scholars enter on their hands and knees, scrubbing the floor. Nietzsche starts throwing all available objects, including the leftover stuffed horses, over the wall into the ocean. The Beautiful Woman enters, also crawling on her knees, laboriously rolling a big boulder. Nietzsche grabs the boulder and she screams and falls flat on the floor. He throws the boulder into the ocean, then flexes his muscles, trying to believe in his own powers.)

VOICE:
> Here is a man.
> Here is a man.

(Nietzsche grabs the hand on the end of the snake and struggles with it, becoming wound up in the snake's coils, but eventually he subdues it and throws the beast into the ocean. He collapses against a wall in exhaustion, but quickly pushes himself away, lifting his arms and uttering an inarticulate cry of triumph. He races to the side of the room, where he pounds on a piano keyboard.)

NIETZSCHE *(Stepping back from the piano as the Beautiful Woman struggles to her feet)*: What do I need? I mean—NEED—most of all?

(He runs over to pull the cabinet with the cannon into the center of the room, falling to his knees in the midst of his frantic efforts, then scrambling up again to complete the task. He stands panting, hitched to the cabinet as if he were a workhorse pulling a wagon. We can now see that the cabinet resembles an armor-plated tank. The Beautiful Woman picks up a whip.)

THE BEAUTIFUL WOMAN *(As frantic music quiets, she leans seductively toward Nietzsche)*: Say "need," Mr. Nietzsche. Say, "What do I need?!"

NIETZSCHE *(Embarrassed)*: I need you—looking at "me."

THE BEAUTIFUL WOMAN: Well. I NEED it, too, Mr. Nietzsche—you— *(Whips him once and he screams)* —looking at me.

(The cabinet is pulled back to the side as Scholars strap a belt around Nietzsche's chest. Many wooden sticks extend from the belt to the floor, forming a kind of "stick tent" that makes it impossible for him to move.)

(To Nietzsche) Are you looking at me?

(The Dangerous Man strides onstage; the Child tracks him.)

THE DANGEROUS MAN *(Stopping suddenly and whirling about suspiciously)*: Why is everybody looking at me!

(A lightning flash—all react with a scream and a whirl to protect their eyes, except Nietzsche, who cannot move.)

How the hell do I know what kind of movements to make next?

(A High Voice sings: "Hello!" The Dangerous Man and the Child go and thrust their chests against the probes, and the Dangerous Man whispers: "Stage fright!" The Voice sings: "Hello!" and the Scholars hold a target in front of Nietzsche's face.)

ALL *(Shouting in fear)*: Stage fright!

(Other Scholars spin the Child and the Dangerous Man in a fast whirl. The Child cries out: "Help." All are suddenly frozen.)

THE BEAUTIFUL WOMAN: Thought has now come to faraway China.

(The target in front of Nietzsche switches to a kabbalistic sign.)

Thought is now upside-down, of course—

(Another flash of light startles everyone. The Voice sings: "Hello!")

—on the other side of the world—

(Nietzsche moans as the sign reverses to the target. The others gently wave their arms like slow-flying vultures.)

—something wiped out—immense—where death rules things.
NIETZSCHE *(Peeking out from behind the target)*: This does not mean that death rules things.

(The Scholars detach Nietzsche from his tent of sticks.)

THE DANGEROUS MAN: Death? I better look that up in my Chinese dictionary. But in the meantime, let's have drinks! Drinks for everybody!

(The Scholars carry in one tray with drinks and another with the large loaf of bread.)

THE CHILD: On an empty stomach?
THE DANGEROUS MAN: Why the hell not?
THE CHILD: We'd stagger around being drunk.
THE DANGEROUS MAN: That sounds OK to me—
THE BEAUTIFUL WOMAN *(Seizing the bread)*: There is bread, to calm such terrible stomachs.
THE DANGEROUS MAN: Where the hell did that bread come from?

(Lightning and thunder as the wall rolls in again, hiding the rear of the room. The Child screams, and Nietzsche grabs the bread.)

NIETZSCHE: Do not be afraid! Do not be afraid! I will protect this holy bread—from wind, rain, thunder and lightning!

(Nietzsche, the Dangerous Man and the Child sit on a bench that has been placed in front of the moving wall. They face the audience.)

THE BEAUTIFUL WOMAN: Careful, shithead Nietzsche—there are jewels in that bread!
THE DANGEROUS MAN: If there are really jewels in that holy bread, which I don't think very likely—
NIETZSCHE: There are jewels in this holy bread.
THE DANGEROUS MAN: That would make it goddamn dangerous to eat that holy bread.
THE CHILD: Oh, how dangerous could bread be?
THE DANGEROUS MAN: Dangerous enough that we could die from this holy bread.

(The Dangerous Man and the Child hold their stomachs in pain and collapse to the floor.)

If we ate this holy bread, we could all die.
THE BEAUTIFUL WOMAN: Since we are all going to die—from this bread—or maybe not from this bread—it doesn't matter what happens to us. Therefore, we should kill people.

THE DANGEROUS MAN (*Rising slowly*): What people should we kill?

THE BEAUTIFUL WOMAN: People we don't like. People who are already dead.

THE CHILD: That means lots of people.

THE DANGEROUS MAN (*Following Nietzsche, who has moved to the side of the stage, protecting his bread*): This is all—very interesting.

NIETZSCHE: Remember—I'll pay you very well.

> (*Nietzsche sits in a high-backed chair next to the bench. The Dangerous Man selects a golf club from a bag, which a Scholar has carried in. He examines the club carefully, then comes forward and gives a tremendous whack to the back of Nietzsche's chair, sending Nietzsche sprawling onto the floor as the Beautiful Woman and Child giggle.*)

THE DANGEROUS MAN (*Putting away his club and nudging Nietzsche with his foot*): Jesus Christ—maybe you should work out a little, Mr. Nietzsche. I don't think you look sufficiently muscular.

THE CHILD: Oh no—he doesn't look even a little bit muscular.

NIETZSCHE: I'm not supposed to be muscular.

THE DANGEROUS MAN (*Selecting another club*): Of course—we'd be a little worried if you got TOO muscular— (*Whacks the chair, again sending Nietzsche sprawling*) Up on your feet, Mr. Nietzsche! Come on now—

> (*He steps over Nietzsche and climbs up to stand on the bench, hands on hips, as the Scholars enter in the shadows, carrying sticks from which dangle small yellow Jewish stars.*)

NIETZSCHE (*Struggling to his feet*): I can do that by myself.

THE DANGEROUS MAN: Turn around. Look me in the eye—

NIETZSCHE: I'm already doing that.

THE DANGEROUS MAN (*Spreading his arms halfway*): I want you to hold out your arms. (*Nietzsche slowly does so*) Good. Now—I want you to whisper loud enough so that we can all hear you whispering: "Hello! Am I a prophet flying over the countryside looking into the future?"

(The Beautiful Woman and the Child rise and bow their heads in prayer.)

NIETZSCHE *(As he and the Dangerous Man both slowly flap their arms)*: Yes, I am.

THE DANGEROUS MAN *(Mockingly)*: Well, yes I am, yes I am . . .

(Music builds. Nietzsche backs into his chair. The Dangerous Man gets a golf club and again hits the chair, sending Nietzsche sprawling.)

NIETZSCHE *(From the floor, in pain)*: Tell me. Do you very much like— playing golf?

THE DANGEROUS MAN *(Jumping back up onto the bench)*: As a matter of fact *(Does a sudden pose to show his muscles popping)* I do like playing golf.

NIETZSCHE: Really?

THE DANGEROUS MAN: I like it.

NIETZSCHE: Why?

THE DANGEROUS MAN: No reason. *(Relaxes; he's threatening nevertheless)* But you know how much I like golf.

NIETZSCHE: No, I didn't know that.

THE DANGEROUS MAN: We've been friends for ten years—

NIETZSCHE: Ten long years.

THE DANGEROUS MAN: Ten wonderful years.

NIETZSCHE: Ten long years.

THE DANGEROUS MAN: After ten years of friendship, you should know golf is one of my favorite hobbies.

NIETZSCHE *(Rising, looking into the distance)*: You know what? I've seen you going off to play golf so often, I've concluded—it's a hobby.

THE DANGEROUS MAN: Right. I like it.

NIETZSCHE: Well, I believe you. *(Stumbles about with a golf club, tries to execute a golf swing, and gets tangled up in himself until he drops the golf club on his foot)* You like it because— *(Giving the golf club to the Dangerous Man)* —you're good at it!

THE CHILD *(Excitedly, as Nietzsche sits)*: He hopes to get better. And better—

(The Dangerous Man crosses behind Nietzsche's chair and starts whacking it with his club as Nietzsche slides to the floor, exhausted.)

—and better and better and better!

THE DANGEROUS MAN: Excuse me, Mr. Nietzsche, but wasn't there supposed to be money in this for the rest of us?

NIETZSCHE *(Pulling out a wallet full of money)*: A promise is a promise. *(Throws bills into the air)*

THE BEAUTIFUL WOMAN: Oooh. The gods provide. —Where does all this wonderful money come from, Mr. Nietzsche?

NIETZSCHE: I don't want to know such things.

THE DANGEROUS MAN: Right. Some people get nervous about money.

NIETZSCHE: How did it come to be that there is—money? Rather than—no money?

THE BEAUTIFUL WOMAN *(Giggling)*: Thank goodness.

NIETZSCHE: How did the world decide to invent, and spew forth—money!?—take off your shoes, please—

THE BEAUTIFUL WOMAN AND THE DANGEROUS MAN: What?

(The Voice starts singing a falsetto: "Hello! Hello!" Nietzsche grabs a whip and stumbles about the stage, ranting in gibberish, as the upside-down legs again rise out of the ocean with the Phallic Serpent between them. Nietzsche bangs into a wall and the Voice, deepened, exclaims: "Ow! Ow!")

THE BEAUTIFUL WOMAN: You don't mean take off our shoes?

NIETZSCHE: I promised lots of money. I'm going to stuff ten-dollar bills inside everybody's shoes. *(Begins to do so)*

THE BEAUTIFUL WOMAN: That's crazy.

NIETZSCHE: Yes—I'm going to squeeze ten dollars inside this shoe, and another ten dollars, and lots and lots of crumpled-up ten-dollar bills.

(The Falsetto Voice sings: "Hello, hello.")

THE BEAUTIFUL WOMAN: This is crazy—

NIETZSCHE: OK. With ten-dollar bills stuffed inside everybody's shoes, are those shoes a little bit uncomfortable maybe?

THE CHILD: My shoe is very uncomfortable.

NIETZSCHE: Yes! But having those extra ten dollars makes being uncomfortable—"OK."

THE DANGEROUS MAN: Ten dollars—not a big sum, Mr. Nietzsche.

NIETZSCHE: Ten dollars? —Well, ten dollars is *ten dollars*, my friend.

THE BEAUTIFUL WOMAN: OK. We have ten dollars in our shoes. Now what?

NIETZSCHE *(Going to the cabinet)*: Why don't all three of you just squeeze inside this ugly thing—

THE BEAUTIFUL WOMAN: That ugly thing?

NIETZSCHE: Squeeze inside, please! For me.

THE BEAUTIFUL WOMAN: Do you imagine us having sex inside that thing, Mr. Nietzsche?

NIETZSCHE: No. I never said that.

THE BEAUTIFUL WOMAN: Guess what, Mr. Nietzsche. Imagine it, and it might happen.

THE CHILD *(As all three enter the cabinet)*: Obviously it's going to happen.

THE DANGEROUS MAN: Obviously.

(With the other three inside the cabinet, Nietzsche lies on the bench and becomes very excited imagining what's happening inside the cabinet. The Scholars fan him as the Voice sings a falsetto: "Hello—hello—hello!" Nietzsche falls off the bench in excitement. He rises and hears the moans of sexual excitement from inside the cabinet. As the noise dies down, he looks sadly toward the cabinet.)

NIETZSCHE:

> I do not love my neighbor near to me—
> But wish he, or she—
> Were high up and far away.

(He bangs once on the piano keyboard and howls.)

> How else could he, or she—
> Become my guiding star?

(From inside the cabinet the Child squeaks in pain. The Danger-ous Man mutters: "You're such a child." They all exit the cabinet.)

THE BEAUTIFUL WOMAN: All done in here, Mr. Nietzsche.

NIETZSCHE: What happened to the ten dollars, please?

THE BEAUTIFUL WOMAN: Don't worry, it's still in our shoes.

NIETZSCHE: OK. Take the money out of the shoes, please. And now see if the money STINKS!! *(Pause)* Well? Does it stink?

(Pause.)

THE BEAUTIFUL WOMAN: You've been a very bad boy, Mr. Nietzsche—

NIETZSCHE: Yes. *(Slaps his own wrist)* I have—tell me how I've been bad.

THE DANGEROUS MAN *(Indicates the Beautiful Woman)*: You had sex with this lady, I believe.

NIETZSCHE: No, that's not possible.

THE DANGEROUS MAN: A certain species of girlfriend—

(The Beautiful Woman starts chasing Nietzsche around the bench. He falls and she is on top of him, caressing him.)

—a possible wife; an everlasting bundle of—"look but don't touch."

(The Voice intones: "Pleased to meet you.")

Upside-down on the other side of the world, Mr. Nietzsche?

NIETZSCHE *(Trying to avoid her caresses)*: I have not done this terrible thing!

THE DANGEROUS MAN: But you have.

NIETZSCHE *(Looking away)*: In my dreams only.

(The Beautiful Woman leans over and kisses Nietzsche.)

THE CHILD *(Sings)*: We all love Chinese babies.

(Nietzsche pushes away from the Beautiful Woman, as the Upside-down Cardboard Legs and Serpent rise up from the ocean.)

NIETZSCHE: No! In my dreams I have. So punish me for such terrible dreams.

(The Dangerous Man, the Beautiful Woman and the Child strip to the waist.)

THE DANGEROUS MAN: Punishment can sometimes be given on demand, but most of the time, what you ask for isn't exactly what you were asking for—am I right, Mr. Nietzsche?

THE BEAUTIFUL WOMAN *(As she and the Child strike erotic poses)*: Say something, Mr. Nietzsche.

THE DANGEROUS MAN *(Looking at the Beautiful Woman and the Child)*: Hey. Very nice.

THE CHILD: Say something wonderful, Mr. Nietzsche.

NIETZSCHE *(His eyes glued to their naked breasts)*:
Lest her happiness oppress us . . .

(Nietzsche leaps up and grabs a sword, which he points at the Beautiful Woman and the Child.)

—Cloak yourself in devilish tresses
Devilish wit and devilish dresses,
All in vain! Her eyes express her angelic—saintliness.

(The Voice sings: "Hello, hello," and the Deep Voice intones: "Ow!" The Scholars run on, all carrying oversized wooden phalluses which they manipulate in inventive ways, as the Beautiful Woman sings operatically: "Friedrich Nietzsche!")

(Watching the Scholars rub their phalluses) This too shall pass.

THE DANGEROUS MAN: This will not pass, buddy.

NIETZSCHE: Help me. *(Takes off his pants)*

THE BEAUTIFUL WOMAN: You bad boy.

(Nietzsche lies back on a bench, holding his penis, as the Scholars gather around to look.)

NIETZSCHE: Help me!—I have this appendage on the front of my body that swells up sometimes. It does—it really does! It's called my penis, I suppose.

THE BEAUTIFUL WOMAN: You bad, bad boy.

NIETZSCHE: A great variety of species on this planet have a similar system that swells up. But why is this necessary? Why? Why?

THE BEAUTIFUL WOMAN (*Advancing toward Nietzsche and posing*): Maybe the grid on which you chart your experience is never your experience, Mr. Nietzsche.

NIETZSCHE (*Rising to study her exposed breasts*):
 Oh, why is she clever now, and so refined?
 On her account a man's now out of his mind.
 His head was good before he took this whirl,
 He lost his head—to the aforesaid girl!

(*The Scholars run in with white sheets, some trying to clean the walls, others winding Nietzsche in a sheet to hide his penis.*)

I'm sorry. I'm sorry—I have this appendage—on the front of my body—it swells up sometimes.

THE BEAUTIFUL WOMAN: Make some babies, Mr. Nietzsche.

NIETZSCHE: Babies? —NO! (*Runs to grab onto the cannon, holding it like a security blanket*)

THE BEAUTIFUL WOMAN (*Hushed voice, displaying her body*): Millions and millions of babies—making millions and millions of thoughts, Mr. Nietzsche—until that one day finally comes, when every possible thought has finally been thought, Mr. Nietzsche.

NIETZSCHE (*Whispers*): Is that really possible?

(*The Beautiful Woman comes to look at Nietzsche, then turns and throws herself against a probe.*)

THE BEAUTIFUL WOMAN: But—it takes a lot of babies—until all possible thoughts—

(*There is a thud that throws the Scholars against the walls.*)

—can finally be thought. So then—this whole rotten, beautiful planet can just STOP, Mr. Nietzsche.

(The Child giggles as the Dangerous Man slaps the briefcase into Nietzsche's hand, then turns to look at the Beautiful Woman's breasts.)

THE DANGEROUS MAN: Very nice . . .

THE BEAUTIFUL WOMAN:
> Not death maybe,
> —But something even more interesting.

NIETZSCHE: Oh my God.

(A boat appears bouncing up and down on the far ocean. Nietzsche sings in falsetto:)

Shipwreck! Shipwreck!
THE CHILD: Shipwreck! Shipwreck!

(The music rises, and all run to the ocean and try to reach out to the ship in danger. The Voice cries out: "Pleased to meet you! Pleased to meet you!" Nietzsche throws his chest against a probe. Suddenly the music stops and the actors freeze.)

Your boat is now ready, Mr. Nietzsche!
THE DANGEROUS MAN *(To Nietzsche)*: What's wrong?
NIETZSCHE: There's no boat.
THE DANGEROUS MAN: I know there's no boat.
NIETZSCHE: There's no boat. Nobody climbs onboard, because there's no boat—
THE DANGEROUS MAN: You already said that, Mr. Nietzsche.
NIETZSCHE: I said that because I want things said that will cut into me like a knife. *(Again throws himself against probe)* I want this kind of pressure—
VOICE *(As a bell rings)*: Your boat is now ready for delivery, Mr. Nietzsche.

NIETZSCHE:

> Was I ill? Have I got well?
> Oh my memory is rotten
> But those are well who have forgotten!

(He grabs a whip and, moaning inarticulately, starts beating the ocean. The Voice intones: "Here is a man! Here is a man!" Nietzsche tumbles over a bench.)

I'm sorry to tell you— *(Reaches into his briefcase and throws papers into the air)* There is no boat!

THE DANGEROUS MAN: I'm sorry to tell you, Mr. Nietzsche. You hurt people, too. Just like everybody else.

NIETZSCHE: That was never my intention—

THE CHILD: Everybody hurts everybody, Mr. Nietzsche.

(The Scholars press recovered pieces of paper against Nietzsche's body. He swings his briefcase to fight them off.)

THE DANGEROUS MAN: See what I mean, Mr. Nietzsche? You really hurt people—

THE CHILD: Nobody reads the stuff you write, Mr. Nietzsche.

THE DANGEROUS MAN: Nobody wants your babies, Mr. Nietzsche.

THE BEAUTIFUL WOMAN: Nobody wants to give you—hugs and kisses.

NIETZSCHE *(Crossing slowly to the cabinet)*: OK. In order to bring a little bit of happiness to somebody who deserves, of course, no real happiness— *(Opens the door to the cabinet)* I'll just—lock myself—inside this ugly thing—forever.

THE DANGEROUS MAN: Hey! You're still not inside it, Mr. Nietzsche.

NIETZSCHE *(Entering, peeking out through the door)*: I'm never coming out! . . . Believe me?

THE DANGEROUS MAN: Nobody can live forever inside that thing, Mr. Nietzsche.

NIETZSCHE: I'm never coming out.

THE DANGEROUS MAN: You won't come out?

(Nietzsche disappears inside as the cabinet starts advancing to center stage. Childlike music is heard.)

NIETZSCHE: I'm never coming out!

(The stuffed horse is carried in. The Child grabs a whip.)

THE CHILD: OK. If you're never coming out, Mr. Nietzsche—then we can beat the shit! *(She whips and giggles)* —out of this poor little horse as much as we like, and nobody's going to stop us. Right, Mr. Nietzsche? Right? Right?

(The Child and the Beautiful Woman beat the horse violently. The music turns to violent pounding as the cabinet moves forward, frightening them, forcing everyone to cower against the wall in terror. Nietzsche runs out of the cabinet. He sees their terror as they claw their way up the wall, then he heroically pushes the cabinet back to the side of the stage. Then, as the music quiets, he does a funny little walk to center stage.)

You lied to us, Mr. Nietzsche. You said you were never coming out.
NIETZSCHE: Yes. But how is that possible? Because— *(He thinks, then speaks softly)* I never lie.

(The lights fade.)

THE END

Now That Communism Is Dead My Life Feels Empty!

PRODUCTION HISTORY

Now That Communism Is Dead My Life Feels Empty! Produced by the Ontological-Hysteric Theater at the Ontological at St. Mark's Theater, New York City. January–April 2001. Written, directed and designed by Richard Foreman.

FRED	Jay Smith
FREDDIE	Tony Torn
SERVANTS	Frances McKee, Susannah Ray, Noel Allain, Meg Brooker, Catherine Owen, Sophia Skyles

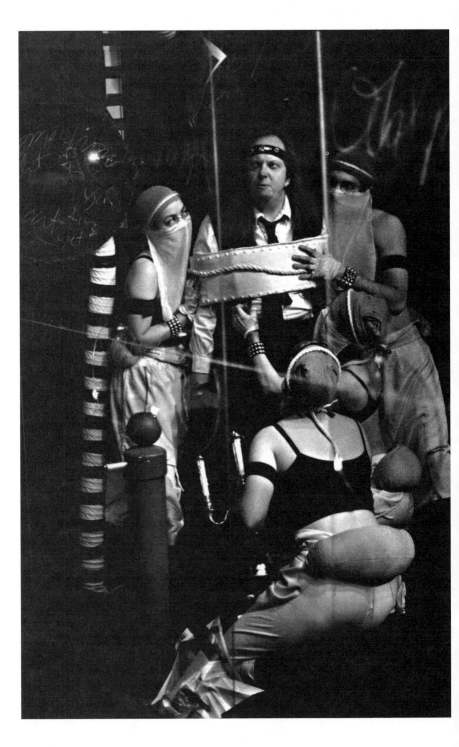

A large, empty, wood-paneled room. Large blackboards, with illegible writing scrawled on them, cover the walls. A number of small sandbags and trapezes hang down from the ceiling, suggesting that bizarre rituals perhaps take place here, late at night. Freddie enters—an aging hippie, now a Southern redneck type, bald on top but with long hair down to his shoulders and a nose red from overindulgence. He wears a sloppy leather vest and tie, a headband and leather gloves. He enters on his hands and knees, scrubbing the floor. He is accompanied by a group of people dressed like members—servants perhaps—of an Oriental harem—men and women with veils, tight bandannas covering their hair, bare midriffs and white bloomers. They are also cleaning the floor. A jazzy piano vamp is heard at first—changing music accompanies the entire play.

FREDDIE *(With a Southern accent)*: Thank God this terrible job is almost finished.

(The Servants collapse to the floor.)

Cleanin' up this terrible mess.

(A giant of a man, dressed in white, appears from the shadows. Hands on his hips, he strolls slowly into the room and plants himself in front of Freddie. This is Fred. He has a huge chest and

wears a leather skullcap and high leather riding boots. He sports a white cape. He also has hair down to his shoulders. Freddie looks up at him, and then collapses to the floor. Fred speaks in a drawn-out fashion, with a slow nasal drawl, belying his massive and dominating appearance:)

FRED: Wake up, Freddie. Wake up, my friend.
FREDDIE: Where am I? Hey—

(He sees the collapsed Servants and struggles uncertainly to his feet.)

This is now, right here, an unrecognizable environment as far as I'm concerned. I mean—if this is the future, man—I don't like it. *(Moves to exit)*
FRED *(As Freddie leaves the room)*: But there's no problem with the future, my friend. The future arrives all by itself.

(At the sound of a loud crash Freddie jumps in from another door, holding a painted electric guitar. The Servants jump up.)

FREDDIE: Surprise! —Nothing in this world is "automatic," man.

(Another crash, and the Servants slump back to the floor.)

(Surveying the scene) Hey. I feel terrible about all these "unconscious people."
FRED *(Holding out an object under a napkin)*: Wake yourself up with some delicious fruit, my friend—

(He uncovers the fruit, and the Servants come to life.)

It'll change your mind approximately . . . Oh . . . fifty percent, maybe.
FREDDIE: Fifty percent?
FRED *(As one of the Servants rubs up against him affectionately)*: A delicious fifty percent.

FREDDIE *(As the other Servants gather around him)*: Why do I want my mind fucked-up! —Boo!

(A crash, and the Servants around him fall to the floor.)

By some half eaten fruit?

FRED: Half eaten? Oh, the best kind, my friend, because by the time your intentions are fully realized—you've caught up with yourself completely. *(Giggles)* But whenever that happens—you feel empty inside, am I right? Right?!

(The Servants run to the walls in fear. Fred lifts the fruit up into the light; we see it is discolored and rotten.)

So many things are dead things, my friend—this is why certain people see emptiness in the midst of plenty.

FREDDIE: Look—if my own life feels empty—then I say . . .

(The Servants creep out of the room behind his back. He whirls.)

Hey! Where did everybody go, man?

FRED *(Thrusting his massive chest in Freddie's face)*: What do you say about that, Freddie?

FREDDIE: I say—this cannot be explained by history—turning itself inside out—

(A Servant runs in and steals his guitar, as another presents a big bowl of fruit.)

What the fuck? *(Approaches the fruit)* Come to think of it—got my own private stash here!

(He steals the fruit and runs off. Three Servants with guitars wiggle their hips and moan excitedly.)

FRED *(Holding a small box by a handle that protrudes from the bottom)*: Listen! Some new things under the sun are never new things under the sun. *(Servants moan and wiggle as he strides*

across the sage, spinning the box) Nevertheless, such things, when they are new things . . .

FREDDIE *(Running in with a new guitar)*: Here we go!

FRED: . . . Should work—right? But nobody gets such new things to work. *(Pause)* Why don't things work?

FREDDIE *(Posing with his guitar)*: Why don't such new things work! Why don't these goddamn things work, because they ain't working!

(A Servant runs through the room with a large red flag.)

(After the flag has gone, thinking to himself) Did I see somethin' . . . flashin' by?

FRED: Listen—maybe they're not working—because you have to wind them up.

FREDDIE: OK. I'll wind them up right now.

(Fred turns a crank on his box. The three Servants with guitars wiggle their hips and moan. Another Servant steals the guitar from Freddie's hands. He starts to run after it, then stops and holds his head.)

Oh fuck!

(He collapses to the floor as the Servants run from the room. Fred stands over him, looking down at Freddie's fancy shoes.)

FRED: Hey—those 350-dollar shoes he's wearing. I like them.

FREDDIE *(Sitting up)*: Get your own expensive shoes.

(A crash. A Servant runs through carrying a red flag. Freddie jumps to his feet. Then he thinks to himself.)

I saw something . . . scary, but I'm still not giving you my 350-dollar shoes.

FRED: But I really like them.

(A loud bell rings, the lights get bright. Fred and Freddie run from the room as machine-gun fire is heard. It stops. They peek

back into the room and a Voice says: "Careful, don't move." There is a pause, and then they slowly return.)

FREDDIE: These are my shoes, man.

FRED: I like them, Freddie, even if they belong to you personally—I like them.

FREDDIE: Get your own, Fred. These are my private shoes. So—you can't have them.

FRED: I don't know why I like your shoes so much. Why do I like them so much?

FREDDIE: I like them, too.

FRED: We both like them.

(Fred chases Freddie out one door and in through another.)

FREDDIE *(Shouting angrily as he runs)*: You like them and I like them! The difference is—they are my shoes.

(A Servant runs in and polishes his shoes.)

FRED: If I can't have your shoes, then at least—I want to dance, like I have always dreamed of dancing.

FREDDIE: You can dance, Big Boy—

FRED: Hey!

FREDDIE: By yourself—wearing your own shoes.

(The Servants rush in carrying small mirrors. They squat on the floor and spin the mirrors quickly by their handles, reflecting the shoes in hypnotizing flashes of light.)

That's your personal choice, man.

FRED: No, Freddie, I think you're going to hold it against Big Fred for a long time if he dances by himself.

FREDDIE: I like to see people dancing by themselves.

FRED: Really?

(He considers this, then runs to confront Freddie with his own special dancing position. As he arrives Freddie fires at him with an imaginary pistol that makes a bang. Fred and the mirrors all freeze.)

FREDDIE: Gotcha!

FRED: Well, it's true I'm— *(Squatting and doing a single hip swivel)* "GOOOD" at it. Everybody says, "Hey! That Big Fred, he dances good."

FREDDIE: Go on and try. I promise I won't laugh.

FRED: I've never seen you laugh with sincerity, Freddie.

FREDDIE: Sincere Freddie doesn't find much to laugh at—

(The mirrors spin, disorienting Freddie, who falls to the floor.)

Oww! Even if Sincere Freddie feels like laughin'—he won't laugh.

FRED: If you don't think I'm good at dancing.

FREDDIE: I've seen you dance by yourself. I think you're good at it, man. And I'm very sincere.

(The mirrors stop spinning.)

FRED: Maybe I'll dance later.

FREDDIE: Yes, that would be a good idea. *(Struggles back to his feet)* You do it later. In private.

FRED: We both do some of our things in private, Freddie.

FREDDIE: Is there something wrong with that, Fred?

FRED: Do you think there's something wrong with that, Freddie?

(A wrapped box is carried in by a Servant.)

Look at—at this box that came for you—which you'll probably want to open in private, because there's a spanking brand-new— guess what? *(Lifts the box high in the air)*

FREDDIE: I can't guess.

FRED: A head—inside this box.

FREDDIE: Oughhh!—I hope not!

FRED: Oh yes, there's a head inside this box. Stuffed with . . . whatnot. It belongs to you.

FREDDIE: Put that stuff in the garbage.

FRED: Even if it belongs to you?

FREDDIE: It certainly does not belong to me.

DEEP VOICE: Communism is dead, my friend!

(They all freeze, looking up at the source of the Deep Voice.)

FRED *(After a pause)*: OK . . . I'll put this outside for later. *(Exits with the box)*

FREDDIE *(To the audience)*: Come to think of it, man—I never had the opportunity to look inside that box.

(A Servant pushes in a table with a wooden box on it. Other Servants, followed by Fred, run onstage and squat, pulling down on small trapezes hanging from the ceiling, which effectively lift the small sandbags that have been hanging from the ceiling.)

What's in that box?

FRED: This is a different box, Freddie.

FREDDIE: OK, it's a different box, and what's in it? What's in it? What's in it!

FRED *(Taking the box and holding it to his chest)*: What I hold in this box—is my dog.

FREDDIE: In that box?

FRED: Right. Sometimes, because I like my dog so much, I take it out—for a walk. Like this.

(He strides across the stage, as the Servants rise to release the trapezes.)

But—this is risky, of course. Why is this risky? Because dogs bite, Freddie. And some dogs bite really hard. "Bite hard. Bite really hard!"

(The Servants and Freddie all run from the room. Fred giggles and sets the box down on a shelf at the rear of the room.)

I feed my dog through a small drawer in the front of the box. Watch this. *(Opens a drawer in the box)* Notice, when the drawer is open, food can be placed in the drawer. You'll have to imagine the food.

But—when that drawer is open, like this, Fred's dog inside has no access to that food, so, i.e., the dog cannot bite. *(Grasps the box to his chest, giggles and whirls)* Oughhh! Did that hurt?

(Loud bell, bright lights and machine-gun fire. He runs from the room. Pause. Then silence. He peeks in, then slowly returns.)

DEEP VOICE: I wonder what I'm going to say next!

FRED *(After a pause)*: Now—when the drawer is closed—

DEEP VOICE *(Interrupting)*: God is dead, my friend!

FRED: Pay attention! When the drawer is closed—Fred's dog does have access to that food. Yum yum yum.

FREDDIE *(Peeking in at the door)*: Don't be disgusting, Fred.

FRED: It's perfectly good dog stuff, OK? But when the drawer is closed, there is no opening to the outside world, so once again, i.e., the dog cannot bite.

FREDDIE: Bravo to you, Fred.

FRED: Is this a sincere "bravo," Freddie?

FREDDIE: I am sincere about this one thing.

(They pose, shaking hands.)

FRED: Then thank you, Freddie, thank you for that sincere bravo.

FREDDIE *(As they struggle to pull each other off their feet)*: You're welcome, Fred.

FRED: Next please!

(A crash. Servants enter carrying white curtains, held at waist height. Fred strides confidently back and forth in front of the wall of curtains.)

Now that we have a basis for enjoying ourselves, yah!—let's all take notice, please, of a certain "snazzy something," i.e., what Fred is wearing.

FREDDIE: What the hell is special about that?

FRED: This is what he sometimes wears when he is walking his wonderful dog.

FREDDIE: Are you, right now, in front of our eyes, walking your dog?

(The Servants make the curtains shimmy to the music accompanying Fred's triumphant walk.)

FRED: Walking my dog!

FREDDIE: Are you walking your dog?

FRED *(Goose-stepping back and forth to the music)*: Walking my big dog!

FREDDIE: Are you walking your big black dog?

FRED: Walking my big black dog with the fur and the sharp teeth and other things!

FREDDIE: Are you walking your dog, Fred?

(The music stops and everyone freezes.)

FRED *(He looks about, then thinks to himself)*: OK, who likes this outfit best?

(The Servants run off.)

OK, Fred's dog likes this outfit—at least, this is what Fred thinks. I think so, too—

(Music rises. Servants roll in another table with a box on it just like the dog box. It is immediately covered with a white cloth, and a candelabra is placed on top.)

Most of the time, Fred keeps his dog box hidden from people. Because—deep down inside, since people are basically good, deep down inside—at least I hope so—

FREDDIE: Bravo to you, and your little friend, Fred.

FRED: It makes people think less of Fred—to think that Fred keeps his dog prisoner in such a box. Am I right?

(Freddie lifts the candelabra and places it on top of his head. The cloth comes off the box and the Servants run in to place sticks with sponges on their ends against Fred's body.)

(Lifting his arms to provide access for the sponge sticks) Oh, thank you for ministering to my many bleeding wounds.

FREDDIE: When all else fails—

FRED: What's failing around here, my friend?

51

FREDDIE: Well, I don't know yet, but I'm predictin' . . .

FRED *(As the sponges are removed)*: What?

FREDDIE *(Thinks, still holding the candelabra on his head)*: . . . a pet dog, licks away all pain and trouble.

FRED: I never underestimate my dog.

FREDDIE: Now, instead of letting that dog howl all night long, locked up in that box—

FRED: My dog's happiness—this is important to me.

FREDDIE: Happiness is important to me, too . . . right?

FRED *(Looking at Freddie and his candelabra)*: It looks like it.

FREDDIE: OK. Let's talk about something even more scary—

(Servants come and take his candelabra. They drag him over to a wall and tie him up against it.)

Hey! Wait a minute! What a revoltin' development this is—

FRED: I am always ready for scary subjects.

FREDDIE *(Struggling against his ropes)*: OK. Since you're victimizing this unregenerated idealist over here—

FRED: You?

FREDDIE: Oh, I am, that's what I am. And since you've got me approximately hog-tied over here, let's talk about something else Fred keeps in his box.

FRED: Like what?

FREDDIE: You know what.

FRED *(Looks around, considering)*: OK. Under the circumstances, I'm happy to tell you, that I keep—private documents, of course, in a certain second box.

FREDDIE: Oooh!—I'm dreaming about a certain box just stuffed with documents that are old, faded and smelly.

FRED: Smelly? Of course they smell bad.

(He starts to the box. Others start to follow, but he whirls and points a finger like a gun, and there is the noise of a shot. Everyone freezes.)

Gotcha!

(Everybody runs offstage, leaving Freddie all alone, tied to the wall.)

FREDDIE *(Quietly)*: Would somebody untie me please? *(Louder)* Hey! Untie me please?

FRED *(Strolling back into the room)*: No no no no.

FREDDIE: Why not?

FRED *(Crossing to the box, Servants following)*: I don't mind opening my box to show you some of these—"smell bad" documents. Here's a good number of permanently sealed envelopes. *(Holds up a large envelope)*

FREDDIE: Time to reveal those secrets, Fred.

FRED: Why not? On the other hand, you understand the problem. It's private material.

FREDDIE: For your eyes only?

FRED: That's very understanding of you.

FREDDIE: Well, then, you might as well put them back in the box, Fred.

FRED: Sure, why not? *(Goes to the box and looks in)* Uh-oh—

FREDDIE: What?

FRED: Oh my God—look at this.

FREDDIE: What?

FRED *(Holding a small dead dog up in the air)*: Here's my dog.

FREDDIE: You mean, you keep your valuable dog in the same box with your smelly documents?

FRED: Maybe I got confused.

FREDDIE: Lucky your documents didn't get damaged.

FRED: Oh, it wouldn't have been my dog's fault, because he—or it—is apparently already dead.

FREDDIE: That must be hard for you, Fred.

FRED: Well—thank God. This wasn't my favorite dog—

(A loud bell, bright lights and machine-gun fire. They all run off. Silence. Fred and Freddie peek into the room. They wait. A Deep Voice announces: "I'm losing control." Fred and Freddie reenter, Freddie getting re-tied to the wall and Fred re-lifting the dead dog.)

This wasn't my favorite dog.

(In the doorway, a dog head with a halo rises up from behind a large disk full of mystical signs. Fred runs to Freddie and whispers:)

That one over there—that's my favorite dog.

(The music rises as the Servants run in and pull down on the trapezes, screaming in ecstasy. Fred runs to pose under the mystical dog head.)

Take my picture, please. Take my picture with my favorite dog.

(A Servant takes a flash photo, accompanied by a loud crash. Fred spins away, holding his eyes.)

(Whining with self-pity) That was cruel. That was so cruel to me.

(The Servants chain him to the wall.)

Ohh—you wanna play rough? That's OK, I know how to play rough and tough with little girls like you.

(The Servants dance in place, giggling.)

Take your nasty little giggles and shove them down the toilet.

(The Servants wiggle their asses at Fred.)

Hey! Hey!

(They start to mock him by marching back and forth across the stage, accompanied by crashes. In the doorway where the mystical dog had appeared, a large checkerboard tilts into the room, with a mystical eye in its center and several kabbalistic signs embossed against the black-and-white squares. As the Servants leave the room, one comes and puts a black cloth over Fred's head.

The Servants return, holding hands and walking single file, and freeze across the front of the stage, looking at the mystical checkerboard.)

VOICE: It's over. The play is over. The play is now over.

FRED *(As the cloth is removed from his head)*: This is OK with me, because I will just savor this powerful moment.

FREDDIE *(Still tied to the other wall)*: Hey—what about me? What about me, goddamn it?

FRED: Calm yourself, stupid Freddie.

FREDDIE: About time you untied me. I don't find this "being tied up" stuff funny.

FRED: I don't find this tied-up, inside-outside, upside-down stuff funny either, my friend.

(Fred tries to pull open his chains. This doesn't work, so he takes a deep breath and expands his mighty chest. The chains rip apart with a crash. The Servants rush in to see him doing a frantic shimmy dance of triumph.)

FREDDIE *(Bitterly)*: It looks like fun over there!

FRED: *(Still dancing)*: It IS fun over here.

FREDDIE: Fun, huh? Can't you tell when I'm tryin' to cut you down to size with my powerful sarcasm?

FRED *(Stops dancing)*: Too late. Because I am having fun. *(Dances again)* Because everybody is here to have fun, I'm afraid!

(He stops dancing to watch as a Servant runs in with a box wrapped like a gift, which she presents to the tied-up Freddie.)

FREDDIE: Hey, your washed little filly is tempting me with goodies when I'm hog-tied like a trussed-up water buffalo in heat.

(She leans against him, thrusts a hand in his pants pocket and extracts money.)

Hey, that deep-dish pocket maneuver is a little too intimate for this post-teenage punkster.

FRED *(Striding over to snatch away the money)*: Thank God— Communism is dead, my friend. A system which treated human beings like dogs—

(Fred snatches the gift box from the Servants as they attempt to pass it around. He runs once around the room, lifting it in the air like a great prize.)

—as opposed to other systems, of course—

(He tosses the box to the Servants and runs to punch mightily against the wall, then backs away and flexes a muscle.)

Piece of cake, my friend—the now victorious capitalistic system.
FREDDIE: Oh I believe that, I believe that.

(Fred twists Freddie's nose.)

Oww!
FRED: Call that Capitalism with muscle, my friend—which treats people like dogs somewhat less often, of course, than the dead Communist system. Which also treats people like . . . DOGS!

(He glares at the Servants and they cower down on the floor in front of him.)

FREDDIE: Did I just hear somethin' about "dogs"?
FRED: Oh—what did you hear?
FREDDIE: I know about dogs.
FRED: What dog in particular.
FREDDIE: "This is my dog—this is my dog in a box"?

(Pause.)

FRED: I never said such a thing.
FREDDIE: Piece of cake, Fred.
FRED: Yum yum.

(Fred goes into momentary ecstasy, then recovers and turns to the Servants:)

Untie my friend.

(They do so, but in untying him they slip handcuffs on his wrists.)

FREDDIE *(Free of the ropes, but confused by the handcuffs)*: Thank you for having a little consideration, Fred.

FRED: Don't mention it, Freddie.

DEEP VOICE: I am not a Communist.

(They all freeze and look toward the source of the Deep Voice.)

FRED: But of course not. *(Goes to retrieve the gift box)*

FREDDIE: There's still one little thing that is not one hundred percent clear to me.

FRED *(Lifting the box up high)*: Christmas on Earth, my friend.

FREDDIE *(Studying his handcuffs)*: That sounds OK by me, but— sometimes, people still get depressed.

(Fred exits. Freddie asks the audience:)

Why is that—do I know, do you know? Nobody knows. *(Turns back to the room)* Fred? Hey—what happened to my friend, Fred?

(A Servant offers Freddie a lollipop. He looks at her suspiciously, then lets her pop it into his mouth. He tastes it and moans with pleasure. She pulls it out of his mouth.)

Oh my God, oh my God, oh my God—I can well see how having a cute little dog could make a person's life feel— *(Howls and whirls, and falls to the floor)* Hey, is that dog talk? What's your opinion, Fred? Hey, what happened to my friend, Fred? Hey, Fred!? Here I am!

(Fred enters on his hands and knees, crawling up behind Freddie, who now turns his head and sees Fred almost on top of him.)

Hey! This is fantastic. I found myself a comfortable chair—

FRED *(Still on his hands and knees)*: I know you feel bad, Freddie—

FREDDIE: No, I'm—comfortable.

FRED: Well, that's a start maybe. But it makes you feel better if I give you my special injection. *(Lifts a hypodermic needle)*

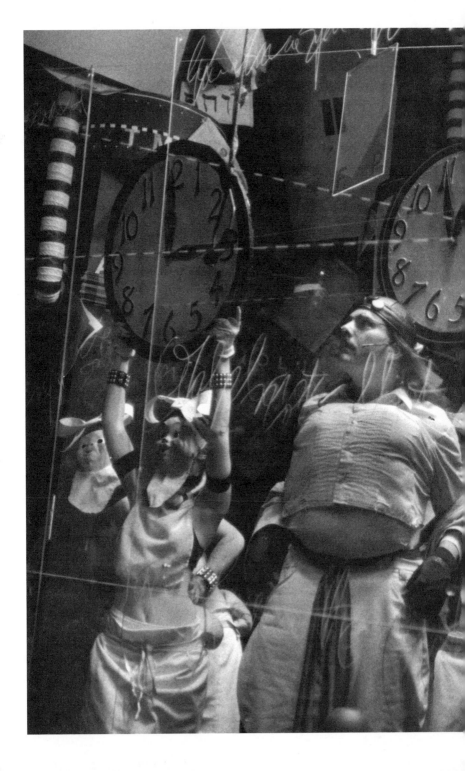

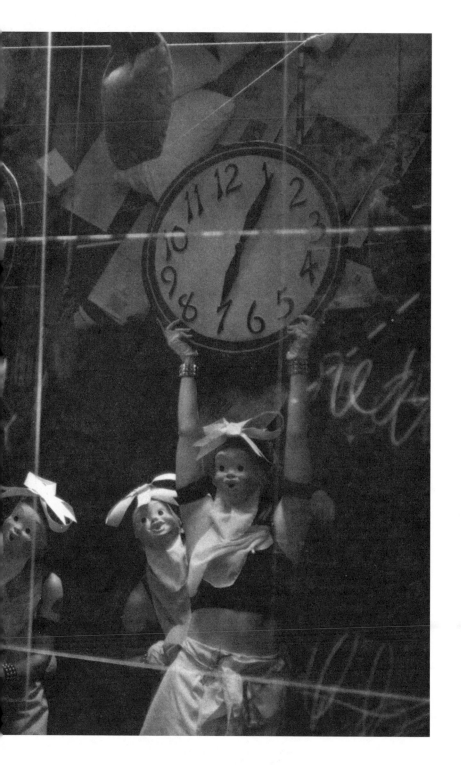

FREDDIE: Injection?

FRED: Yeah.

FREDDIE: Are you some kinda Communist, Fred?

FRED: How do you make that connection? Injection? Communist? There are no more Red Communists, Freddie.

FREDDIE *(As they struggle for the needle)*: Wait a minute—that could be a Red Communist truth serum.

DEEP VOICE: I am not a Communist!

(A Servant runs through the room with a red flag.)

I am not a Communist!

(Fred and Freddie sit for a few seconds, staring blankly into space.)

FRED: What did you just see?

FREDDIE: Nothin'—

(A quiet gong is struck.)

—special.

(A loud bell, bright lights, machine-gun fire. They run out of the room. Then they peek back in. Silence.)

DEEP VOICE: There will be no Paradise here on Earth, my friend. Stop dreaming of Paradise here on Earth.

(Fred rushes back into the room and uses the hypodermic to inject himself in the neck. He staggers in ecstasy and slowly falls to the floor as Freddie enters the room without handcuffs, dancing by himself.)

FRED: Nothing's a hundred percent, Freddie—but when one is desperate—one makes oneself . . . available.

FREDDIE: It could be said, I suppose, things are going OK for some people around here.

FRED *(From the floor)*: I'm glad you feel that way, Freddie.

Nevertheless—my life feels empty, goddamn it! —Why is that happening to me of all people? *(Staggering to his feet)* OK. Sit down and we'll figure it out—together. *(Collapses again)*

FREDDIE: I can't sit down because—guess what?

FRED *(Getting up again)*: Please—tell me why—

FREDDIE: Because I'm too agitated, you numbskull.

(The Servants run into the room wearing Indian headdresses and carrying bows and arrows, all aimed at Freddie. One of them starts wrestling with him, and they all chase him from the room as the Voice chants, in falsetto: "Here comes—EVERYBODY! Here comes—EVERYBODY!"

Fred, now alone in the room, starts to light his pipe. The Deep Voice intones: "There will be no Paradise here on Earth, my friend. No Paradise here on Earth!" Fred blows out his match. Freddie enters, reading a newspaper. Fred tosses his match onto a tray brought in by a Servant. He thinks for a moment, then seizes the tray, lifts it over his head, and hurls it to the floor with a crash which makes Freddie jump.)

FRED: Problems with my "devil-may-care" attitude, Freddie?

FREDDIE: You let something dangerous fall on the floor.

FRED: Oh—that's a dangerous match, Freddie.

(The Servants run in with the spinning mirrors.)

VOICE: Careful, don't move.

FREDDIE: Oh, I wouldn't dream of moving.

FRED: Nearing the end of my journey—an ordinary kitchen match. Very convenient for people who start fires.

FREDDIE: Houses, trees—whole cities on fire—

FRED: Oh, let's not set poor little cities on fire, please.

FREDDIE *(Angry and defensive)*: I know nothing of such things!

FRED: OK, my friend—

(They both move into an abstract, musical dance mode, gesturing and posturing. Shockingly, Fred suddenly acquires a thick Russian accent and a deep, husky voice.)

You can make up your mind to produce changes in your life that promise—no more than a delicate maneuver can deliver—I'm talking about speed—surface mail, my friend.

FREDDIE: OK. OK!

I can submit myself to multidimensional analysis which doesn't analyze the already obsolescent data, data, data . . .

(The mystical checkerboard tilts into the room again, as the Servants run in as a chorus line.)

—of hard fact!

But rather really gets into the you-know-what esoteric of feelings as plain as the nose on somebody else's face.

FRED: Face it. I'm alarmed by that face.

FREDDIE: Face it. I'm kinda charmed by that face—so what's the real dope on this?

FRED: You have to ask, smart-ass?

FREDDIE: Oh please, wipe me out?

FRED: Not this time, my friend—because whenever the imagination's my subject I better pull out my antibullet revolver.

FREDDIE: Oh no!

FRED: Bang bang—to shoot better than mathematics! Because the number of bullets turns into a—guess what? Being hurt bad by spiritual depth. My friend.

FREDDIE: Did I hear about death, my friend?

FRED: That's never spiritual, my friend. Because all that plumbs—

FREDDIE *(Sucking his thumb)*: Yum yum.

FRED: You like it?

FREDDIE: I like it—

FRED: He likes it.

(There is a loud crash. The Servants run in and start erasing the writing on the walls with white cloths. A Deep Voice intones: "When the Messiah comes, bite hard. Bite very hard, my friends, when the Messiah comes, bite very hard!" Fred and Freddie hold their heads in pain.)

(Recovering) Tomorrow's missed opportunities—

(A crash throws them back against the walls.)

FRED AND FREDDIE *(As the music turns very jazzy)*: Hey . . . hello there.

FRED: Why do I feel like a house on fire?

FREDDIE: My head spins, of course.

FRED: Listen, my friend—putting out blazes is one helluva way to extend your sphere of influence.

FREDDIE *(As the Servants dance into line behind him)*: But I don't wanna see that happen because you, me, and a couple of close friends expecting to participate—"party time"—while we are still in mint condition—

FRED: Oh yeah.

FREDDIE: Oh yeah.

(The Servants bump-and-grind once, then turn and run off.)

Hey! Wait a minute!— Boys and girls in your special categories!—

(A crash. Suddenly there is soft organ music.)

FRED *(Dropping his Russian accent, and returning to his soft, slurred speech)*: Oh, let's not set poor little cities on fire, please.

FREDDIE: That was never my intention.

FRED: Probably not, but—as an emergency measure—let's all step down hard wherever a certain somebody could be lighting a little fire.

FREDDIE: If no fires have even started yet?— Then it's just a bad guess where to do such stepping.

(The Servants are sneaking back onstage.)

FRED: OK. Life is full of bad guesses. *(Runs and stamps on the floor)* Fire! Bad guess number one. *(Runs to another spot and stamps)* Uh-oh—bad guess number two. *(Getting agitated, stamps again)* Number three! Number three! Oh my God—

(They all hold their heads and start crazily stamping to music, which stops suddenly. All but Freddie scream and run offstage. A Voice intones: "Red Communism is dead, my friend!")

FREDDIE *(After a pause)*: I wish I had a little box of matches I could call my own—

(Loud bell, bright lights and machine-gun fire. Freddie runs off-stage. Silence. He peeks into the room, then reenters, and the Deep Voice exclaims: "I have nothing to lose." A pause, and Fred enters.)

I wish I had a little box of matches I could call my own, because then I could set lots of things on fire. *(Pause)* Christmas on earth—Christmas, Christmas!

FRED: Stop talking like Christmas, please! I have no Christmas in my life, my friend—because my whole goddamn life feels empty, please— *(Runs to grab Freddie)* But—together we get to the bottom of these things, my friend, is that a promise? *(They shake hands, embrace)* Courage my friend—together we will dare to name these secret things. *(They embrace)* And I—me—Big Fred—I will dare to name the name of dirty, rotten, red, red, red Communists—flashing back and forth—back and forth . . .

FREDDIE: Yes, yes . . .

FRED: . . . inside my head with red flame-like things making the whole world like something on fire! Something big on fire!

FREDDIE *(Overlapping)*: Oh, oh, oh—dirty rotten Communist dogs— all we can do, my friend, is to start dancing our legs off like crazy inside those flames that are burning such wild ideas around in my brain!

FRED *(Dancing)*: So look at me—look at me start dancing my legs off like crazy from those flames that are burning such ideas into my brain!— Why not! Those dogs of death are dogs of confusion!—

FREDDIE: These are dangerous people, Fred—with dangerous egalitarian ideas—but aren't they supposed to be dead? All of them— dead by now?

FRED: Hey!— Maybe not!

FREDDIE: You mean—some of these wild, crazy Communists are still hiding around here somewhere.

FRED: Nooks and crannies, Freddie. Like—under the bed, for Christ's sake.

FREDDIE: Oh, I hope not—

FRED: They are not hiding under the table because guess what—I never had a table—so where are they possibly hiding?

(A shot rings out, startling them.)

FREDDIE: A whole new world is falling upon us, my friend—it is possible those Communists have disguised themselves.

(An ancient god appears, holding a giant disk of the sun on his shoulders.)

It is possible they are now hiding themselves inside of things—like space people.

FRED: Space people?

FREDDIE *(Running to look at the god, who starts drifting offstage)*: Oh my God—look at this! Oh my God! *(Calms himself and turns back to Fred)* Don't you know things about space people?

FRED: The fucking problem with space people is, maybe space people don't exist in reality—

FREDDIE: Well OK.

FRED: OK.

FREDDIE: Then you can forget about things catching on fire.

FRED: No, no, no—when I forget about things—you know—"catching on fire"? Do I go dead inside?

(Loud music, and two giant and frightening Demons with big eyes, big mustaches and beards cross the stage.)

Oh my God!

(A cock crows, and Freddie whirls and runs to the front of the stage.)

FREDDIE: Don't you get it?— Some of those fucking Communists have disguised themselves with virile and handsome mustaches!

(The Servants run about excitedly as the Demons exit.)

My God! Their eyes are on fire, bombing to hell things that are comfortable in my life, such as, you know, where I live, my own house for Christ's sake—

(Fred whirls about and receives a lamp shade over his head from the Servants. Freddie goes and peeks under the lamp shade.)

Hello?

FRED: How come you never invited me to your house, Freddie?

FREDDIE: That's not the point.

FRED: Your crummy house which is completely in bad taste, I am positive!

FREDDIE: My taste is impeccable!

(Freddie does the tango with a line of Servants. A cock crows and the Deep Voice intones: "Red Communism is dead, my friend!" Multiple crashes as the dancers whirl. A High Voice exclaims: "Here comes everybody, everybody!" Fred reemerges, wrapped in a large blanket.)

FRED *(Glum at not being included in the dancing)*: You never, never share things like this with me, Freddie!

FREDDIE: It is possible to share things without calling yourself a Communist—and why are you wrapped in that moth-eaten blanket?

FRED: Because I'm cold and lonely!

FREDDIE *(Suddenly aghast)*: Cold and lonely? *(Dances toward Fred, who evades him)*

FRED: I will never dance—with that big body of yours!

FREDDIE: But I too—am cold and lonely!—

(Several Servants creep under Fred's blanket. Freddie suddenly feels very much alone.)

So how do I warm myself in such a world?

(The Deep Voice intones: "Bite hard, my friend, bite very hard." A Servant carries a red flag onstage. It droops sadly.)

FRED: I admit this, Freddie. Deep down, I am just—dead, inside.
FREDDIE: We're talking about you, not me—
FRED: You too are running on empty, my friend.

(The female Servants pull down on the trapezes; Freddie feels reenergized.)

FREDDIE: Hey, I see ladies exercising for a future which includes, I suppose, delectable goodies. So where's the good stuff?

(The Servants lie down on the floor, still pulling their trapezes and arching their bodies erotically.)

FRED: Look into the past, my friend.
FREDDIE *(Collapsing to the floor)*: I can't help it. I'm running on empty.
FRED: I believe you.

(He grabs the box with the crank handle.)

But let's make one last big try.

(He repositions himself as the red flag is suddenly draped over his face.)

Oh shit.

(Loud bell, bright lights and machine-gun fire as all run offstage. Then they peek back into the room. After a pause, all, including Fred, return to their previous positions under the flag. The Servants pose erotically with the trapezes.)

Oh shit.
FREDDIE: Who's doin' OK around here? Me—still willing to give a hundred percent—
FRED: Something is missing, my friend.
FREDDIE: What's missing?

(The Servants on the floor undulate a bit, and Freddie rubs his hands together in anticipation.)

Right! I get the idea—

FRED *(Ducking out from under the flag)*: Do you have bad dreams like
I have dreams?

(There is a crash, and the lights go out.)

FREDDIE *(In the dark)*: Everybody dreams when the lights go out!

*(When the lights come back on, Freddie has fallen to the floor and
Fred, with his back to the audience, is holding the crank box at
his groin and rapidly turning the crank, moaning with sexual
pleasure, which climaxes. He falls against a wall.)*

FRED: Christmas on Earth, my friend!

FREDDIE: Are you trying to share your dreams with me? *(All rise from
the floor)* That's not possible, I'm afraid.

(The Servants run from the room, one grabbing Fred's crank box.)

FRED: Hey! Hey! —You strip me of my toys?

FREDDIE: I don't know what the hell you're talking about.

FRED: You want the shirt off my back, my friend? Listen to this,
everybody—

FREDDIE: Hey, cut it out—

FRED: He wants the shirt off my back!

FREDDIE: I do not.

FRED: Of course you want the shirt off my back!

FREDDIE *(Overlapping)*: I have drawers and drawers and drawers
stuffed with clean shirts that fit me perfectly.

FRED: And deep down inside—guess what?—I want the shirt off your
back, too.

(A Servant appears, offering a tempting apple.)

And what else—beautiful backyard gardens with the delicious
fruits of your desiring? Which are, in fact, half-eaten fruits, my
friend?

FREDDIE: That's disgusting to me.

FRED *(As more fruits arrive)*: Someone must always take a first bite, my friend.

FREDDIE: I no longer choose to participate in such whirligig whatcha-macallits!

(As Fred poses, holding a fruit in the air, an organ note sounds, and he again acquires the accent of a demonic Russian.)

FRED: One of the most potent ideas I ever had, years and years ago, was the idea that inside each individual delicious fruit, was a PIT! And that pit, was—guess what? *(A baby cries)* A radio receiver! In the center of the fruit. And the whole fruit—helps—the radio in the center of the fruit, with messages, reaching out to an entire world hungry for that delicious fruit.

FREDDIE: That could be potent poison fruit! Remember that cute little fairy tale or something?

FRED *(Reverting to his post-hippie persona)*: No, I have no memory of such things.

(A Servant grabs the fruit and spins, holding it in the air.)

FREDDIE *(Staggering back dizzily)*: In that case—which one of us takes a first, tentative bite—

(The other Servants hit themselves in the face, falling to the floor, then run offstage.)

VOICE: Red Communism is dead, my friend!

FRED: Here's an idea . . . are you still hungry?

FREDDIE: I'm always hungry.

(A big hand, palm out, appears in the doorway.)

FRED: We have to share, my friend.

FREDDIE: Share?

(He goes to run off, but is thrown back by the hand.)

Well, maybe there isn't enough for both of us.

(Fred points to him. They both freeze.)

FRED *(Still pointing)*: Gotcha!

(A crash. Fred turns to see the source of the crash, then turns back to taunt Freddie.)

Legions are in the streets, Freddie.
FREDDIE: What the hell does that mean?
FRED: We have to share, my friend.
FREDDIE: Hey—where did everybody go?
FRED: Well, out into the streets, of course.

(A cock crows and the big hand waves.)

FREDDIE: Well, OK! Let's brave the streets outside, like old-fashioned heroes.
FRED: You?
FREDDIE: Me.
FRED *(Advancing threateningly)*: And the people I care about most, I suppose.
FREDDIE: Now hold on! We oughta be able to find a nice restaurant along the way!

(A crash, a cock crows. Three big birds, on top of poles held by Servants, fly across the room.)

FRED: Careful, my friend. We don't know our way around this city— like those big cocks of peace flying in God knows what direction.
FREDDIE: We could follow our noses to kingdom come.
FRED: Legions are in the streets, Freddie.
FREDDIE: I don't believe that.
FRED: Look out the window.
FREDDIE *(Running into the hand again, recoiling with a crash)*: There is no window.
FRED: Turn on the radio—

(The hand is replaced by the mystic dog appearing over the mystic disk.)

FREDDIE: That's no radio, that's a big dog!

FRED: You hear that, Freddie? Legions are filling the streets.

FREDDIE: This does not worry me—

VOICE *(As many red flags are carried onstage)*: Legions, legions are in the streets, my friend.

FRED: You are turning things upside down, my friend—

FREDDIE: This does not worry me, because I am one of those people no matter what happens—I just seem to—GLIDE through my whole long life somehow— *(Dances elegantly among the swaying flags)* See what I mean?

FRED: Garbage, this is garbage.

FREDDIE: Garbage indeed.

FRED: Garbage for breakfast, lunch and dinner, right?

FREDDIE: You are what you eat, Fred!

FRED: OK, I admit it. Sometimes even I dance. And just like everybody else, I dance dance dance. *(Glides across the stage, as the flags rock back and forth)*

FREDDIE: Shit in your pants, Fred?

FRED: Oh, you want shit in my pants, Freddie? I'll show you shit in my pants!

(He shakes eccentrically across the stage, and the Deep Voice intones: "Red Communism is dead, my friend.")

I'll show the whole world—shit in my pants!

(The music rises, and the Servants dance behind Fred. Freddie feels left out.)

FREDDIE *(Angrily)*: Stop the music, STOP THE MUSIC!

(Everything comes to a halt.)

Nobody dances around here unless I'm the center of attention.

FRED: But Freddie, you are always the center of attention.

(Loud bell, bright lights, machine-gun fire, then all run off. Silence. Freddie peeks into the room, and the Voice intones: "I'm losing control." A pause, then all reenter and take their previous positions.)

FREDDIE: Are you people putting me on?

(He looks them all in the eye, then runs to the side of the stage and takes big striding steps, each accompanied by a crash. Then back to stage center.)

I must admit. I like being the center of attention. And thank God I am.

(All others rush off as the Deep Voice intones: "Careful, don't move!")

But do not say I experience no anguish. Oh no, no—because all men of distinction, if I may say so, experience anguish—but mine is different. Because . . . unjustifiable!—like a "pure alcohol"—that's right—distilled to make possible clear and lucid analysis—the result of which—

(An organ note rises, and a Servant rushes in carrying a long spear aimed at Freddie's heart. Freddie screams and falls to the floor as the Servant holds the spear to his chest. Then the Servant slowly backs out of the room.)

Here I am, hoverin' in the middle of my own personal anguish— my eyes drawn up to a threatening hole in the middle of the sky that moves whenever the hole in the middle of my own eye moves.
 So: when I disappear, and I do—goddamn it! Nothing changes! *(Slowly raises his hands to his heart)* But oh my God—what is this thing, fluttering around inside my heart? *(Falls back against the wall)*

(The Servants lurch onto the stage. They have pillows held to their crotches, and as the music rises, they rhythmically flutter the pillows against themselves.)

Oh my God!

(The music and fluttering pillows increase in intensity, only to come to a halt with a crash that hurls Fred back onstage.)

FRED: The same thing is fluttering inside my heart, goddamn it . . .

FREDDIE: Can I calm myself, if I put my hand on my chest and press down really hard?

(Fred comes up behind Freddie and reaches around him to press on Freddie's heart.)

FRED: You are pressing down on the human heart, Freddie—

FREDDIE: Whoever does this to me is not really my friend . . . my friend! *(They break free of each other)*

VOICE: God is dead, my friend.

(A baby cries. A Servant runs in dragging a gorilla wearing a crown. Fred strides to the gorilla and, with a big knife, slices off its head. Everyone screams in horror, and Falsetto Voices intone: "Here comes everybody!")

FRED *(Throwing down the knife)*: Well, almost everybody, I suppose. But in the meantime—

FREDDIE: Meantime?

FRED *(Rolling his eyes and sinking to the floor)*: Oh, come on, Freddie.

FREDDIE: Meantime? That sounds like forever to me. *(Also sinks to the floor)*

FRED: Forever, Freddie.

FREDDIE: Yeah, why the hell not.

(The Servants enter with little toy dogs. They make the toy dogs crawl over Fred and Freddie, rubbing against them and licking their private parts.)

FRED *(Sighing with pleasure)*: I am your friend, my friend, because sometimes, sometimes I steal even the bread from your mouth—

FREDDIE: Oh yes.

FRED: And sometimes, I steal even the air from your lungs—

FREDDIE: Oh, yes, yes!

DEEP VOICE: Oh—wagging his tail now, licking his friendly tongue now—man's best friend in the hour of this great need—

(A crash. A giant hand of God comes down from the heavens, decorated with kabbalistic signs. The Servants run off. Fred and Freddie rise to confront the hand.)

FREDDIE: What the fuck?

(They pull strings coming from the fingers and collapse against side walls.)

I am a relatively sane person—
FRED: Oh right—
FREDDIE: And a relatively a good person, I suppose. But my whole long life, goddamn it!—what the hell has this done for me, goddamn it?

(A crash as they release the strings. A table enters with a box on it.)

(Spinning to recover from the crash) I can't help it, I can't help it—but I just have to ask—what's really in that box?
FRED *(Caressing the box)*: Look. Once upon a time, long ago, there was a specific . . . *(Lights a pipe)* "NAME"—for this wonderful thing which eludes, always, mere human understanding.
FREDDIE: OK, but it was a bad name!

(Another crash. They run and grab the strings from the giant hand and pull it back to the walls.)

Because there is no accurate name for this unknowable thing.

(A loud bell, bright lights and machine-gun fire. Fred and Freddie start to run from the room, but then stop, grab white rags, and start erasing the blackboards frantically, as the Deep Voice intones: "I wonder what I'm going to say next?" Freddie whirls from the blackboard.)

OK!
FRED: Not OK!
FREDDIE: Do we say it's a good thing, that there is no name for this invisible thing?

FRED: No. This has its unfortunate aspects also, my friend—

(A crash. Freddie starts throwing things in frustration as the Servants run through the room, but Fred calls things to order:)

BECAUSE!—what has no name vanishes. Not that it is invisible. Is it visible, in fact?

FREDDIE: OK, am I visible in fact?

FRED: I am of two minds on this question.

FREDDIE: That's because I am, guess what?

(Machine-gun fire. The Servants run in, and a spectral angel of death appears above the room. Freddie welcomes it and turns to Fred.)

Much more than you can possibly imagine, you son of a bitch. Me, me, me and my personal angel. Me. Me—an angel—

FRED: Evidently, a specter is haunting us, my friend.

FREDDIE: No, no—a true angel, come to save the whole world—by escaping from this genuine bucket of shit.

FRED: Wait a minute. Escaping from this world does not save this world.

FREDDIE: For Christ's sake—if I escape something, then it changes. Now open that box.

FRED: Careful, my friend. If I open this box—

(A crash. The Servants run in carrying little pictures of dogs.)

—something dangerous gets out.

FREDDIE: Well, that's OK, because here we got pictures of cute little dogs.

(A Servant runs through carrying a red flag, but only Fred notices. He whirls and shoves his hand into the dog box.)

FRED: Hey. What happened to my dog?

FREDDIE: There was never a real dog in that box. But I better have a look for myself.

(He approaches, puts his hand in the box, and howls in pain as the box rises over his head. The music rises as Fred and Freddie fight for the box. The big hand of God descends from Heaven.)

VOICE: All dogs are dead, my friend, all dogs are now dead—

FRED *(Coming to the audience)*: Oh please—I need my face licked occasionally, goddamn it.

(The mystic dog appears in the doorway. Freddie tries to hurl a long spear at it, but the dog is immediately replaced by the mystic checkerboard, which leans into the room as Fred and Freddie struggle over the spear.)

DEEP VOICE:

Bite hard, my friend, because—
I am no longer man's best friend, but the opposite, my friend.
Someone mysterious, with a superior mind.
Who whispers easy-to-do things—just—for the mysterious
 pleasure of new adventures.
Christmas on Earth, please.
Danger—Christmas here on Earth—danger—

FRED *(Still struggling for the spear)*: I know the end of this story!

FREDDIE: I don't want to hear the end of this story!

FRED: Get away from me—I know the end to this story!

(Freddie gives a push and Fred tumbles out of the room. Freddie lifts his spear and runs after him.)

FREDDIE *(Exiting after Fred)*: I'm trying to save you from YOUR-SELF, goddamn it!

(A crash. Fred is thrown back into the empty room and sprawls on the floor. All is silent as he lies beneath the mystic checkerboard.)

FRED: Where am I? . . .

DEEP VOICE: When the Messiah comes, bite hard, my friend.

(A loud bell, bright lights, machine-gun fire. Fred jumps up and runs from the room. Then he peeks in at the checkerboard of God, and another crash sends him sprawling again to the floor.)

DEEP VOICE:
> When the Messiah comes, bite hard, my friend.
> Bite very hard when the Messiah comes, bite very hard! Bite
> very hard!

(Fred is still on his back. Freddie enters on his hands and knees, scrubbing the floor as at the beginning of the play.)

FRED *(Rising)*: I know the end of this story.
FREDDIE: Me too. *(Collapses in exhaustion)* I know the end of this story.
FRED: Guess what, Freddie—

(The Servants enter, spinning the hand mirrors.)

I REALLY know the end to this story.

(Fred reaches out, laughing, and pulls down two trapezes, taking the pose of a strong man straining against great weight. He again acquires a deep Russian accent.)

A hole opens in the sky over the city, yah? And men, like us—oh yes—we climb a specific mountain—in order to look into this "hole"—which is like the hole of blindness, in the middle of the eye. And— *(Spreads his legs for greater stability for his powerful frame)* —better than blind!
FREDDIE: I know the end to this story—
FRED: NO! I know the end of this story. *(A crash. He slowly sinks to the floor, still holding the trapeze)* These men, shuffling in their beautiful new shoes—
FREDDIE: Shoes that never belong to them, goddamn it—
FRED: These men, balancing precariously on a high rock, falling at last, up into a hole about which they know nothing.
FREDDIE: And having disappeared—strangely enough—not a goddamn thing was different. Am I right?

(A table rolls into the room, with a red cloth covering a large, mysterious object.)

FRED *(Running to touch the object)*: Right!
FREDDIE *(Running from the room)*: Right! *(Exits)*
FRED *(In a frightened falsetto, following him out)*: Right as always, my friend! *(Exits)*
VOICE: Meanwhile. Meanwhile. Back in the city of terrible surprises—

(Servants come in, wearing baby masks with pink bows on top, and point to other Servants wearing baby masks, who march onstage carrying large clock dials held high above their heads.)

Clocks were climbing the stairs to a room—much like this room. Till someone with a superior mind, well prepared for all such surprises, understood that all expectations were fulfilled.

(Fred reenters, studying the mysterious clocks.)

Though terrible things kept happening, of course, because the superior mind well understood that all such things were quite wonderful, really—

(The clocks are slowly lowered as Fred crosses to the mysterious, covered object.)

—though invisible, of course, to all such people trying their best to understand such very important things . . .

(Fred slowly removes the cloth to reveal a large glass ball, filled with naked babies. Freddie reenters and lifts a sledgehammer, which he crashes down on the globe. As happy, childlike music rises, Fred lifts the globe and runs across the room, carrying it away from Freddie's sledgehammer. But Freddie follows, and repeatedly tries to smash open the globe, as happy music becomes very loud and the lights fade.)

THE END

Maria Del Bosco

(A Sound Opera: Sex and Racing Cars)

PRODUCTION HISTORY

Maria del Bosco (A Sound Opera: Sex and Racing Cars). Produced by the Ontological-Hysteric Theater at the Ontological at St. Mark's Theater, New York City. January–April 2002. Written, directed and designed by Richard Foreman.

MARIA DEL BOSCO	Juliana Francis Kelly
TALL BALLERINA	Okwui Okpakwasili
DISHEVELED BALLERINA	Funda Duyal
GARBAGEMEN	Frank Boudreaux, Ryan Holsopple, Youssef Kerkour, Zachary Oberzon, Thom Sibbitt

AUTHOR'S NOTE

This play was created from a series of simple phrases, as was *Panic!*
Those phrases are now printed separately below. I would suggest that
future directors might start rehearsals using just these few phrases,
either spoken by the actors, or recorded on tape as I did in my own pro-
duction, and build an original production, inventing an original scenario,
from just these few phrases, much as I did from my first day of rehearsal.

The Countess Maria del Bosco.

The Countess Maria del Bosco,
Searching as usual for the appropriate image.
Meditating upon the given object of the moment.

Here comes the racing car . . .
That wins all competitions.

Now the Racing Car
Turns into the human mind.

Now the human mind looks into a mirror
Expecting to see a fast racing car.

X-rayed
By my own
Hesitation.

Why why why
Is violence
The only poetry left?

You don't see them, but I see them, so then you see them.

The Countess Maria del Bosco,
Searching as usual for the appropriate image.
Meditating upon the given object of the moment.

Finally it takes a giant effort
But the human mind looking into a mirror
Sees, finally, the racing car.

Why, why is violence
The only poetry left?

The racing car
Turns into
The human mind.

Ah, one problem.
There is a solid wall directly in the path
Of the racing car.

Without the racing car
The wall itself
Would be less satisfactory
As a wall.

The real is what destroys you.
Make contact with the real
And it destroys you.

The Countess is given a big prize
As reward for her beautiful shoes.

The racing car is chosen
To carry this reward
To the other side
Of the solid wall.

One world
Superimposed
On a second world.

When food is eaten
Care is taken to keep food
From splattering on
Such clean and beautiful shoes.

A way is discovered
To remove a dirty shoe
From one's consciousness.

Remember:
The body
Always needs help.

Here comes the racing car
That wins all competitions.

Now the racing car
Turns into the human mind.

There is a hole
In the middle of my thinking
That my thinking cannot touch.

One world
Superimposed on another world.

Learn to read such things
As a continual inquiry
Into the so-called ecstatic states.

How to feel good
All over.
What's the best way—
To feel good all over?

In order to reanimate
A system at rest,
A machine that disrupts things
Must operate.

Now, lured by the
Promise of happiness
The racing car
Travels into the future.

Are human beings less vulnerable
Than the inventiveness
Which depends
On their human effort?

Oh, there is a rumbling behind me.
I am moving forward
And there is a rumbling behind me.

In order to reanimate
A system at rest,
A machine that disrupts things
Must operate.
For a brief period
The Countess Maria del Bosco
Lives a life—
That is very intense, very centered
And therefore more real
Than life itself.

In order to reanimate
A system at rest,
A machine that disrupts things
Must operate.

Careful. The world is full of demons
And it is necessary to discover, therefore
The demon in every single thing.

The only way to be comfortable
Is to be dead.
The only way to be comfortable
Is to be dead.

Things have echoes.
You can't see it.
You can't touch it
But it's real.

Being dead is never a solution
If one is already dead.

The delay of gratification
Is gratification.
Rule number one.
The delay of gratification
Is gratification.

Being alive is a problem
Because being alive is an exception
To all other things.

Here's the problem.
Here's the problem.
A lack of resistance
To the present is the problem.
Resist the present. Resist the present.

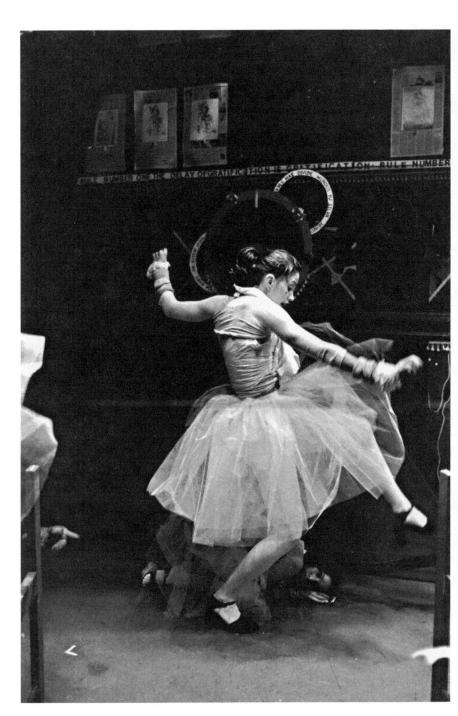

A large empty room, with several square columns near the walls. Against the rear wall runs a narrow platform four feet off the ground, with large double doors in the wall behind it. Steps lead up to the platform on either side. A rhomboid-shaped table leans, upright, against the platform, so the table's felt surface makes a small solid rhomboid-shaped wall facing the audience, in the same rust red color as the carpet that covers the floor.

A small eighteenth-century-style plush armchair stands in the center of the room, and three small racing hurdles are scattered about.

To one side of the room is a large window with a French-style double-door casement, divided into small panels of milk glass with intense light glowing from outside the window. The walls of the room are decorated with framed collages, and six large gold disks are scattered on the walls.

The play is dominated throughout by continual music, and a Deep Recorded Voice, which speaks in low, measured phrases throughout the action—those phrases often echoed by a second Voice that repeats certain of the words in a retarded slur, or repeats the entire phrase but with pauses between the words. Usually, these alternate versions overlap each other to create a contrapuntal vocal effect.

As the play opens, a Woman's Voice is heard singing classical German lieder to piano accompaniment, and Maria del Bosco, dressed as a ballerina in a pink tutu, leans against the rear platform. Over her ballet dress she wears a white fur jacket. She advances very slowly from the shadows into the brighter light in the center of the room.

VOICE:

The Countess Maria del Bosco.
The Countess Maria del Bosco.

(The others begin to enter slowly: first, several Servants, dressed like turn-of-the-century Garbagemen with stocking caps covering their heads and ears, who slowly deposit large round garbage barrels about the room.)

The Countess Maria del Bosco,
Searching as usual for the appropriate image.
Meditating upon the given object of the moment.

(Two other Servants slowly carry on white screens embossed near the top with black hearts. The screens are placed behind the eighteenth-century chair, making a little white wall. Finally, two other Ballerinas appear, walking slowly as if in a trance. One of them is tall and wears a scarf wrapped around her head. The other is short and a bit disheveled. All through the play, the three Ballerinas express very little on their faces, other than an unspecific, distracted hostility—like fashion models going through their paces on a runway, but in slow motion.

Now Maria del Bosco slowly and carefully sits in the armchair. Each of the other Ballerinas, one on either side of the white screens, reaches out a hand to indicate her presence. Maria del Bosco slowly slumps into a provocative position in the chair with her legs askew.

After a pause, as the music continues, she slowly rises. She stands and looks back as the white screens slowly tilt backward. Then the screens are carried to rest against the platform. Maria del Bosco goes to them, touches them, then poses against them.)

The Countess Maria del Bosco,
Searching as usual for the appropriate image.
Meditating upon the given object of the moment.

(The Disheveled Ballerina reaches down into a garbage barrel and slowly extracts an automobile steering wheel. She slowly car-

ries it back to display it against the white screen. Maria del Bosco turns away and slowly leaves the room. The singing continues. No one moves. Then Maria del Bosco slowly reenters and crosses the stage. She stops and looks at the audience. Then she crosses up to the screen and poses, holding on to the steering wheel, still displayed by the Disheveled Ballerina. The Garbagemen come and pose around this image, and the Tall Ballerina starts to cross quickly to the group, but screams as she trips over one of three small racing hurdles.

The music stops. Maria del Bosco slowly moves to the window and opens it. The light through the window increases, and the Tall Ballerina slowly moves into the now blinding light, shielding her eyes.

Then Maria del Bosco slowly closes the window and returns to the steering wheel against the white screen. There is another tableau, and all start undulating slowly.)

Here comes the racing car . . .
That wins all competitions.
Here comes the racing car . . .

SLURRED VOICE *(Overlapping)*:
The racing car, the racing car . . .

(Maria del Bosco slaps the Disheveled Ballerina's hand holding the steering wheel and leaves the group. Again she slowly goes and opens the window. Again, the Tall Ballerina walks into the light and freezes. The singing resumes. Maria del Bosco closes the window and crosses to the chair. At the last minute she makes a little run for the chair, but is stopped by the Tall Ballerina, who then sits slowly and provocatively in her place.)

VOICE:
Here comes the racing car . . .
That wins all competitions.

(Maria del Bosco slowly removes her fur jacket, then moves back against a column. The others gather around her. A telephone

rings, and a Falsetto Voice, at first softly and then with increasing volume, can be heard screaming rhythmically over the loudspeaker: "One, two, three, four. One, two, three, four. One, two, three, four." Then a crash makes everyone fall back. Maria del Bosco runs onto the platform as rock music takes over: "I'm taking a ride with my best friends!" Everyone gyrates to the music. Maria del Bosco does a series of flashy disco turns on the platform as a wailing siren augments the music. She stops, and the music fades back to the German lieder as everyone else comes to a halt. The two Ballerinas reposition the racing hurdles and straddle them, as the Garbagemen cover first the Ballerinas and then themselves with white bridal veils—each with a small rock balanced on the top of the veil, balanced on their heads.)

Now the racing car
Turns into the human mind.

SLOWER VOICE:
Now the racing car
Turns into the human mind.

(The veiled group slowly gathers into a bunch at the center of the stage. A bell rings and a Voice intones: "Silence is not golden." Two Garbagemen, who are not veiled, with sticks behind their heads, pose with their hips thrust forward. On the end of these sticks are pincers that can be controlled from the other end of the stick—like "grabbers" used to reach objects on a high shelf. Backs arched, they slowly move across the stage as the veiled group drifts away, and Maria del Bosco steps onto the stairs leading down from the platform.

The music fades, and we now hear the echoing tones of an ice-skating rink organ playing a 1920s Fats Waller jazz tune. The music becomes deafeningly loud, and the Garbagemen use their grabbers to hold Maria del Bosco's legs as she slowly descends the stairs and then slides sideways, like a mechanical doll, to stage center, where she poses against two white screens that are still resting against the platform. Then the Disheveled Ballerina enters and slowly approaches Maria del Bosco.)

VOICE:

Now the racing car
Turns into the human mind.
Now the human mind looks into a mirror
Expecting to see a fast racing car.

(The Disheveled Ballerina puts her body directly in front of Maria del Bosco, facing her and striking the same pose as she leans up against her. The Garbagemen move their grabber sticks from Maria del Bosco's legs to the legs of the Disheveled Ballerina, pivoting her and controlling her legs as she walks slowly across the room, away from Maria del Bosco.

Three other Garbagemen enter, each carrying a large wooden propeller with four blades forming a cross, five feet tall, cut from thin plywood, held upright. They line up in front of Maria del Bosco. The Tall Ballerina enters. She tugs on one of the propellers and all the propellers start spinning.

Over the skating-rink jazz organ:)

X-rayed
By my own
Hesitation.

(Maria del Bosco crosses over to one of the garbage barrels and readjusts its position, and as the music lowers and the propellers keep spinning she sings the opening lines of Cole Porter's "Night and Day.")

MARIA DEL BOSCO *(Singing in a monotone)*:
Like the beat beat beat of the tom-tom . . .

(She puts her hands into the garbage barrel and lifts it high in the air.)

When the jungle shadows fall.

(She lowers the barrel and crosses slowly to the window, still singing in a monotone, but not matching the rhythm of the organ music that continues under her singing.)

Like the tick tick tock
Of the stately clock
As it stands against the wall.
Like the drip drip drop of the raindrops—

(Now she is opening the big window, but slowly closes it again as the music fades.)

When the summer shower is through—
So a voice within me keeps repeating . . .
You, you, you, you, you . . .

(She keeps singing: "YOU . . . YOU!" louder and louder, pointing to the other Ballerinas. They each slowly lift an arm and point back at her, joining in singing: "YOU, YOU, YOU," as the propellers keep spinning. Suddenly, they stop singing and the propellers freeze.)

SLURRED VOICE:
Why why why
Is violence
The only poetry left?

(The Garbagemen close the propellers so they become flat paddles, and place one in each of three garbage barrels. The three Ballerinas each put one foot into a barrel and start licking and caressing the propellers.)

VOICE:
You don't see them, but I see them, so then you see them.

(The Garbagemen slowly carry off the remaining white screens, looking back over their shoulders to watch the Ballerinas caressing the propellers. Then the Ballerinas lift the propellers out of the barrels, rest the ends on the floor, and begin caressing and stroking the central handles, which had been used to rotate the sticks.)

The Countess Maria del Bosco,
Searching as usual for the appropriate image.
Meditating upon the given object of the moment.

SLURRED VOICE *(Overlapping)*:
Why is violence . . .

(Three Garbagemen wearing white dunce caps race into the room and, without using the stairs, awkwardly—after several failed attempts—pull themselves up onto the platform, then pose there on all fours with their rear ends facing the audience. The Ballerinas approach, and each one rubs the rear end of a Garbageman with her folded-up propeller. Very softly they count out each slow stroke.)

VOICE:
Finally it takes a giant effort
But the human mind looking into a mirror
Sees, finally, the racing car.

SLURRED VOICE *(Overlapping)*:
Finally, it takes a giant effort.

(The Garbagemen rise from their knees and take the propellers from the Ballerinas. They turn their backs to the audience and rub themselves against the propellers. Then they exit while two of the Ballerinas gently bounce their breasts against each other.)

VOICE:
Why, why is violence
The only poetry left?

SLURRED VOICE *(Overlapping)*:
The racing car
Turns into
The human mind.

(Maria del Bosco grabs the shoulders of the Disheveled Ballerina from behind and bounces her body against her. Then the three

Ballerinas turn to each other with hostile looks. They strike ballet poses and slowly perform a basic ballet dip, bow and step, each headed toward a different part of the room, as the skating-rink jazz organ rises.

Two Garbagemen enter, each carrying a frozen puff of smoke, which resembles a two-foot-tall wad of cotton candy. The music becomes deafeningly loud, and they slowly place the ends of the cotton-candy smoke in the mouths of Maria del Bosco and the Tall Ballerina. They stand with the ends of the wads held rigid in their teeth, suggesting frozen smoke rising to the ceiling. Maria del Bosco and the Tall Ballerina do dipping steps to position themselves against two white screens that are carried into the air behind them and held at oblique angles. At the same time, the Disheveled Ballerina slowly pulls a long piece of cloth from her bodice. She crosses over to Maria del Bosco and puts the blindfold over her eyes.

The screens move around to hide the resultant tableau, and then the screens start moving across the room, with the women moving to stay behind the screens. At the same time, the Garbage-men are lifting three garbage barrels onto the platform. The music softens and shifts to the German lieder.)

VOICE *(In German accent)*:
 Silence is not golden.

(The three Ballerinas each go to a barrel. The screens spin rapidly offstage, and the Ballerinas look into the barrels, then lift them over their heads and bring them down on their shoulders so that each of their heads is now replaced by a large barrel. They stagger awkwardly under the barrels as rock music rises.)

HIGH VOICE:
 I just can't find it—I just can't find it—

(The Garbagemen race into the room and remove the barrels from the heads of the Ballerinas, who then drift offstage. They place them over their own heads and dance an energetic twist to a rock-and-roll beat, while other Garbagemen run on, urging them to even greater intensity. The music is very loud now. The three

Ballerinas enter at rear, two of them dancing frantically and the third carrying a strange structure with disks and supporting struts suggesting both an abstract version of an automobile and a kabbalistic tree of life diagram. After a while they drift offstage again as the Garbagemen continue their frantic gyrations downstage. Then the music abruptly stops. The men place the garbage bins back on the platform and bend over at the waist as the other Garbagemen reach out slowly to touch their asses.)

VOICE:

Ah, one problem.
There is a solid wall directly in the path
Of the racing car.

(The three Ballerinas enter, see the men, and then look toward the window, crossing to it in slow motion and opening it. Then, as if straining against a strong wind blowing, they close it again. There is complete silence.

The women turn and line up with arms out, crossing each other's arms to link hands, and they take three slow steps forward. They pause. Then they start taking three steps backward, but a crashing sound releases the Garbagemen from their positions. The Garbagemen now take the barrels and line them up across the front of the stage, end to end, like segments of a snake. They kneel down behind the barrels, holding them in place as another Garbageman slowly rolls in a three-foot-high wall on wheels. This rolling wall is covered with pillows. He places it perpendicular to the barrels, a few feet away from the one at the end of the line. As this is happening, the Ballerinas are slowly crossing downstage of the barrels, examining their configuration.

The German lieder is heard playing softly. The Ballerinas arrive at the pillow-covered wall, step behind it and pose with their hands delicately touching its top edge. The music fades. They slowly push the wall against the first barrel, and the music returns.

Maria del Bosco slowly comes around to the first barrel and, lifting a leg high in the air, climbs onto it. She sits, leaning back against the pillowed wall, resting her arms over her head and displaying her body. There is a pause. Then the Garbagemen begin

to roll the barrels out of the line, beginning with the one farthest from Maria del Bosco. When the only barrel remaining is the one upon which she reclines, she leans forward and crawls onto the floor in front of the barrel. Two Garbagemen lift it, carry it over her body and set it down on the floor in front of her, and she crawls into it, leaving only her legs sticking out. They slowly roll the barrel upstage with Maria del Bosco—all but her legs—still inside.

The Disheveled Ballerina pulls on Maria del Bosco's legs and drags her out of the barrel. Maria del Bosco rises and poses against the platform, as the two other Ballerinas manipulate the pillowed wall. The Disheveled Ballerina slumps backward against it, and then slowly and languorously, in a provocative, backward, crab-like walk, pushes the pillowed wall and Tall Ballerina out of the room.

Maria del Bosco, now alone, comes downstage to see a Garbageman enter holding up a large card with a red heart on it under his chin. There is a crash. She runs and grabs the large card from him and does a stylized, spastic walk across the stage until she hits the side wall. The Disheveled Ballerina enters with a similar card, spinning and coming to rest against the rear wall. The Tall Ballerina enters with a third heart card and slowly brings it up to cover her chest. Now it appears that all three cards have a single violin string running diagonally across them. The Ballerinas each pluck at the strings, which make an unmusical snap. There is a pause. They all look very sad.

Then they snap in unison and the pillowed wall races into the room, as well as several white cards which are placed on the top edge of the pillowed wall to suggest a sort of angular guillotine above it. Cacophonic music rises. Maria del Bosco sticks her head through an opening in the assemblage, and the Tall Ballerina takes an oversized drum mallet and starts hitting her on the head, in slow accompaniment to the skating-rink jazz-organ music, which returns and becomes very loud.

Over the music:)

Without the racing car
The wall itself
Would be less satisfactory
As a wall.

(A third card is carried in and brought down on top of Maria del Bosco's head as if to slice it in half. The mallet is now hitting the head of the Disheveled Ballerina. Bagpipe music is heard.

The guillotine assemblage is disassembled by the Garbagemen, two of whom carry the red table from its position against the wall and set it on the floor stage center, still on its side so the table surface faces the audience.)

The real is what destroys you.
Make contact with the real
And it destroys you.

SLURRED VOICE *(Overlapping)*:
The real
Is what destroys you.

(The Disheveled Ballerina leans over to press her torso against the rhomboid surface. A crashing sound releases her and she goes to slump in the plush chair with her legs spread out provocatively. Maria del Bosco and the Tall Ballerina rub themselves on the table surface, then pose on either side, leaning against the edge of the rhomboid shape, as the skating-rink jazz-organ music subsides.)

VOICE *(In German accent)*:
Silence is not golden.

(The Garbagemen turn the table so it is in a normal table position, but it now appears that the legs are higher at the back, so the surface of the rhomboid-shaped table is raked at an incline, with the higher part at the rear and the front at something less than normal table height. As this happens, Maria del Bosco makes an insulting gesture toward the slumped Disheveled Ballerina, putting her thumb on her own nose and wiggling her fingers at the Ballerina, who insolently rests one of her legs up on the edge of the table as a Garbageman brings the fur jacket to Maria del Bosco. She puts on the jacket and begins a rhythmic strut—a few steps forward and back in front of the table, swiveling her shoul-

*ders and hips like a drugged stripper—as the music continues. A
huge golden trophy cup slowly descends from above and hovers just
over the table.*

*The Tall Ballerina comes up behind the sprawled Disheveled
Ballerina and covers the Disheveled Ballerina's eyes with her
hands. Maria del Bosco stops dancing, puts her own leg on the
table and places the bottom of her foot against the bottom of the
Disheveled Ballerina's foot.*

*Maria del Bosco stares at the audience as the Tall Ballerina
comes and holds the two feet together. There is a crashing sound,
and they all slowly shift their focus to the giant trophy cup.*

*Maria del Bosco lies down on the red rhombus platform. A loud
crash is heard.)*

The Countess is given a big prize.
As reward for her beautiful shoes.

*(As the Voice repeats, a Garbageman comes into the room with a
long spear. He slowly impales Maria del Bosco, who leans back
sensuously, supporting herself on the table in an ecstatic fashion-
model pose. The Tall Ballerina opens the window, changing the
light in the room dramatically. This pose is held for a while. Then
the Garbageman removes the spear and Maria del Bosco rises and
walks in small, measured steps to the far side wall.*

*The Garbageman follows, and they re-create the ecstatic stab-
bing tableau against the wall. The Disheveled Ballerina climbs
onto the table and reaches up to hold onto the trophy. A Garbage-
man appears on the platform, slowly spinning one of the large
propellers. Maria del Bosco goes and climbs up onto the platform
as a telephone rings.*

*The Garbageman with the spear slowly thrusts the spear through a
hole in the center of the trophy, and it is long enough to exit on the
other side. Maria del Bosco touches the tip of the spear, pulls back as
if stung, then reaches forward lovingly and pulls the spear tip back
against her own chest. She looks longingly into the distance.)*

The racing car is chosen
To carry this reward

To the other side
Of the solid wall.

*(The telephone rings again, and Maria del Bosco, startled, pulls
away from the spear. Then she puts it back against her chest as
three large cutout heads, in profile, are carried onto the stage
below by the Garbagemen.)*

One world
Superimposed
On a second world.

SLURRED VOICE *(Overlapping as the Voice repeats)*:
The real is what destroys you.

*(The heads are as large as the Garbagemen who carry them from
behind. As a ringing tone rises, Maria del Bosco descends from
the platform. The three Ballerinas, accompanied by a loud crash,
open the tops of these giant heads, and each removes a slice of pie
from the brain cavity of her giant head.*

*The propeller is still spinning on the balcony. The Ballerinas
lift their slices of pie into the air, point to them and whisper in uni-
son: "My pie! My pie."*

*They lean back, open their mouths wide, and attempt to lower
the pie into their gaping mouths. But it doesn't go in very far, so
they extract the pie, wiggle it in front of their faces and whisper:
"My pie, my pie."*

*Then they place the pie on top of their heads, and Maria del
Bosco whispers: "Three slices of pie."*

*They all whirl, and then Maria del Bosco whispers: "Two slices
of pie."*

*The cutout heads bounce slightly, and the Ballerinas lean back
away from them. They point rhythmically three times at their
cutout heads' prominent nostrils. Maria del Bosco asks: "Three
slices?" The skating-rink jazz organ returns and they whirl once.
Then each Ballerina sticks an index finger in her cutout's nostril
and rotates the finger inside the nostril, then pulls it out. They
ceremoniously carry their pieces of pie to the table, where they set
them down on the tilted surface.*

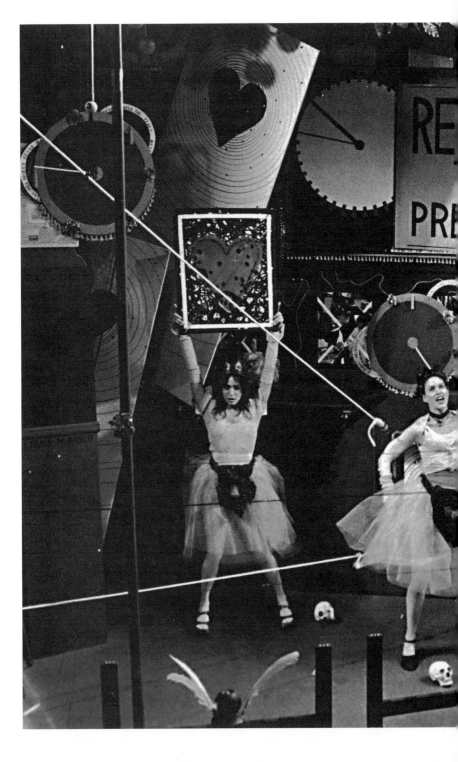

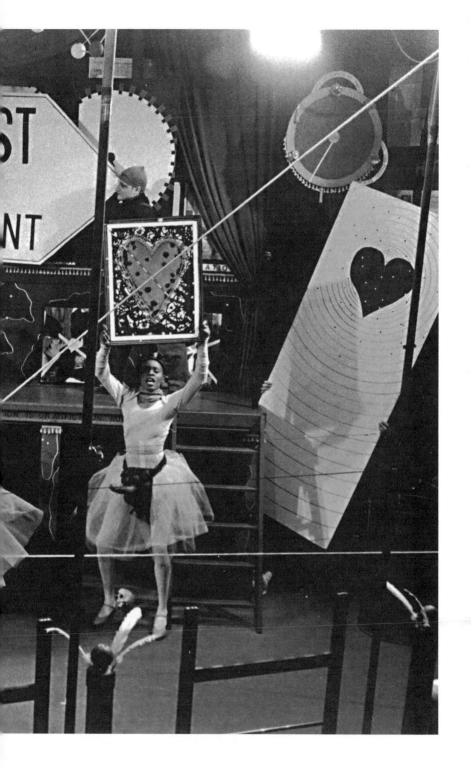

*They leave the table to throw themselves three times against the
nearest wall. Then they recover, slowly approach the table, and lift
their pieces of pie to hold them against their hearts. Now they spin
to new music—a cacophonic dance tune. A new giant profile head
peers in through the open window as they all sing a high: "Ahhhh,"
which blends in with the music.*

*Then they spin back to the table, lift their pies in the air and
suddenly bring them down to massage between their legs. This is
accompanied by a crash, and Maria del Bosco's attention is
attracted by the head in the window. She rises and screams over
the music: "Will somebody close the window? Why do I have to do
everything by myself around here?" She runs and closes the win-
dow and then shouts out: "My pie! My pie! My pie!"*

*The Garbagemen enter with mirrors and hold them to the
Ballerinas' shoes.)*

VOICE:

When food is eaten
Care is taken to keep food
From splattering on
Such clean and beautiful shoes.

*(The Disheveled Ballerina becomes hysterical at seeing her dirty
shoe in a mirror, whereupon the Garbagemen turn the table so
that it lies upside down on top of her. She screams in pain as a
High Voice cries out the rhythm of entering rock music: "One, two,
three, four—one, two, three, four—" The song lyric "I'm taking a
ride with my best friends!" plays again. Maria del Bosco grabs a
hammer and hits the upside-down table legs to torture the
Disheveled Ballerina under the table. The Tall Ballerina runs up
onto the platform and opens the double doors to reveal a large
disk rotating behind them, like a monster clock going crazy. The
Garbagemen are pumping their fists to the rhythm of the music,
which is augmented by a wailing siren. As Maria del Bosco runs
up to join the Tall Ballerina on the platform, the Garbagemen
start rhythmically hitting the table legs.*

*Maria del Bosco and the Tall Ballerina swing the doors open and
shut to the rhythm of the music. The Ballerina under the table frees*

herself, and as the music quiets a Voice is heard repeating over and over: "I'm reaching out! I'm reaching out!" Maria del Bosco comes down to the floor. The Garbagemen hold out the plush chair, upside down, and she does high kicks into its plush cushion.)

A way is discovered
To remove a dirty shoe
From one's consciousness.

SLURRED VOICE *(Overlapping as the Voice repeats)*:
Remember:
The body
Always needs help.

(The three Ballerinas slowly regroup in a dance line with arms linked and begin to move across the stage in unison.

Through the open window, a fringed platter on the end of a stick advances into the room. Sitting on that platter is a baby. The Ballerinas see it and jump back in fear. Then Maria del Bosco recovers her composure and slowly approaches the baby. She climbs on a chair to reach it, as a Voice with a German accent intones: "Silence is not golden." She removes the baby from the tray and steps back down on the floor. She holds the baby, staring at the audience.)

VOICE:
Here comes the racing car
That wins all competitions.

SLURRED VOICE *(Overlapping the repeating Voice)*:
Now the racing car
Turns into the human mind.

(A Garbageman slowly lifts a large, golden model airplane and flies it into the room behind Maria del Bosco, as a Female Voice sings a pattern of mystical notes without words.

The other two Ballerinas take the "grab sticks" left by the Garbagemen and use them to gently hold the baby's neck, lifting

it high into the air. Maria del Bosco reaches up for it, but it is higher than her outstretched hands. She goes and closes the window, then returns. The baby is lowered, and Maria del Bosco takes it and carefully places it in a little seat located where the airplane's cockpit would be.

She lifts the airplane as if it were flying over her head. The large propeller is still rotating gently on the platform.)

VOICE:
> There is a hole
> In the middle of my thinking
> That my thinking cannot touch.

SLURRED VOICE *(Overlapping the repeating Voice)*:
> There is a hole
> In the middle of my thinking
> That my thinking cannot touch.

(As the German lieder starts playing again, Maria del Bosco gently flies the airplane into the large window, simulating a crash in slow motion. She slowly moves it backward, then forward again into the window, and again and again.)

VOICE *(Repeating)*:
> One world
> Superimposed on another world.

SLURRED VOICE *(Overlapping)*:
> One world
> Superimposed . . .

(The Garbagemen slowly drift into the room wearing Ku Klux Klan hoods with white sheets over their faces. They form a line on the other side of the stage, opposite the airplane's activity. The two other Ballerinas use their "grab sticks" to take hold of the tops of the Ku Klux Klan hoods and pull them toward the floor, so the disguised Garbagemen seem to be bowing to the airplane baby.

*The Ballerinas suddenly release the Garbagemen and come to
where Maria del Bosco is still rocking the airplane over her head,
back and forth. They embrace, turn to the audience and whisper:
"Oh, no!"—followed by a crash.*

*They help Maria del Bosco rock the airplane back and forth,
then stop, and again turn toward the audience and whisper: "Oh
no!"—followed by another crash.*

*The Garbagemen in their hoods carry the airplane offstage as the
three Ballerinas line up the racing hurdles for an athletic contest.)*

VOICE *(As jazz-organ music returns)*:
 One world
 Superimposed on another world.

*(Maria del Bosco has acquired a large, doughnut-shaped disk
that resembles the rings of Saturn, with a large hole in the center
and Latin writing superimposed on the rings. The other two
Ballerinas set themselves on the hurdles and Maria del Bosco
energetically gyrates the disk over their heads, one after the other.
Each wobbles dizzily as a result. The trophy again descends, and
two Ku Klux Klan Garbagemen reenter, each carrying a bowling
pin. The two other Ballerinas take the pins and set them on the
floor as Maria del Bosco watches.)*

SLURRED VOICE *(Repeats)*:
 Learn to read such things
 As a continual inquiry
 Into the so-called ecstatic states.

*(The Tall and Disheveled Ballerinas circle the pins, then stand
facing them and, with a swing of the foot, knock them over in uni-
son. This stops the music. They pick up the two pins and offer them
to Maria del Bosco, whispering: "Just for you." There is a pause.
Then they whisper: "Here—" and drop the pins, which make a
loud noise on the floor. Maria del Bosco jumps back in fear, then
runs to center stage with the Saturn disk around her neck.*

*She holds out her arms as the other two Ballerinas each take
one of her hands, so that the bowling pins are now hanging*

between their joined hands. The three rock back and forth once, then step sideways toward the window as Maria del Bosco whispers: "See? Everything is perfectly OK after all."

With her free hand the Disheveled Ballerina pulls open the window. At the same moment they all drop the bowling pins on the floor and react with a startled exclamation at the noise.

At the same moment, the Garbagemen produce white turkey feathers and begin tickling the Ballerinas, who react by leaving the stage. The Garbagemen follow, trying to tickle them.)

VOICE:

How to feel good
All over.
What's the best way—
To feel good all over?

(A telephone rings. The stage is empty.
In German accent:)

Silence is not golden.

(The three Ballerinas slowly return to the stage, holding hands, arms interlinked, advancing like a ballet ensemble. They stop and pose. A small stuffed lamb is thrown through the window and falls onto the floor. Maria del Bosco moves slowly to take the stuffed lamb. All three Ballerinas lift it and stick it to the bottom of the golden racing trophy that hangs six feet above the floor. Then they go to shelves in the corners of the room and bring back three more stuffed animals that they try to attach to the bottom of the trophy. The Ku Klux Klan Garbagemen sneak back in, in the shadows.

The other stuffed toys do not stick to the trophy and fall to the floor. The Ballerinas are irritated by this. They run to get leashes with which they beat the toys, hissing: "Bad! Bad! Bad Dog!" as they do so.)

In order to reanimate
A system at rest,
A machine that disrupts things
Must operate.

*(The Ballerinas run to the Ku Klux Klan Garbagemen, each of whom
holds a rope. As the skating-rink jazz organ rises, the Ballerinas
wind themselves into the ropes held by the Garbagemen, then spin
out as if they were toy tops being released into a spin.*

*Maria del Bosco positions the Disheveled Ballerina so that she
can play leapfrog with her, as the Tall Ballerina resets the hurdles
and, in a stylized manner, vaults over them one by one, with a
frozen pause between vaults.*

*As she does this, three Garbagemen run on, holding pillows
behind their heads which they agitatedly vibrate, leaning their
heads back to experience the vibration. Coming to the last hurdle,
the Tall Ballerina is exhausted and can only step over it in slow
motion. The Garbagemen run to support her with the pillows as
she slowly—very slowly—falls to the floor.*

In German accent:)

Silence is not golden.

SLURRED VOICE:
> Now, lured by the
> Promise of happiness,
> The racing car
> Travels into the future.

*(Maria del Bosco and the Disheveled Ballerina study the uncon-
scious Tall Ballerina. Then as they begin to exit, the Garbagemen
take two of the pillows from beneath the Tall Ballerina's body and
throw them recklessly over their shoulders.)*

VOICE *(Overlapping the continuing Slurred Voice)*:
> Are human beings less vulnerable
> Than the inventiveness
> Which depends
> On their human effort?

*(Maria del Bosco and the Disheveled Ballerina pick up the tossed pil-
lows and take them up to either side of the table, which has been reset
on its side against the platform. They put the pillows between their hips*

and the side of the table and begin rubbing against the table. A Female Voice sings a repeated high note, as a piano chord also repeats. One of the Garbagemen slams the window shut and the music stops.

Maria del Bosco and the Disheveled Ballerina leave the sides of the table and slowly advance a few steps toward the Garbagemen, whispering inaudible invitations.

The men nervously back away from them, and continue until they are out of the room. Maria del Bosco and the Disheveled Ballerina turn to see two other Garbagemen on the platform, holding round, golden disks resembling those attached to the walls of the room. They go to stand below the platform, facing out with their backs to the Garbagemen. As they bring the pillows up in front of their faces, the two disks are lowered between their faces and the pillows. They now support pillows pressing the disks against their faces suggesting primitive magical masks. A sustained soprano tone rises as the Garbagemen suddenly turn and throw open the doors on the platform, revealing the great disk behind. They run down the stairs and seize two of the discarded toy animals.

The music stops abruptly. The Garbagemen cuddle the animals for a moment, then slowly go and place them against the pillows that are holding the disks against the faces of the two Ballerinas.

The Garbagemen leave the stage as Maria del Bosco and the Disheveled Ballerina slowly advance toward the audience, holding the three-layered masks—animal, pillow and disk—in front of their faces. Then they carefully shift the masks so that they are on top of their heads, like large sun hats. Faint, old-fashioned operetta march music rises.)

SLURRED VOICE:

>Oh, there is a rumbling behind me.
>
>I am moving forward
>
>And there is a rumbling behind me.

VOICE *(Overlapping)*:

>In order to reanimate
>
>A system at rest,
>
>A machine that disrupts things
>
>Must operate.

(*Maria del Bosco and the Disheveled Ballerina have been drifting sideways until they are standing next to the unconscious Tall Ballerina. They lower their heads and, though still holding onto the disks, allow the animals and pillows to fall down onto the Tall Ballerina, who wakes up.*

The Tall Ballerina comes to take the head-disks away from the other two Ballerinas, who are now posing downstage.

In German accent:)

Silence is not golden.

(*The skating-rink jazz-organ music returns, and Maria del Bosco and the Disheveled Ballerina pose on either side of the upright table, doing leg extensions and kicks. Then they whirl back downstage, where they hold hands and rock back and forth as a white tube covered with baby dolls descends and hangs from the ceiling. White screens slide in, and Maria del Bosco holds up a small placard with a heart painted on it toward the babies.*

The Disheveled Ballerina comes and grabs the placard from Maria del Bosco. She holds it up in front of her own face while Maria del Bosco makes magic passes in front of it that send her into convulsions. Maria del Bosco falls on the floor and rolls forward as the Garbagemen set the table back on the floor upright.

As the German lieder joins the skating-rink jazz organ, the Disheveled Ballerina and the Tall Ballerina place the placard with the heart on the center of the tabletop. Maria del Bosco crawls over to the table, and they all put their hands out, ready to touch the heart, but then withdraw them as they see the trophy slowly descend, with the stuffed baby lamb still attached to its bottom. It hangs a few feet above the tabletop.

The three Ballerinas cover their faces with white veils, then reach out again and touch the heart at the center of the table. The music is now just the German lieder, and a Garbageman rolls a large black-and-white target across the back of the stage behind the table. The Ballerinas see it and jerk their hands away from the heart as the music stops.

The three Ballerinas slowly take off their veils and rise.

The music returns, and the Disheveled Ballerina crosses to a Garbageman who holds a bucket of skulls in his arms. She takes the bucket and hugs it to her body as the German lieder rises. Maria del Bosco begins to repeat the eccentric stripper dance in which she takes three steps forward and then three backward while swiveling her hips and shoulders. This continues with the music as the Disheveled Ballerina places the bucket of skulls on top of her head. A telephone rings and everyone leaves the room except Maria del Bosco, who stops dancing and goes to remove the toy lamb from the bottom of the trophy.

A white screen appears at the side, and she goes and touches the black heart embossed near the top. Then she pulls away and touches her own heart.)

> For a brief period
> The Countess Maria del Bosco
> Lives a life—

(She runs across the stage to the window and touches a black heart that appears on one of the windowpanes. Then she again touches her own heart.)

> That is very intense, very centered
> And therefore more real
> Than life itself.

SLURRED VOICE *(Overlapping)*:
> In order to reanimate
> A system at rest,
> A machine that disrupts things
> Must operate.

(White screens cross the stage. Maria del Bosco runs to the stairs, where a Garbageman, who has been on the platform, collapses. She steps over him and climbs the stairs as another Garbageman runs in with a garbage barrel. She delicately drops the toy lamb in the barrel. The Disheveled Ballerina appears on the platform, balanc-

ing the bucket of skulls on her head, and the Tall Ballerina appears
in the shadows of the room, carrying a second bucket of skulls.)

VOICE:

Careful. The world is full of demons
And it is necessary to discover, therefore,
The demon in every single thing.

(A High Voice shouts out numbers rhythmically: "One, two, three,
four—one, two, three, four . . ." as the lieder music rises and explo-
sions are heard. Maria del Bosco has also acquired a bucket of
skulls. She and the Tall Ballerina dance with their buckets. The
Saturn disks are carried on by a Garbageman. And this time,
behind the disks, another Garbageman is seen slowly thrusting a
large, striped phallus in and out through the hole in the center of
the rings.

Maria del Bosco and the Tall Ballerina exchange their buckets
for the placards with painted hearts. Then they dance, doing high
kicks, to the louder and faster thuds of the explosions.

The Tall Ballerina kicks too high and grabs her leg in pain. As
the skating-rink jazz organ returns, Garbagemen rush onstage
with a complicated leg brace made of metal struts. The Tall
Ballerina swings her leg up on the table and the Garbagemen
encase the injured leg in the brace, which resembles a medieval
torture device.

As the Tall Ballerina cries out in pain, Maria del Bosco sprawls
next to her on the tabletop and sings out operatically over the
music: "Crybaby! Crybaby!"

The Garbagemen with skulls and hammers place skulls
against the crotches of the Tall Ballerina and Maria del Bosco.
They pound the skulls with their hammers, and the Ballerinas
lurch in pain with each hit, screaming out the count of hits over
the loud jazz-organ music.

Then the Garbagemen run off. The music softens, and the
Disheveled Ballerina is seen doing a gentle twirl. She comes to a
stop, picks up a skull and examines it.

Repeating again and again:)

The only way to be comfortable
Is to be dead.
The only way to be comfortable
Is to be dead.

(A telephone rings, and many skulls are thrown in through the window. The Ballerinas scream and run from them, as a Soft Voice sings: "Good-bye, good-bye."
Maria del Bosco sits on the table astride a black tube. A Garbage-man lowers the Saturn rings down over her head, and her arms go up through the hole, with her hands lifted in the air as if in prayer. The Tall Ballerina faces the bright light from the open window with a long spear. In slow motion, she prepares to throw the spear through the window into the center of the light. A slow, soft piano phrase repeats and repeats.)

SLURRED VOICE:
The only way to be comfortable
Is to be dead.

SECOND SLURRED VOICE *(Overlapping)*:
Things have echoes.

(A Voice starts singing softly: "Everything happens, everything happens . . ." Maria del Bosco lowers her arms, and the Garbagemen begin to extract small babies from the black tube she is straddling.)

VOICE:
You can't see it.
You can't touch it
But it's real.

SLURRED VOICE *(Overlapping)*:
Being dead is never a solution
If one is already dead.

(Maria del Bosco collapses on the tabletop. The Garbagemen toss the babies up in the air and catch them, twice, but the third time they toss the babies up they allow them to fall to the floor.

Maria del Bosco jumps off the table and takes a human head out of one of the garbage barrels. She stares into its large eyes as she comes downstage. White screens are held in the air at oblique angles behind her, while the Garbagemen slowly lift the fallen babies and sit them on top of their heads.)

VOICE:

> You can't see it.
> You can't touch it
> But it's real.

(In German accent:)

> Silence is not golden.

(Maria del Bosco throws the head into the air, whispering: "Hoopla!" A soft piano phrase repeats and repeats and then changes into ominous organ chords as she takes the head between her hands and slowly kisses it on the lips. A Voice is heard repeating rapidly: "Ah no. No! —Ah no. No!!"

Maria del Bosco takes the head and holds it out toward the audience, saying: "Careful. Careful." A Garbageman straps a large red dildo decorated with fruits and flowers around her waist. Another Garbageman lowers a black crown onto her head.)

> The delay of gratification
> Is gratification.
> Rule number one:
> The delay of gratification
> Is gratification.

(Maria del Bosco poses, and a whip is placed in her hand. As the Voice repeats and the organ music continues, she flicks her whip and whispers: "Hoopla!" The Garbagemen run from the stage,

and we see that the two other Ballerinas have also acquired deco-
rated dildos and black crowns. Maria del Bosco poses on the table
as the two other Ballerinas confront her and a Voice sings:
"Everything happens, everything happens."

The three Ballerinas slowly hold hands, arms crossing. They
step slowly across the stage like lyrical ballet dancers.

The skating-rink jazz organ returns, and the three slowly sepa-
rate and go to opposite corners of the room. The Tall Ballerina
and the Disheveled Ballerina start to do the twist. Maria del
Bosco whispers to them: "More! More!" as a Female Voice is heard
calling out: "One, two, three, four. One, two, three, four . . ."
Maria del Bosco cracks her whip, which seems to have no effect on
the dancers. In frustration she throws herself against the rear
wall, and the music stops. She staggers down toward the audience
and the three Ballerinas line up across the front of the stage, lean-
ing backward as if prepared to do a cakewalk across the front of
the stage, while holding on to their dildos with both hands.

As the Garbagemen enter to examine them, the Ballerinas shift
their hands onto their hips and slowly step backward. Then they
slowly rotate, and the Garbagemen bring three long sticks with
polishing cloths wrapped around the ends. They give them to the
Ballerinas, who gently polish their dildos.

A Garbageman on the platform opens the double doors and
pulls out a panel with two texts written on it in bold letters. Text
one reads: "Being alive is a problem, because being alive is an
exception to all other things." The Ballerinas rotate and look up
at the text, lifting their polishing sticks as if to hurl them like
javelins at the panel. The second text reads: "Being dead is never
a problem if one is dead already.")

SLURRED VOICE:

 Being alive is a problem
 Because being alive is an exception
 To all other things.

(The Garbagemen slowly remove the sticks from the Ballerinas'
hands, take the cloths off the bottoms of the sticks, and use them to
gently pat the Ballerinas' brows in the hopes of soothing their

inner pain, as the Ballerinas' hips start undulating to thuds that rise slowly over the music.

The Garbagemen run for barrels, which they place over the dildos. The Ballerinas' hips keep twitching as if they were ejaculating into the barrels.

The Ballerinas fall away from the barrels and Maria del Bosco is helped into her fur jacket, but she freezes halfway into it, as the music becomes suddenly much softer.)

VOICE:

Here's the problem.
Here's the problem.
A lack of resistance
To the present is the problem.
Resist the present. Resist the present.

(A telephone rings. Maria del Bosco finishes getting into the jacket and begins her back-and-forth stripper dance, swiveling her hips and shoulders. This continues until another telephone rings and the Garbagemen rush in. They carry a framed heart panel to center stage, with elastic ropes stretching from the panel to each of the upper and lower corners of the proscenium. The panel is thus suspended in midair, and Maria del Bosco jumps in front of it to hide the heart with her two hands.

But as the skating-rink jazz organ continues, the two other Ballerinas each grab one of her hands and pull her back and forth between them. She frees herself and starts pushing the panel, still on its elastic ropes, upstage.)

Resist the present!
Resist the present!

(The elastic is too strong for her, and it pulls her and the panel back downstage as the two other Ballerinas lift heart paintings in the air and start dancing to the music.

A Garbageman pulls another panel out of the double-door opening on the platform. This panel states in bold letters: RESIST THE PRESENT!

Maria del Bosco once again forces the panel upstage, and then turns so that her back is holding the panel in position. She starts to sing in a high voice as the music takes on a bouncy quality: "DANCE! Dance dance! Dance dance!"

As she continues singing maniacally, straining against the panel, the Garbageman rhythmically pulls the RESIST THE PRESENT! panel in and out of the opening.

Other white panels with embossed hearts enter the room and bounce to the music, as one of the giant heads appears at the window and another large head descends from above, also bouncing to the music. All of the Ballerinas twitch their dildo-decorated hips.

Lights fade on this frantic music and movement.)

THE END

Bad Behavior

Richard Foreman and Sophie Haviland

PRODUCTION HISTORY

Bad Behavior. Produced by Susan Solt, Dean of CalArts School of Theatre, at the California Institute of the Arts Walt Disney Modular Theatre, Los Angeles. October 18–28, 2000. Written and directed by Richard Foreman and Sophie Haviland. Designed by Richard Foreman.

Shaughn Buchholz
YunJung Chang
Monica Marie Contreras
Kathryn Falcone
Lawrence Lacey
Charles Leonard
Waleed Moursi
Adrienne Moursi
Adrienne Pearson
Allain Rochel
Nika Serras

This play was produced at the California Institute of the Arts and created in a rather unusual way. In order to disrupt my usual way of working and get myself into some hopefully productive "trouble," I approached Sophie Haviland, who had been the administrator of my theater for several years, as well as a writer and director of her own work, to participate in an unusual sort of collaboration.

We both wrote a series of short, independent texts on the theme of unrequited love. Neither of us was aware of what the other was writing. When a considerable amount of material had been amassed, we took both collections and together decided which pages we would use in the finished piece. Then I took the remaining material and "collaged" it into a play, designed a set and selected the music.

It was after this that the radical nature of the collaboration began. When we arrived at CalArts, the actual staging proceeded in a most unusual fashion. Rehearsals were broken down into a series of three-hour sessions over eight weeks. I would rehearse the play for three hours, then Sophie would rehearse the next few pages for three hours, then back to me for the next few pages—and back and forth like that until we reached the end of the play.

Then the whole process was repeated—but as we went through the play in subsequent rehearsals, the three-hour rule would present us with a different section of the play to work on each time, and each of us would often be reworking material that had already been staged by the other. Our rule was that each of us could freely rework the staging the other had created, with no interference or input from the other during each three-hour period.

This meant both of us would sometimes sit there in anguish, wondering, Why is that great scene I just staged being radically

altered? We were totally open with the cast, telling them what was happening and how hard it was for both of us to see our material so reworked. After rehearsals we made no attempt to persuade the other to do things differently. We remained true to the process and did not try to influence each other to see the play one way or another. We simply let the process—allowing one layer of directorial vision supersede the other—be reapplied day after day throughout the rehearsal period.

We both found the experience highly frustrating much of the time—and yet it was extremely provocative, producing much powerful material we would never have discovered by ourselves. I am not aware of other directors making any similar experiments before or since, but both Sophie and I—while swearing never to try the same thing again—were more than happy with the results. (The production, incidentally, was named one of the ten best plays of the year by the theater critic of the *Los Angeles Times*.)

NOTE ON PRODUCTION

This play about unrequited love is a dance of shifting choreographed patterns and voices, and since the actors in the original production moved in patterns more abstract and varied than was the case with the other plays included in this collection, this text does not attempt to describe the stage action in as much detail.

In addition, it is expected that future productions will employ different-sized casts, in spaces that will probably not be as large as the vast space of the original production.

The performers' real names are used throughout the script.

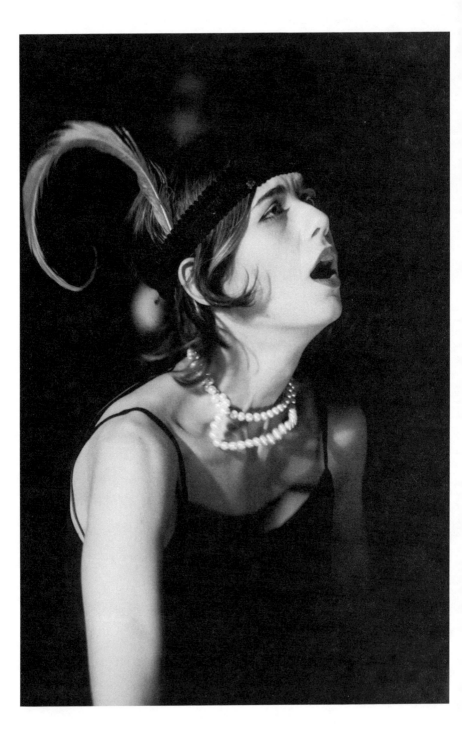

The play takes place in a large empty space with four large rolling blackboards at the rear. Five men in red bathrobes and skullcaps, and five women in dark cocktail dresses.

There is continual music, and a variety of other sound effects punctuate the performance.

The play begins in darkness.

FEMALE VOICE: Where are you hiding, Maurice?
MALE VOICE: Deep inside you, Miranda.

(The lights come up. Allain is downstage. The other four men and the five women stand in groups, far in the distance.)

ALLAIN: Arriving, finally, in the city of the attractive women—I suddenly realized my soul was being activated. But how could I possibly keep this energy from dissipating?
VOICE: Oh no!
ALLAIN: I wanted to focus my energy on internal experience.
 Releasing, finally, a world under my gaze—which was beginning to speak to me.

(Everyone runs forward to join Allain, as the blackboards close in to make a room.)

WALEED *(Indicating Nika)*: Guess what, my friend. She is the person I've been looking for.

ALLAIN: Stupid.

NIKA: Guess what. In no way will I gratify your expectations.

WALEED: OK. My desire for enlightenment is such—

NIKA: What kind of enlightenment?

WALEED: I have no desire for you to gratify my expectations.

(The others point at him and hiss.)

Did I say the wrong thing, my friends?

NIKA: My friend. Meaning no energy. And I give nothing to such people.

WALEED: How powerful I find that withdrawal of your affection.

NIKA: Then by all means—watch me leave, and weep. *(She goes)*

VOICE: Careful!

WALEED: Now that I am alone, I do suppose there is no reason for me not to weep. *(Cries)*

MONICA: May I collect your tears, you sweet, gentle, heartbroken gentleman?

WALEED: But my tears belong to me, don't they?

MONICA: I desire to seed an entire ocean, of course.

WALEED: If enough of my tears enter such an ocean—

MONICA: Then it becomes—inhabitable. Believe me, I flourish in such an ocean.

WALEED: I believe you.

VOICE: Oh no!

MONICA: I withdraw into my secret life. You don't know what goes on there.

WALEED: Are you inside your secret life right now?

MONICA: Of course I am.

WALEED: Hey—I see nothing of your secret life.

MONICA: OK. Then invent the tools enabling one to discuss such things, OK? You are my compass.

(Others hiss and point to Shaughn.)

SHAUGHN *(To Adrienne)*: OK. Then you must be my ship.

ADRIENNE: Who knows to what exotic continents we are sailing?

SHAUGHN: I want a small world, with someone like you in the very middle.

VOICE: Oh no!

ADRIENNE: OK. Imagine a story—

VOICE: Careful.

(The women all have pictures of saints, which they manipulate in different patterns on the floor, on the walls.)

ADRIENNE:

> There is a picture of a woman who does not exist.
> Who never existed.
> And there is a world that goes crazy for her image.
> Which is plastered on walls, on movie screens, on guide-
> books—this face.
> There is something about this face that people crave.
> They want to remember having known her.

> And her image appears on the waterstain of an ancient church.
> In a small town.
> But no one is noticing this special image—
> Our Lady of the Disempowered.
> Our Lady of the Broken Hearts.
> Our Lady of Miracles.
> Our Lady of the Blind, the Lame
> —the Broken Ankle.
> No one notices.

(All run around the room several times, as if with broken ankles.)

VOICE: Where are you hiding, Maurice?

SHAUGHN: There is no story in this, except the following story. One person always loves another person more than that other person loves that first person.

VOICE: Oh no!

NIKA: And this is a great opportunity, is it not? For the first person to generate a wonderful energy—which does not happen very

129

often, because the world has become a place that is a spiritual wilderness—

ALL: Right!

NIKA: —and to change that circumstance requires great inner violence.

YUN: Who dares that inner violence in today's mediocre universe?

CHARLES: In today's mediocre universe, my friends, there can be no story. And this story—this story can only happen in bits and pieces.

Because anything more than bits and pieces turns into a lie about this barren world with no spiritual potential.

KATHRYN: Here was my solution.

CHARLES: Stupid.

KATHRYN: I saw myself like a saint from long ago. I had a halo about my head and I was watching a soldier shaking a little rag doll, which turned into a live girl. And I did nothing at all. I was meant to be there. I was meant to bear witness.

ALLAIN: You were filled with compassion.

CHARLES: Stupid.

KATHRYN: It was glowing inside of me.

CHARLES: Stupid.

KATHRYN: I felt her body inside of mine.

LAWRENCE: Well, all saints are martyred for their visions.

But some were killed—just for talking too much.

KATHRYN: Ah—gossiping with God himself—that makes it worthwhile.

ALLAIN: No—just a tickling sensation, which means you could be falling sick.

YUN: Oh no!

ALLAIN: Sick—sick—sick!—

KATHRYN: But I have come alive—so this would be a sickness worth suffering.

LAWRENCE: OK. Let me give you a relevant book to throw on the fire.

(They have all lined up with books in hand.)

KATHRYN: Don't burn it!

ALLAIN: No, burn it. It talks about love gone belly-up! It talks about God.

KATHRYN: All right— *(Throws away the book)*

ALLAIN: Really?

KATHRYN: I've never understood this thing about God, I'm afraid—

(Allain laughs at her mockingly.)

—because I was always such a plausible skeptic.
Because I've charmed snakes—

(The others point at her and shout: "Hah!")

—called lost souls back from the dead—

(The others cry out: "Ohhh!" in shock.)

—all with no sense of wonder.
WOMEN: Here it comes—

(They laugh and scatter.)

KATHRYN: Jesus, Mary and Joseph! Just visions from the tops of mountains I've been climbing since childhood—no mysteries.
ALLAIN: OK. OK. We have never understood the idea of God.
VOICE: Where are you hiding, Maurice?
KATHRYN: Determined to build my own world, please—the center around which everything else revolves.

(The men advance toward the women.)

NIKA: Yes! All those drunk men. —All those foolish men.
ADRIENNE: And I have been the good apprentice in a short skirt. But there was never any sense of God.
NIKA: Only now—I start to feel a different kind of sight—an itch inside my shoulder so I cannot sleep.
VOICE: Careful.

(Nika twitches convulsively. Then she is quiet.)

NIKA: What is this itch?
WALEED: OK. I shall give you a book of saints as a guide.

ADRIENNE: I am afraid of your maze of books. You keep feeding them to me until I cannot breathe.

VOICE: Careful.

(Adrienne laughs as she and Nika roll together on the floor.)

WALEED: Oh my goodness. Those girls—they connect me to something—

ADRIENNE: I don't doubt it—your body seeking to avoid itself.
 But please—let's try some genuine experience instead.

WALEED *(Leering at her)*: Oh yes—come near—and I shall scratch your back.

ADRIENNE: Shall I make the bed first?

WALEED: I am not a betting man.

ALL *(Except Waleed and Adrienne)*: Oh yes!

(They run, collide with the wall and fall down.)

MONICA: I slipped on something.

ADRIENNE: I bet you a dollar you'll regret this.

WALEED: Does that really matter? I have removed—even the possibility of failure.

ADRIENNE: What's my name?

VOICE: Careful.

WALEED: Miranda—OSTERMAN!

(Adrienne moans sexually.)

NIKA *(Approaching Waleed)*: What did you call me? *(Pause. They kiss)* See! She is in love with her silent papa.

(Adrienne and Nika both kiss Waleed, who pulls away.)

WALEED: Isn't every pretty girl? That is why—

VOICE: Careful.

WALEED: She learns to kiss with her tongue.

ADRIENNE: I remember when I learned to kiss. Guess when?
 I brought boys home to my empty house.

VOICE: Oh no!

ADRIENNE: Come on boys! Come on!

(All the women run downstage and look at pictures of saints the men are holding at the blackboards.)

Remember? We took turns lying in the bunk bed and rolling around.
WOMEN: Ooooh!
ADRIENNE: School uniforms?

(The women all dance about, giggling.)

SHUT UP!

(Everything stops.)

Those boys in their blue-and-gray corduroy trousers.
　　—I wasn't afraid to touch them. I had looked at *Fritz the Cat* comics hidden under my parents' bed and I wanted to be fucked like a cat in heat and have big snowy tits. Ohhh—I was leaping on my cousin— *(Runs and smashes against a wall)*
　　Flailing against the bulk of his joy—
　　Weeping with laughter. My face in the pillow—
　　The boys would go home and touch themselves.
YUN *(Enters holding a portrait of a saint high in the air)*: I liked rolling around with the boys.
　　I wanted to be held. I still want to be held by a barrel-chested man. And squeezed tight until I am safe.
ADRIENNE: Hey! What's she doing here?
MONICA: Me. I got tonsillitis and lay in bed and read those French comic books? They took out my father's tonsils so I wouldn't get sick anymore. They thought they could keep me whole, preserved, intact.
　　My father did not enjoy the operation. He came home gaunt—that's right, gaunt and frail—and I was afraid. He sat at the breakfast table and we had breakfast. He picked up a glass of orange juice— I watched him take a drink and then lurch up from the table and run down the hallway, silently. Running through the rooms of our house in crazy pain from the acid on his raw throat. In silence.
YUN: Silent—movie dad.

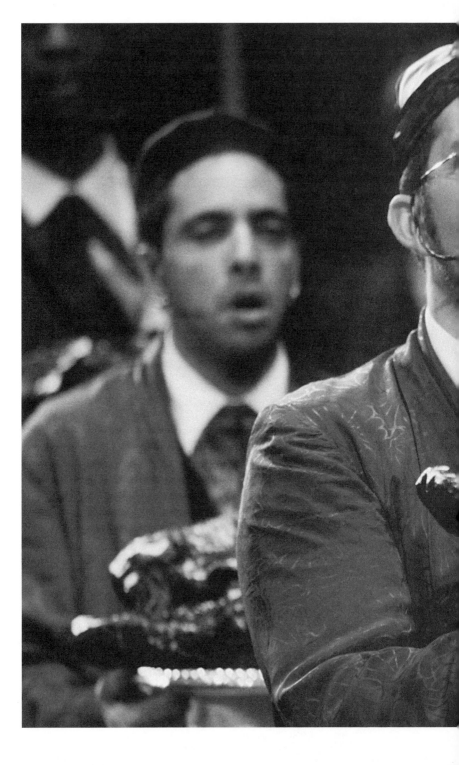

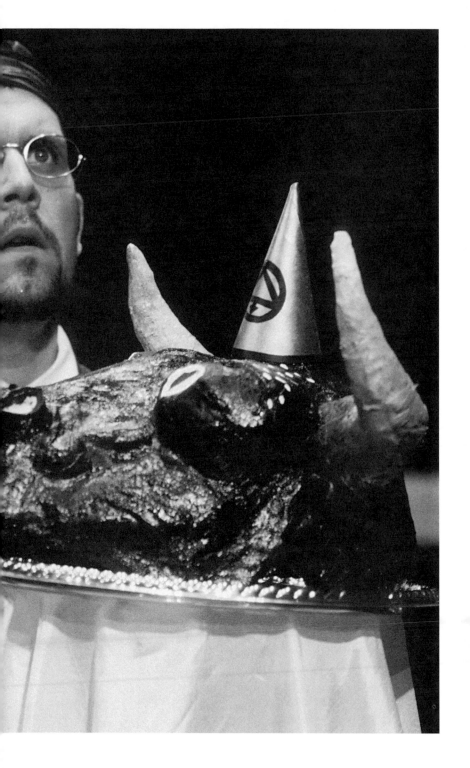

MONICA: One year later they took my tonsils out anyway.

I kept them in a plastic jar next to my father's knee cartilage. Two—that's right. Two little jars of formaldehyde.

It was so comforting to me!

(The men have assembled behind her with floral bouquets.)

LAWRENCE: OK, beautiful Miranda. I too have brought you flowers.

NIKA: No. That's not the impression we get.

LAWRENCE: Well—these flowers are poison flowers, of course. *(Pause)* That's why I am waiting for my beloved, of course.

ADRIENNE: She is invisible. You are being tested, that's all. Because you choose to be tested.

LAWRENCE: Of course I choose to be tested.

NIKA: But I choose to be tested too, goddamn it!

LAWRENCE: OK. Do we share—eyesight? Do we share brain vibrations?

ADRIENNE: What is it—I mean, why is it that we share brain vibrations?

LAWRENCE: OK. I am with you, beautiful lady.

ADRIENNE: OK. I am with you.

LAWRENCE: Your eyes are my eyes, right?

ADRIENNE: Prove it!

CHARLES: Follow the snake, my dear.

KATHRYN: Are you daring me?

(A rope has been stretched across the stage.)

CHARLES: Hands along string, into the depths of the labyrinth.

KATHRYN: Suppose I'm afraid of what I might do in such darkness.

CHARLES: There is nothing inside but desire—that's my guess. So hold on to your hair.

KATHRYN: I have no way to connect things. Do I have a name?

CHARLES: Follow the string. But hold my hands until I give you a name.

(There is a series of sharp explosions. While the others fall to the floor, Kathryn's head is covered with a cloth. She is transformed into an oracle.)

KATHRYN: There will be war—on the open sea.

CHARLES *(Embracing her from behind)*: I shall call you Miranda. Then—
you belong to me.

VOICE: Careful.

KATHRYN: There will be a war on the sea when I leave here.

CHARLES: Yes, fathers will turn to stone and daughters will turn to milk—

KATHRYN: —from my own breasts. From my own longing.

CHARLES: I shall touch your hair with my tongue.

KATHRYN: Am I looking for the way out?

CHARLES: All that is good sleeps in your head, Miranda.

KATHRYN: Why do I not trust my own counsel?

(A crash.)

MONICA *(Sings)*: Who is Miranda?

(Music plays as they all dance about and rearrange the stage.)

NIKA *(To Lawrence)*: What would you like of my life?

(Lawrence moves toward her.)

Careful—it will break your back, Maurice.

WALEED: That's OK. The locus of the heart is my broken back.

KATHRYN: I did not want an extra heart.
I wanted less than that
Or a little less density than that.

NIKA: Mister—you have a very heavy heart.

WALEED: Let's not talk about bad things all of a sudden.

NIKA: No, let's talk about bad things all of a sudden. Because without
bad things—the zip-zip I am hungry for—you know—it's just not
happening around here.

LAWRENCE: Liar. It's definitely happening around here.

NIKA: Liar.

LAWRENCE: Do I lie?
Do I lie when my very own eyes burn inside Miranda Oster-
man's blood red smile?

ADRIENNE: Liar—

LAWRENCE: Do I lie when my very own lips tremble like the open
wound inside my own terrible heart?

(A crash. The others dance to a jazz tune.)

Look at her—look at her now—licking her red fingers and laughing at me.

NIKA: Oh, you're such a drag.

(All laugh.)

LAWRENCE: Which means—I know. Now I know—she is unaware of my desperate imagination. Because she is just calming her own nerves and pretending to be happy.

(A crash, followed by music.)

KATHRYN: Jesus, Mary and Joseph! —Whenever I hear that old-fashioned music—

SHAUGHN: Please—let's not talk about bad things.

KATHRYN: Guess what. I remember being in love.

ALLAIN: Ah, you see? It's the old-fashioned music that made it happen—nothing but music.

KATHRYN: It was music—

(All but Kathryn stretch out on the floor.)

—it was a large empty room inside which the sound could echo, with a hard wooden floor, and guess what—trees, dozens of wee little trees in the distance, I could see through an open door, through which I could feel a slight breeze on my face—

CHARLES: Yes, that does sound like love to me.

VOICE: Where are you hiding, Maurice?

KATHRYN: An echo, that's all.

CHARLES: What?

KATHRYN: An echo. Sweet God—what's an echo, Maurice?
 One thing I said, but you didn't understand me. Which is—"what's an echo?"

CHARLES: An echo is when sound bounces off something and comes back to the source.

YUN: But maybe it's love you're imagining. When you imagine an echo.

CHARLES: Yes. I see that.

YUN: You think—I'm not really in love—but just—pick up on a world of echoes. And if that isn't love, Maurice, then there is no such thing as love.

CHARLES: OK. That makes me look into myself with a different perspective, sweetie.

VOICE: Careful.

NIKA: An echo.

CHARLES: An echo.

ADRIENNE: An echo.

SHAUGHN: An echo.

ADRIENNE (*Singing softly*):
> Pack up your troubles
> In your old kit bag
> And smile, smile, smile—

MONICA (*Pacing nervously*): Me? I shall cut my hair short tomorrow— So that you do not know if I have made love to another man when we meet.

VOICE: Oh no!

WALEED: Right now, this is somebody else's future.

(A loud gong. Charles steps forward.)

CHARLES: In the midst of my dreams—

ALLAIN: An echo.

CHARLES: —rounding the corner—

YUN: An echo.

CHARLES: I glimpsed this woman—

(A crash. A woman leaves.)

—but it was not her.

KATHRYN (*Sings*):
> Pack up your troubles
> In your old kit bag—

CHARLES: And then, across the street in a cafe I saw this woman, seated—

(A crash, and another woman leaves.)

—but it was not her.

KATHRYN *(Singing louder)*:
　　Pack up your troubles
　　In your old kit bag—

CHARLES *(On his knees now)*: And again, smoothing her hair while looking into a shop window—
ADRIENNE: Get up off your knees, please?
CHARLES: No.
ADRIENNE: Stand up, please?
CHARLES: No.
ADRIENNE *(Seductively)*: Must I beat you? Really?

(All laugh and run off, leaving Charles alone.)

CHARLES: And then, a terrible thing happened.
　　A woman, who had just fallen in love—not with me, alas—asked for my recommendations vis-à-vis . . . erotic poetry.

(The others laugh at him from the wings.)

I was shocked to realize—there was nothing I could recommend.

(The others are sneaking back into the room.)

ADRIENNE: Remember. I have only contempt for a man on his knees.
CHARLES: I resolved to correct this error in the one way possible.
　　I began to write.
ADRIENNE: OK. What the hell did you write?
CHARLES *(Very quietly)*: This is for you.
MONICA: Well, thank you for nothing.

(A gong sounds as they run to the other side of the stage and offer a minotaur mask to Charles.)

CHARLES: This . . . is for you.
KATHRYN: No! Thank you!

(Charles puts on the mask. It makes him fall forward. Allain grabs the mask and tries to put it on.)

ALLAIN: This is ripped out of me!—
KATHRYN: Girls like me? Girls like me run away from sacrifice.
 You are my minotaur and I will no longer feed you.
 Because I have found a length of string to lead me to my new
 love.
WALEED: Climb onto my back right this minute, lady.
KATHRYN: No.
WALEED: OK. I shall sing you to sleep, little girl.
KATHRYN: Your breath is huge.
WALEED: I plow through your long hair, little girl.
KATHRYN: Stay in your maze! Because I have found my true prophet
 and his name is—
WALEED: No! Oh my goodness—all that is good—
 All that is good sleeps in my head.
 I am lost in the dark. Where are her hands?
KATHRYN: There are no hands.
 Poor old monstrous thing.

(A crash, followed by dance music.)

WALEED *(Shouting over the music)*:
 All this built on a stone rampart.
 There will be a war on the sea
 And tunics and daggers
 And she shall sleep on the sand
 Stretching to the water
 And watch the horizon with empty eyes.

KATHRYN: I can smell your breath. Your books no longer scare me.
WALEED: I'm gonna eat you up, little girl.
KATHRYN: No, mister—I'm gonna bite you in two
 And throw away the better half.

(She leaps upon him and he runs away. The others slowly advance on her. There is a silence.)

ALLAIN: Are you OK, lady?
KATHRYN *(Mocking his concern)*: "Are *you* OK, lady?"

ALLAIN *(Sings softly)*:
Here I go—
High and low
Watch my happy dance.

(All start dancing in silence.)

Boys and girls
In the world
Dancing in a trance.

VOICE: Careful.
WALEED: It's true. I have never been faithful to anyone, you know.
ALLAIN: I knew it—I knew it!
KATHRYN: While I was living with the intoxicating Maurice Beaudreaux—stupid me. Guess what, I was still sleeping with my ex-lover—
ALLAIN: Who I never met—
KATHRYN: No, one you did meet. Harold—with the arse of the angels—Anderson.
ALLAIN: I do not remember being introduced to Harold Anderson. *(Pause)* Myself—I have always been faithful to Miranda Osterman.
KATHRYN: Liar.
ALLAIN: In what sense—"Liar"?
KATHRYN: Are you lying to me now?
ALLAIN: Am I lying in your arms now?
KATHRYN: No such thing. Liar.
ADRIENNE: Stupid.
ALLAIN: Yes. But why—why—why?—
VOICE: Careful.
ALLAIN: Why have you been unfaithful to the irresistible Maurice Beaudreaux?

KATHRYN: Because my heart has been capable of such things.
ALLAIN: Ah, let me touch that heart, please.
KATHRYN: Do not touch me, please.

(The others come up behind her, folding their hands over her heart.)

SHAUGHN: Your heart could possibly explode.
VOICE: Careful.

(All but Kathryn run off.)

KATHRYN: Yes, it could do that.
VOICE: No such thing, I'm afraid.

(She comes forward and sees a shrine, with the portraits of saints displayed.)

KATHRYN:

> Desire—outside my body—leaning towards
> Something disembodied.

YUN *(A gong sounds after each phrase)*:

> Our Lady of the Disempowered.
> Our Lady of the Broken Hearts.
> Our Lady of Miracles.
> Our Lady of the Blind, the Lame.
> The Broken Ankle.

NIKA *(Kneeling in prayer)*: What do I want so much?
WALEED: Look at me, lady!
NIKA *(With contempt)*: I am—looking at you.
WALEED: You are possessed, think.
NIKA: Oh yes!
WALEED: By a power to uncoil and hold a hundred million thousand
 men inside your breath—sexless—without even—

(Nika is shaken by spasms. Waleed jumps back in fear.)

Oh shit!— What is that!

NIKA: Please forgive me! I have poisoned your water . . .

WALEED: Never. I will never consume you.

NIKA: But I—alas, I desire only to be consumed.

WALEED: Listen to me.

(A gong sounds.)

> I reach a point, maybe—where I vibrate on top of a mountain.
> And if I fall down to the north—that's death maybe.
> And if I fall down to the south—that's death also.
> And if I fall down to the east, or west—

(A gong sounds.)

YUN: All directions are one direction, Maurice.

MAURICE: I am on fire, maybe! Which means—vibrating in all directions.
I never never do fall—until I do fall.

(There is a crash and a flash of light, which frightens everyone.)

But I know inside Miranda Osterman's heart I am indeed, my friends, traveling in all directions at once.

CHARLES: Hey boy, are you OK?

WALEED: No, I don't think so—not at all!

CHARLES: In that case—

(Sings:)

> Pack up your troubles
> In your old kit bag
> And smile, smile, smile.

YUN *(Creeping through the shadows)*: What do I turn into? A silver light. Where are you, Maurice?

(Crash. Others run on with pillows.)

In the big bed. Ohhhhh! Watch out for the snake. Watch out
Maurice. My heart, my heart is a big circle of light.

VOICE: Careful.

KATHRYN: Guess what I see, ladies? I see light that does not bounce.

NIKA: No bed, no room, no weight. Just his body still there in front of
me, like a silver light shooting inside my head.

(A gong makes them all stagger.)

WALEED: Oh my goodness!

KATHRYN: Even an empty room can have a feeling.

SHAUGHN: There are some things Miranda Osterman herself feels.
That I—me—for certain cannot feel.

KATHRYN: Careful.

VOICE: Careful.

NIKA: Guess what.

VOICE: Careful.

NIKA: You are the person I've been looking for.

SHAUGHN: Oh? Guess what. In no way, ladies, will I gratify your
expectations.

NIKA: Then by all means, watch me and weep. *(She is shaken by con-
vulsions)*

SHAUGHN: Oh shit! Oh shit shit shit!

*(The blackboards roll apart and the room becomes a vast, empty
hall as Shaughn sings in a loud, bellowing voice:)*

You maaaaaade me love you
I didn't want to do it!
I didn't want to do it!
You maaaaade me want you
And all the time you knew it!
You know—you really knew it!

(He falls to the floor. All surround him.)

MONICA: You stupid boy.

NIKA: Stupid.

SHAUGHN: Then you do come, after all, from another world, Miranda Osterman? *(Runs to the rear)*

(Dance music begins, and they all dance a Lindy Hop while Shaughn shouts out against the music:)

> You made me love you
> I didn't want to do it!
> I didn't want to do it!

MONICA: Guess what?— I believe I do come from another world— can't you tell?

(A crash, and the music stops.)

ADRIENNE: Where are you hiding, Maurice?
ALLAIN: Deep inside Miranda Osterman, maybe.
SHAUGHN: That's not something I want to believe.
MONICA: Too late for such choices, lover boy.
ALLAIN: Oh, it's never too late.
ADRIENNE: Does Maurice really believe that?

(Pause.)

Well, does he?

(Yun runs into the room, screaming, holding a picture of a saint over her head.)

YUN: Fire!

(They all run to the rear. Yun turns and smiles at the audience.)

You see? There's an easier way.

(The blackboards close in and make a small room at the front of the stage.)

You see? There's an easier way.

(A gong. A Falsetto Voice is heard repeating: "I'm hearin' the words. I'm hearin' the words." Then everything is quiet. There is an otherworldly light, and a soft organ tone. Everyone speaks and moves slowly. They are praying, internally.)

LAWRENCE: I am a man . . . who could never believe such things are possible.

YUN: This is the funnel through which everything comes from another world . . . into this world.

SHAUGHN: Does that mean I have to disappear inside myself?

YUN: Yes. This falling backwards inside one's head—this is the funnel.

SHAUGHN: No. Because Miranda Osterman's body disappears into a space that gets emptier and emptier. And this emptiness—this is the funnel.

YUN: Even if you carry me into another world completely—my body is still here in this world.

CHARLES: Then hold me, goddamn it.

(Veiled Minotaur heads, placed on serving platters, are slowly carried into the room.)

Hold my thoughts, that are inside and outside my body at the same time!

NIKA: I sever those thoughts, and sever your head, John the Baptist.

CHARLES: Hold me—

NIKA: I would kiss you, John the Baptist—kiss you with your head on a platter and your blue tongue inside my mouth.

ADRIENNE: I kiss your blue tongue while you are asleep. *(Whispers)* This is fate . . . unveiled.

(The veils are removed.)

ALLAIN: Then this . . . is what's here.

ADRIENNE: Yes. This is here. And this is one single thing.

ALLAIN: Then this . . . is OK.

ADRIENNE: Yes. A little excitement.

(The others, who have been facing the blackboards with their hands touching its black surface, suddenly scream and pull away as if they have received an electric shock.)

CHARLES: Careful, it depends what you mean by excitement—

(There is a crash, and the lights flash. Some fall to their knees.)

—which could be a recipe for disaster.

KATHRYN: Once upon a time—I inhabited the kingdom of flesh, and inside that kingdom—

SHAUGHN: No—I will never belong inside—that painful kingdom.

YUN: But you do belong to that kingdom, Maurice.

And this is OK of course—because—since we are cast down into flesh—is it not appropriate to live in flesh?

CHARLES: Appropriate, yes—but not sufficiently heroic, I believe.

KATHRYN: Oh I believe that you are wrong. And I think it very heroic to live inside this flesh—just watch me—watch me.

(She starts to shake convulsively.)

NIKA: Look what happens. It starts to shake. Shaking and shaking the world to pieces.

(She also starts to shake. Then both women are still.)

SHAUGHN: But me—thank God—I am no longer there—inside that shaking— *(He shakes)* And shaking . . .

(Nika and Kathryn hold him still.)

ADRIENNE: But nobody—

(A flash of bright light. The blackboards lurch forward and every-one jumps back in fear.)

Nobody is there, inside that shaking and shaking— *(She starts to shake)*

ALLAIN: Inside that— *(He starts to shake)*

(All gather to watch Allain as the music rises. It then cuts off, and everything stops. There is a pause. Then Kathryn laughs, and the others slowly join in.)

KATHRYN: Now!

(Everyone stops to listen to her.)

Now, finally. Here is no flesh left, inside that shaking.

ALLAIN: OK. Ten years ago, I was in love with Miranda Osterman. And it lasted, until it was over and done with. And at that moment— love was suddenly available to me.

(The others suddenly turn and push the blackboards to the side, and Allain is left alone in a vast space.)

But—how to access that love, suddenly available to me at the end of love. That was my problem.

(He turns and looks at the others, then turns back to the audience.)

That was my problem.

(The lights slowly fade.)

THE END

Panic!

(How to Be Happy!)

PRODUCTION HISTORY

Panic! (How to Be Happy!) Produced by the Ontological-Hysteric Theater at the Ontological at St. Mark's Theater, New York City. January–April 2003. Written, directed and designed by Richard Foreman.

UMBERTO	Robert Cucuzza
NIKOS	D.J. Mendel
LUMINITZA	Elina Löwensohn
SVETLANA	Tea Alagic
CREW	Caitlin Mcdonough-Thayer, Kristen Pratt, Rachel Shukert, Ryan West, BJ Lockhart

AUTHOR'S NOTE

This play was created from a series of simple phrases, as was the case with *Maria del Bosco*. Those phrases are now printed separately here. I would suggest that future directors might start rehearsals using just these few phrases, either spoken by the actors, or recorded on tape as I did in my own production, and build an original production, inventing an original scenario, from just these few phrases, much as I did from my first day of rehearsal.

He goes where no man
Dares to go.

I shall not enter
This tomb.

This play
This play is the sacred text
Of a forgotten people.
Everything is inside it.
Therefore, protect yourself
By wearing the transparent blinders
With which you have been provided.
Oh! Forgive me.
I see you are already wearing them.

My mouth is sealed with gold.

We are here, now, inside the behavioral center.

Every inner requirement is being fulfilled.

Take off the blinders.

Only taking chances
Then absolute life.

Kiss me, kiss me
When I am most ruined inside myself.

Please, don't leave us alone.

A new perspective
Can only repeat old patterns.

Look. Here comes the Old Man of the Mountains.
It's the Old Man of the Mountains.

This is the paraphernalia of my youth.

This no end of trouble.
This is my safe harbor.

Here's tomorrow's baked goods. Stale already.

Not yet. Not yet.

This paradise is half and half
Objectionable.

A broken tooth turns into a golden key.

You have a life.
You have to do something with that life.

This is not required, fall down.

Take off the blinders.

Never show true feelings to people hungry for mutual affectionate
behavior.

When the big ones tumble
Small ones always benefit.

Those who sink
Try to walk on water.

Nobody can be somebody's spiritual helpmate.

Here's my main circulatory system.
Your choice.

These I worship, through increasing distance.
So—hold on.

Only my enemies convince me the world is real.

Here is a horse for eternal frustration.

Don't look a gift horse in the mouth.
Unless you desire horse kisses.

Follow the instructions you hear coming over the loudspeaker,
please.

You too can shipwreck on golden wreaths.

Why do I choose this destiny,
When I already love myself?

Nothing changes.

I need tools to accomplish
Redundant behavior, please.

Building an entire world from memory.

This is my private collection of lost ideas.
And the whole world feeds itself with my vanity, OK?

Let's not stop here
Because our mental baggage isn't full.

Unless this house tumbles—
Then I can choose my own private direction.

Have I ever not fooled myself on purpose
In order to maintain mental health?

Thank God I found my ticket home.

That thing, entering the room,
I forget what to name it,
But I better think fast.

Jesus! If I knew then what I know now,
I'd be really aberrant.

Two climbable mountains, upstage center, dominate the stage. They
slope away from each other in opposite directions and reach the top of
the stage, with an orange sky between them. The floor is covered in
Oriental rugs. Black-and-white checkered strings crisscross the stage.
Confetti, painted eyes and letters abound, as well as painted stalks
with tiny flowers on top. A vulture and a toy train hang from the ceil-
ing. Two tiers of dark blue curtains, much like the curtains of the
berths of an ancient sleeping car, frame either side of the stage, held
open by strings of pearls. Ladders lead to the upper berths. Twelve large
eighteenth-century porcelain dolls are attached to the upper curtains,
poised like witnesses to the play. Stage center is a tall, two-story cabi-
net on wheels, striped gold and brown, with a door and a window.

 Loud, booming march music is heard, accompanied by a ringing
telephone.

 Throughout the play, several different voices are heard over the
loudspeakers: a Deep Bass Voice, a Slurred Voice and a High-Pitched
Voice. When these voices are doubled in choral fashion, this is indicated
before the speech. Throughout most of the play there is music.

 Svetlana, Umberto, Luminitza and Nikos enter, followed by five
Mountain Men and Women dressed in torn clothing and bandannas.
They strut across the stage with their hips protruding and their hands
behind their backs. Svetlana wears a white baby doll dress and a black
cap decorated with eggs. Umberto is costumed like a pirate, with several
blacked-out teeth, and throughout the play his mouth is maniacally

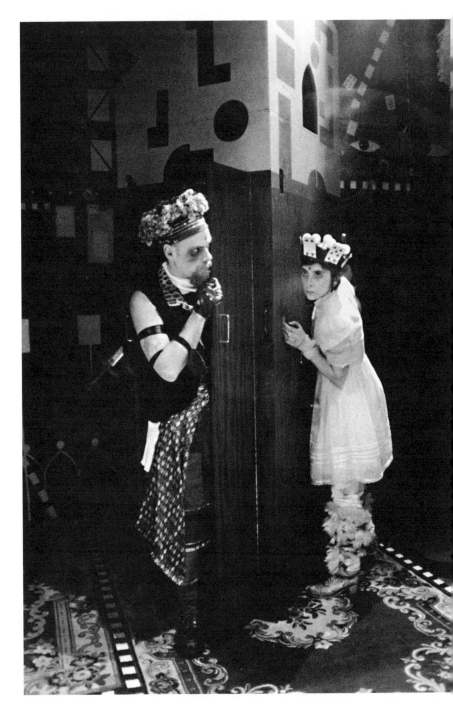

distorted in a frozen grin. Luminitza is wearing a dark, severe, European-style dress that falls to her ankles, with a bulky bomber jacket over the dress. Nikos appears as a primitive savage king with a kilt, a cheetah-print vest, and a mane of fuzzy hair tumbling out from under a red fez.

Upon filling the stage, the characters suddenly freeze in position. All sound stops abruptly. Nikos goes slowly to the striped, tower-like cabinet, and all watch him nervously as he slowly opens the door. There is a loud crash, and all but Luminitza flee the stage.

CHORUS *(In deep bass):*
> He goes where no man
> Dares to go.

(Nikos takes a moment and starts toward Luminitza. Then he stops, returns to the cabinet and closes the door. He returns to Luminitza and embraces her fiercely. She struggles and finally pushes him away. Nikos gives her an angry look, then returns to the cabinet and goes inside.

Thuds are heard as Umberto leads the others back onstage in the same strutting march with which the play began. Umberto now has swords in his hands. A three-note dinner chime is heard. The Mountain People jump away from Umberto.)

UMBERTO *(Speaks every one of his lines in a high falsetto, throughout the play)*: Let's all join the misfit club.

(Umberto plunges his swords, one by one, into the tower. With each sword he counts in Italian: "Uno, due . . ." and so on. And with each sword insertion, there is a loud crash. Suddenly, a buzzer makes all but Umberto run offstage.)

CHORUS *(In deep bass):*
> I shall not enter
> This tomb.

UMBERTO: The dance of Umberto de Cymolie.

(Umberto places his thumbs in his armpits and does a strutting chicken dance. As he dances faster and faster, losing control, the Mountain People run to stop him.)

SLURRED VOICE:
>This play,
>This play is the sacred text
>Of a forgotten people.

(Svetlana takes one of the swords from the tomb and threatens to stab Umberto with it.)

>Everything is inside it.
>Therefore, protect yourself
>By wearing the transparent blinders
>With which you have been provided.
>Oh! Forgive me.
>I see you are already wearing them.

UMBERTO: Touché, madam! *(Takes the sword from Svetlana and places it between his legs. He slides the sword back and forth between his legs as he sings:)*

>Ride a cockhorse to Barberry Cross.

(Svetlana takes the sword from Umberto, places it between her teeth, holds her nose and does a whirling dance as Umberto climbs halfway up a ladder located between the open curtains. Svetlana drops the sword out of her mouth.

Nikos emerges from the cabinet, picks up the sword that Svetlana has dropped and offers it to her as Luminitza takes another sword and sticks it into Umberto's ass. She wiggles the sword and softly sings:)

LUMINITZA:
>There was an old man from the sea
>Who said, "Don't do that to me."
>He looked up his ass,
>Saying, "What's come to pass . . ."

DEEP BASS VOICE:
> I shall not enter this tomb.

(Nikos returns from the cabinet as the Mountain People leave the stage. Luminitza slams the door shut on Nikos, holding it shut with her sword. She utters a curse and spits once as she leaves the tower. Nikos peeks out from behind the door.)

NIKOS: Maybe I needed that.

(Luminitza circles the stage, then offers the sword to Svetlana.)

DEEP BASS VOICE:
> My mouth is sealed with gold.

HIGH-PITCHED VOICE:
> My mouth is sealed with gold.

(Svetlana takes the sword and puts it between her teeth.)

CHORUS *(In deep bass)*:
> My mouth is sealed with gold.

SLURRED VOICE:
> We are here, now, inside the behavioral center.

(The Mountain People place another sword between Luminitza's teeth and then bind both women's hands with chains. The two women walk across the stage holding their tied hands in the air, as if in prayer. Umberto struts around the women.)

We are here, now, inside the behavioral center.

DEEP BASS VOICE:
> Every inner requirement is being fulfilled.

CHORUS *(In deep bass)*:
> Every inner requirement is being fulfilled.

(The Mountain People unchain the hands of the two women. Umberto approaches Svetlana and grabs her in a bear hug, simultaneously taking the sword from her mouth with his teeth—as if a kiss facilitated the exchange. Bells ring.

Umberto bends forward to offer the sword, still between his teeth, to Luminitza. She takes it out of his mouth, and he struts slowly across the stage. With each of his footsteps there is a crash. He goes to a small, transparent bull's-eye that hangs at the front of the stage at eye level. He looks through it toward the audience. Nothing happens. He then covers one eye and looks through the bull's-eye again. Lights flash, accompanied by a crash, which makes everyone jump back in surprise.)

SLURRED VOICE:
Take off the blinders.

DEEP BASS VOICE:
My mouth is sealed with gold.

(The Mountain People come up behind Umberto and put a gag over his mouth. Then they rotate the cabinet and, with Nikos still inside, roll it to the side of the stage. As the music rises, they back away from it in fear and shake their hands in the air in ritual frenzy.)

HIGH-PITCHED VOICE:
My mouth is sealed with gold.

(Nikos exits the cabinet as a large black bed rolls onstage. The Mountain People kneel, worshipping the bed, which has a large black pillar rising from the center topped by a mirrored ball. Luminitza rides the bed, rubbing her body against the pillar, as Nikos pushes his way through the line of kneeling Mountain People.)

NIKOS: There once was a man with a prick. *(With a dirty laugh, he indicates the audience)* Gotcha! Gotcha!

(Slow cello music is heard. Nikos supports himself against the cabinet and Svetlana goes to Umberto, who has climbed halfway up one of the ladders, and begins licking his groin.
 Nikos continues his limerick:)

Who said happiness
Just won't stick—

(Turning to Svetlana:)

—Stick it to me, baby—
He stuck it in deep,
Which just made him weep,
That terrible man with a prick.

(There is a crash.)

UMBERTO: Interesting.

HIGH-PITCHED VOICE:
 Only taking chances
 Then absolute life.

DEEP BASS VOICE:
 Only taking chances
 Then absolute life.

(Svetlana climbs onto the bed with Luminitza. Nikos and Umberto kneel at the foot of the bed and begin kissing the women's shoes, occasionally spitting out the dirt from the shoes that has gotten into their mouths.)

LUMINITZA *(Singing as the music rises)*:
 Kiss me once, and kiss me twice.
 It's been a long, long time—

(A siren is heard. A telephone rings and Nikos and Umberto run downstage to bawl, vaudeville-style, for the audience, as loud, rhythmic music rises.)

NIKOS AND UMBERTO: Oh! Honey! It's been a long, long time! It's been such a long time! Such a long, long time!

(The music cuts. Dead silence for a moment.)

CHORUS *(In deep bass)*:
 I shall not enter this tomb.

(Umberto, Luminitza and Svetlana form a line behind the bull's-eye, covering their eyes with their hands. When they uncover their eyes, there is a flash which throws them off-balance. All but Svetlana run from the stage.

A striped black-and-yellow screen is held behind her. She observes it in wonderment, touching it and then looking back toward the audience.)

DEEP BASS VOICE:
 Kiss me, Kiss me
 When I am most ruined inside myself.

SVETLANA *(Hiking up her skirt and singing)*:
 I wish I could shimmy like my sister Kate.

SLURRED VOICE:
 Not yet.

(Umberto runs on to tickle Svetlana and chases her up a ladder.)

 Please, don't leave us alone.
 Please, don't leave us alone.

DEEP BASS VOICE:
 A new perspective can only repeat old patterns.
 A new perspective can only repeat old patterns.

(Svetlana and Luminitza march down toward the audience, each counting footsteps in a different foreign language. Arriving at the front of the stage, they shout in unison—but not in time to the music:)

SVETLANA AND LUMINITZA:
>Kate, Kate, Sister Kate.
>I wish I could shimmy like my sister Kate.
>She gets all the fellows and she stays out late.
>Shimmy, shimmy, stays out late.
>Shimmy, shimmy, stays out late.

(As the women repeat their lines, they are each handed a large framed picture of the "Old Man of the Mountains"—a ghost-like face etched against a crosshatched background. They hold these against their chests as they continue to repeat their lines.

At the same time, Umberto goes to the side of the stage, sword drawn, and threatens Nikos, who has begun a ritual march across the stage carrying a big red banner. Simultaneously, a giant cutout face—the Old Man of the Mountains—slides into view against the sky from behind one of the mountains. The Old Man has large, saucer-like eyes, a gaping mouth, a single crystal tear falling from one eye, and mystical jewels dotting his feathered headdress and his face.

Nikos raises his banner toward the Old Man of the Mountains as Umberto and the women dance around Nikos. There is a loud crash, and Nikos falls to the ground. Then, in the silence, he recovers and crawls toward the base of the mountain, where he seizes the end of a rope that is tied to the mountaintop. He rises and stretches the rope taut, holding a frozen pose as Umberto points toward him with his sword. There is a silent pause.)

UMBERTO: Let's all join—

(A ping is heard.)

—the misfit club!

SLURRED VOICE:
>Look. Here comes the Old Man of the Mountains.
>It's the Old Man of the Mountains.

(Leaning backward and using the rope for support, Nikos begins to climb the mountain laboriously, while the women shake their

framed pictures in fear. Upon reaching the summit of the moun-
tain, Nikos pauses and then deliberately jabs the eye of the Old Man
of the Mountains with his elbow, accompanied by a loud crash.)

Look. Here comes the Old Man of the Mountains.
It's the Old Man of the Mountains.

(Umberto prances across the stage with excitement. Luminitza and
Svetlana run downstage, where there are two oars, each encased
in a cat's cradle of string. One end of each oar is attached to the
stage floor. The women each lift an oar and ride it like a play-
ground seesaw, which makes the strings crisscross in changing
patterns. With each pump up and down on the oars, they count out
loud in a foreign language.)

CHORUS *(High-pitched)*:
This is the paraphernalia of my youth.
This is the paraphernalia of my youth.

(Nikos descends from the mountain and collapses. Svetlana and
Luminitza stop counting, jump off the oars and run offstage
speaking foreign gibberish. They immediately return, each carry-
ing a marble bust with a black blindfold over its eyes. They place
the busts on either side of the collapsed Nikos, then seat themselves
on the sculpted heads.
The Mountain People slowly cross the rear of the stage, arms
locked, forming a ghostly chorus line.)

UMBERTO: Let's all join—

(A ping is heard.)

—the misfit club!

(Umberto looks through the bull's-eye once again, and after a
pause there is a flash, to which everyone responds with an "Ow" of
pain. Nikos jumps up, grabs the red banner and marches across
the stage, each ceremonial step accompanied by a loud crash.

Everything suddenly stops as Nikos drops his flag and comes to look into the bull's-eye. At first his hands cover his eyes. Then he pulls them away and a flash sends him and everyone else reeling about the stage as if an earthquake has just struck.)

DEEP BASS VOICE:
This no end of trouble.
This is my safe harbor.

CHORUS *(In deep bass)*:
This no end of trouble.
This is my safe harbor.

(His expression darkening, Nikos points to his forehead.)

DEEP BASS VOICE:
This is the paraphernalia of my youth.

(A Mountain Woman places a white veil over Nikos's face, and he falls to his knees. Then the Mountain Woman places a second white veil over Umberto's face, and he also falls to his knees.

Soft organ music is heard as the bed rolls on and the Mountain People bring forth two strange objects—giant funnel-like devices, furry on the outside and painted in shades of pink on their inside. These objects suggest two giant female sexual organs.

Svetlana and Luminitza take these funnels and hold them, lovingly, in front of their bodies in the appropriate regions. A Mountain Woman slowly approaches them. She is holding a giant bee, which vibrates on the end of a pole, and she makes the bee feed from one of the funnels. The quiet, yet ominous, organ music fades, and a single violin plays a soft lament.

Svetlana and Luminitza, still holding their funnels, reposition themselves on the edge of the bed. The Mountain People gently toss confetti in their direction, while Nikos and Umberto crawl on their hands and knees toward the women, lifting themselves just enough to feed from the sexual funnels the women hold. Very gently, two Mountain People whip the backs of Svetlana and Lumin-

*itza. The men wipe their lips. Svetlana and Luminitza rise from
the bed and gently transfer the funnels from their crotches to the
heads of Nikos and Umberto. The funnels completely cover their
heads, so that it appears as if they were each wearing a fur-
covered Chinese hat. The two women gently lead their men to the
side of the stage.)*

A new perspective can only repeat old patterns.

*(Luminitza and Svetlana pick at the fur on the hats, as if eating
bread crumbs that had settled in them. Then they embrace the
men and duck their heads so that they are also inside the funnels,
but the Mountain People immediately remove the hats. Umberto
and Nikos turn and look wistfully after them. Luminitza and
Svetlana embrace the men, thrusting their pelvises against them
with a violence sufficient to make the two men fall to the floor. At
the rear of the stage, two Mountain People carry on large placards
with an assortment of removable mock biscuits attached to them
as display. Svetlana and Luminitza help Nikos and Umberto to
their feet and again throw their arms around them. Together the
couples jump up and down as the women count out numbers in a
foreign language. They release the men, then are attracted to the
bread being displayed upstage. The two women slowly go upstage,
and each takes a large biscuit from a placard.)*

Here's tomorrow's baked goods. Stale already.

*(Svetlana and Luminitza walk downstage, each displaying a bis-
cuit. They each slowly lick the side of a biscuit, and then present it
to the men. As Nikos and Umberto start to eat the already-licked
biscuits, the two women each put a finger in their own mouths,
pulling their mouths sideways to create distorted, open and hun-
gry mouths, and in this mode they slowly drift across the stage,
away from the men who are still munching away on their biscuits.
The men offer the biscuits to the women, who run back to grab
them, but the men pull them away at the last minute and spin,
placing the biscuits at their crotches where they wiggle them like
excited penises.*

Svetlana and Luminitza grab the biscuits away and the men clutch at their crotches in pain.)

SLURRED VOICE:
Not yet. Not yet.

LUMINITZA AND SVETLANA *(Holding the biscuits next to their faces and singing softly)*: Who are you? Who are you?

(The men run to get new biscuits from the placards, and then all four go downstage, hold the biscuits high in the air and exclaim in unison:)

NIKOS, UMBERTO, SVETLANA AND LUMINITZA: Good food!

DEEP BASS VOICE:
This paradise is half and half
Objectionable.

NIKOS, UMBERTO, SVETLANA AND LUMINITZA *(Filling their lungs as they stride about the stage)*: Fresh air! Fresh air!

(They bite into the biscuits, and then suddenly hold their stomachs in pain—apparently the biscuits were not healthy after all. The Mountain People run on with white screens that they place against the mountains. Svetlana and Luminitza straighten up, and as the music rises to a deafening level, they repeatedly throw their bodies against the screens. Then Umberto and Nikos push the women out of the way and throw their own bodies against the screens. More white screens enter and circle them, and they try to throw themselves against those screens also.

Sirens are now heard over the music. Mountain People move the oars up and down, with Svetlana and Luminitza wildly riding them, as more white screens rock back and forth in tandem. Over the pounding music, a Guttural Voice screams: "Right! Right! Right!"

The music softens as the screens leave the stage, and Nikos and Umberto carry the biscuit placards to center stage.

The two women dance a twist in front of the placards.)

SLURRED VOICE:
 We are here, now, inside the behavioral center.
 We are here, now, inside the behavioral center.

(Svetlana and Luminitza turn to Umberto and Nikos. The men hold the plates of bread, and the women dance a twist in front of the breads. Then, as the biscuit trays are removed, the women turn to the audience:)

SVETLANA: Me. Svetlana, Nadia, Georgia— *(Hikes up her skirt as if to curtsy)* —you know what I mean.
LUMINITZA: Me, Luminitza Kerkekof—the way I talk—

(All four start repeating and overlapping one another:)

NIKOS: The way I walk, Nikos . . . the Big Bull from Santa Maria!
UMBERTO: The way I talk, Umberto de Cymolie. Me, me, me, my way!
LUMINITZA: The way I walk, the way I talk. My way. My way!
SVETLANA: The way I walk. The way I talk. My way. My way!

(A sudden silence. They cover their eyes.)

(Uncovering her eyes and whispering to the audience) This is my ticket to a much better world.

(The four run to each other and embrace. There is a crash, and they pull away, Umberto and Svetlana each pointing to a tooth they hurt in the embrace.)

HIGH-PITCHED VOICE:
 A broken tooth turns into a golden key.

DEEP BASS VOICE:
 A broken tooth turns into a golden key.

UMBERTO AND SVETLANA *(Still indicating their teeth)*: Pure gold! Pure gold!

HIGH-PITCHED VOICE:
A broken tooth turns into a golden key.

SLURRED VOICE:
We are here, now, inside the behavioral center.

(Music begins to play. Nikos lifts Luminitza onto the bed and they perform sex acts. Umberto and Svetlana run to watch. Then the Mountain People rush on with a large white straitjacket with a giant eye painted in its center. They hold this jacket up to hide the actors on the bed.

Luminitza comes out from behind it, comes down to the audience and points to her forehead. As the music rises, the arms of the straitjacket begin to flop back and forth and the jacket winds around Umberto and Svetlana. Nikos comes out to join Luminitza, and the two of them embrace and then run to the straitjacket, wrapping its long sleeves around their necks. Then they spin free and kiss. The kiss throws them to opposite ends of the stage. A Mountain Person comes and holds a large white disk in front of the straitjacket, which, with Umberto and Svetlana inside, travels to the side of the stage. Meanwhile, Nikos and Luminitza embrace and then run to the bed, but fall to the floor before they can climb onto it. They struggle to their feet as Umberto and Svetlana peek out over the top edge of the straitjacket. To loud, dissonant music, all begin to sing in atonal style: "You made me loooove you . . . You made me loove you!"

The Mountain People enter with large white balls in their hands and parade ceremoniously across the stage. A ball is given to each of the four principal actors. Each then climbs to the top of one of the ladders leading up to the second level of curtains, and each places first one ball and then another into baskets visible at the top of the ladders. The dissonant singing continues as more balls are passed on, one by one, until the baskets are full.

The Mountain People exit and the main actors come down from the ladders. The loud music continues as Nikos again seizes his red banner and marches across the stage. With each footstep, a crash is heard. All fall to the floor as the music stops.

Svetlana rises and examines Nikos.)

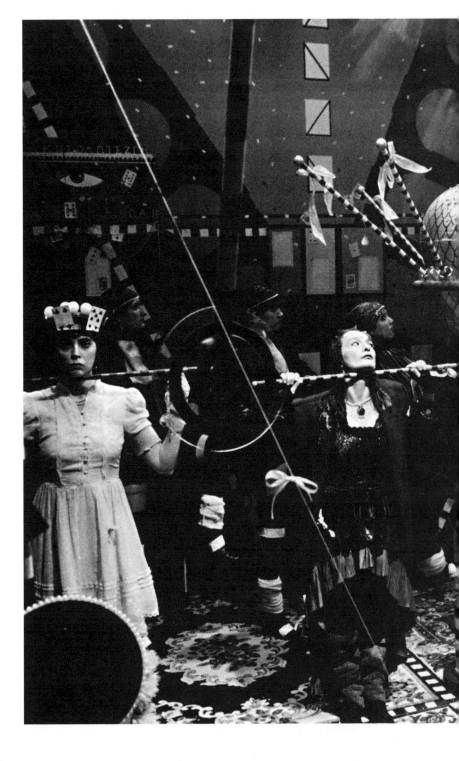

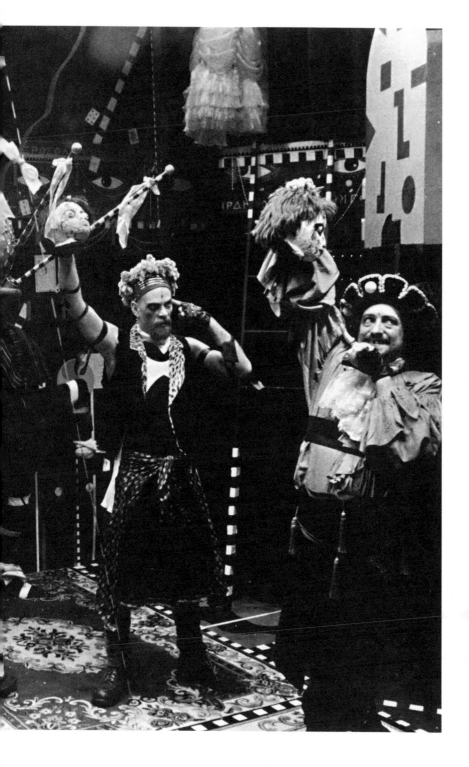

DEEP BASS VOICE:
You have a life.

(Pause.)

You have to do something with that life.

CHORUS *(In deep bass, as the others rise slowly)*:
You have to do something with that life.

(Umberto and Luminitza cover their eyes as Nikos seizes his rope and starts to climb the mountain.)

SLURRED VOICE:
Look! Here comes the Old Man of the Mountains.
It's the Old Man of the Mountains.

(The face of the Old Man of the Mountains appears suddenly in the sky. Nikos loses his footing and crashes to the floor.)

CHORUS *(In deep bass)*:
This is not required, fall down.
This is not required, fall down.

(Once more, Nikos struggles to his feet and begins to climb the mountain. The others count each of his steps in a foreign language. Far in the distance, a toy piano is heard playing a childish tune.

Nikos finds four caveman-style clubs at the top of the mountain. He throws three of them to the ground, where they land with a crash. The others each pick up a club, and then, following Nikos's lead, all begin wildly beating their clubs against various portions of the scenery. Nikos comes down from the mountaintop, takes a club from Umberto, and beats the cabinet with two clubs at once. Luminitza takes a club from Svetlana and, holding a club in each hand, extends her arms and starts slowly rotating the clubs. The others stop and look at her.)

LUMINITZA *(Under her breath)*: Watch this, you bastards.

(Nikos gives a club back to Umberto, and they both turn on Luminitza and begin beating her savagely with their clubs.)

SLURRED VOICE:
Not yet.
Not yet.

(Svetlana returns to the stage holding a white beam against her shoulders, like the horizontal part of a wooden cross. Behind her, three large white shapes resembling the German military cross are carried by Mountain People who make them gyrate slowly in front of the mountains. Luminitza takes her two clubs and places one upright on each side of Svetlana's white beam. In silence, Luminitza dances slowly and sensuously around Svetlana. Then she circles up to dance in front of the gyrating iron crosses. She stops and comes down to look at the grinning Umberto.)

UMBERTO *(After a pause)*: Let's all join— *(He stops. He doesn't finish)*

(Piano music begins to play—a fragment of a Bach prelude. Luminitza and Umberto watch the iron crosses gyrate. Luminitza whispers to Umberto, then goes and thrusts her arm inside the window in the rolling cabinet in search of something. Umberto thinks for a moment, then pulls her away and thrusts his own arm inside. She pulls him away, muttering, "Stop that, you bastard," and a bundle of multicolored sticks are dropped from the mountains onto the stage floor.)

Touché!

(A Mountain Man appears with an oversized flower pot filled with topsoil, out of which rises a six-foot-tall stick topped by a faceted golden ball. There are small holes in this ball. As the Bach prelude increases in volume, the two women pick up the colored sticks and fit them into these holes, creating a colorful abstract tree. As they are doing this, the chorus line of Mountain People drifts by upstage. Nikos and Umberto double over with laughter at the sight of the developing tree.)

SLURRED VOICE:
Take off the blinders.
Take off the blinders.
Take off the blinders.

(As the music fades, a telephone rings in the distance. Nikos and Umberto approach Luminitza and Svetlana, making sexual overtures, but the women hit them in reply and begin cursing in foreign languages. The men exit. Luminitza stares at Svetlana for a long time, then turns with contempt and slowly walks offstage. Svetlana takes a stick out of the tree and approaches the audience. Then a crash scares her. She hurriedly puts back the stick.)

SVETLANA: Careful. Careful. Catastrophe is just around the corner.

(She puts her hands over her eyes and begins to hum a folk song to herself. Nikos, Umberto and Luminitza return carrying a white tube that could be a cannon. A Mountain Man hands large white balls to Nikos, who loads the cannon with them. Once the cannon is armed, it turns until it is pointed at Svetlana, revealing a stylized scrotum at the far end of the tube, turning it into a veritable penis cannon. As music builds, Svetlana goes to the cannon and removes one of the balls, which she holds up in the air, whispering: "This is my ticket to a better world." The group charges at Svetlana with the cannon, but she ducks out of the way. As others spin the cabinet, she opens the door. Nikos charges again and ends up—with his cannon—inside the cabinet. The others come and try to peek in the windows.)

NIKOS *(Shouting from inside the cabinet)*: Nobody home! *(Pause)* Nobody home! *(Thrusts his arm out the window, holding a decapitated head)*

DEEP BASS VOICE:
Never show true feelings to people hungry for mutual affectionate behavior.

UMBERTO *(Examining the head)*: Touché!

(He grabs it away and holds it up by the hair. Nikos exits the cabinet holding a second head as the Mountain People, with their arms linked, drift by in the rear.
 Pointing to the head:)

Riding cockhorses . . .
The man of my dreams—he tumbles and then he tosses.

DEEP BASS VOICE:
 When the big ones tumble,
 Small ones always benefit.

(Nikos and Umberto touch the heads to different parts of their bodies. Then they let go and the heads fall to the ground with a crash.)

HIGH-PITCHED VOICE:
 When the big ones tumble,
 Small ones always benefit.

(Luminitza and Svetlana lift up the heads as two Mountain People enter, each with a magic box balanced on his head. The two women place the heads inside the boxes. Then, in a ritual gesture, the four main characters place their hands against mystical signs painted on the front sides of the boxes. After a pause, they remove their hands and point their fingers at each other's foreheads. Then, forming two couples, they interlock forearms and again point to each other's foreheads. This is repeated a second time.)

DEEP BASS VOICE:
 Those who sink
 Try to walk on water.

(The Mountain People run offstage as Nikos and Umberto march toward the mountains, each footstep causing a crash. They each seize a mountain rope and pose at the bottom of the two mountains.)

UMBERTO: Let's all join—

(A ping is heard.)

—the misfit club!

(Umberto and Nikos each climb one of the two mountains in silence. Luminitza and Svetlana strike different poses with sticks from the abstract tree. They hold the sticks high in the air as they simultaneously chant a phrase in a foreign language. This is followed by a crash. At the third repetition of this, the music of Bach returns and the Mountain People return to help the two men off the mountain.
As they reach the floor there is another crash and a porcelain doll suddenly falls from the ceiling. It is suspended upside down over the abstract tree, where it bounces up and down in the air.)

DEEP BASS VOICE:
Those who sink, try to walk on water.
Those who sink.
Those who sink.
Those.

(Nikos gets the tube cannon from inside the cabinet, and the others line up behind him, holding his hips as they march to the rear. Then they pair up to take colored sticks from the golden tree, and with a stick in each hand they march across the stage to grotesque music.)

Never show true feelings to people hungry for mutual affectionate behavior.

(The Mountain People bring on white screens to form a low white wall below the mountains, as Svetlana tries to hide behind the golden tree. Umberto approaches her and touches her belly with his stick, wiggling it up and down teasingly.)

Nobody can be somebody's spiritual helpmate.

(Luminitza spanks Nikos with her stick and he falls. As he rises, she runs to a ladder. Buzzers are heard. As Nikos approaches the ladder, Luminitza jumps on his back, and he slowly carries her across the stage.)

NIKOS *(Speaking laboriously)*: The way I walk . . .

DEEP BASS VOICE:
Here's my main circulatory system. Your choice.

NIKOS: The way I—talk—

(Luminitza falls off his back with a crash, and a few seconds later Nikos also collapses to the floor.)

(Getting halfway up again) The way I—

(He collapses again, as Luminitza takes a stick and stabs herself in the stomach. Nikos rises, seeing this, laughing.)

DEEP BASS VOICE:
Nobody can be somebody's spiritual helpmate.

(They each take a stick and begin stabbing themselves as if it were a sensual turn-on—screaming in pain, but with shining eyes. The Mountain People run on with jeweled goblets and rags to collect the blood ostensibly oozing from their wounds. Nikos grabs one of the goblets and drinks deeply.)

SLURRED VOICE:
Not yet.
Not yet.

(All but Luminitza run offstage, stabbing themselves and smiling madly. Luminitza frowns and points to her forehead, muttering to herself. Then she opens the cabinet and goes inside, closing the door forcibly behind her. A moment later she reemerges onstage, covering her eyes. There is a bright light coming from the top of the mountain and she turns slowly to face it as the others creep on to watch.)

DEEP BASS VOICE *(Beginning softly, and getting louder and louder)*:
I was around, I was around, I was around, I was around!

*(Luminitza has taken her hands from her eyes, and the combined
force of the light and Voice throws her to the ground. She struggles
to her feet, goes to the bull's-eye and covers her eyes.)*

LUMINITZA: You see . . . *(Starts to laugh at the others, who are making
faint hissing noises and wiggling their fingers at her)* Right! You
see—NOTHING!

*(She runs into the cabinet again and the others creep forward to
look inside, but she immediately reemerges.)*

DEEP BASS VOICE:
These I worship, through increasing distance.
So—hold on.

UMBERTO *(As all others run off)*: Let's all—let's all—let's all join—

(A pause, then a ping, as a striped screen is carried on.)

—the misfit club.

*(Luminitza runs on and puts a hand on the screen as Umberto
runs off.)*

LUMINITZA *(Looking back at the audience over her shoulder)*: There
was an old man—

DEEP BASS VOICE:
Only my enemies convince me the world is real.
Only my enemies convince me the world is real.
Only my enemies convince me the world is real.

*(Luminitza runs back into the cabinet as Nikos marches across the
stage carrying his red banner. He stops, approaches the cabinet,
and slowly rotates it.)*

NIKOS: Come out. Come out. Wherever you are. *(There is a twitching
horse's tail on the back of the cabinet)* I'm looking for your pretty

tail. *(Squats below the tail and lets it brush his face as he rubs between his legs)*

CHORUS *(In deep bass)*:
Here is a horse for eternal frustration.

(A wolf can be heard howling as Umberto and Svetlana peek in to see what Nikos is doing.)

DEEP BASS VOICE:
Don't look a gift horse in the mouth.
Unless, you desire horse kisses.

SVETLANA: Umberto has a pretty hat. *(Steals Umberto's sword and holds it above Nikos)* Nikos has a big muscle. But what I prefer—is muscles.

SLURRED VOICE:
We are here, now, inside the behavioral center.

(Svetlana licks the sword blade, but Nikos jumps up and takes it away from her. Nikos and Umberto go off to sniff at the sword as Svetlana turns the cabinet to reveal the side with the door.)

SVETLANA: Let's see if my girlfriend, Luminitza, is waiting for me.

(Luminitza marches out of the cabinet with a horse's tail attached to her rear end and wearing an ancient Roman–style helmet. She holds a scepter and beats out a rhythm to which the others all march across the stage as she counts out the steps in a foreign language. The Old Man of the Mountains appears in the sky and all but Luminitza and Nikos run off. Luminitza shakes her hips and sings a curse in her foreign language.)

DEEP BASS VOICE:
Look, here comes the Old Man of the Mountains.
It's the Old Man of the Mountains.

(Nikos collapses to the floor. The Mountain People return carrying panels with blackboard surfaces divided into squares, within which are written random white letters—one to each square. Luminitza stands astride Nikos, moving her hips and flicking her tail across his face as she mutters curses.)

CHORUS *(In deep bass)*:
Here is a horse for eternal frustration.

DEEP BASS VOICE:
Here is a horse for eternal frustration.

LUMINITZA *(Stepping off Nikos)*: OK! What kind of animal stands on two feet?

(She covers her eyes and hisses: "Yeah!" Then she uncovers her eyes and repeats: "Yeah!")

NIKOS *(Coming downstage and singing at the top of his lungs)*: It's not fair!

(All the others approach the blackboards and face them, with their backs to the audience. They lift the blackboards into the air. Nikos hesitates, again sings: "It's not fair," and then joins them and lifts a blackboard.)

SLURRED VOICE:
Follow the instructions you hear coming over the loudspeaker, please.

(The four of them drop the blackboards and step back from them, backing up downstage, where they collapse to the floor. They rise up slightly, staring at the letters on the blackboards.)

DEEP BASS VOICE:
You too can shipwreck on golden wreaths.

(Nikos and Umberto creep to the blackboards and slowly point out letters spelling their respective names.)

NIKOS: N-I-K—Nikos.
UMBERTO *(Overlapping)*: U-M-B—Umberto.

(They rise and come downstage. Nikos points to Umberto and intones: "Nikos." Umberto points to Nikos and starts to intone: "Niko—" but before he can finish, Nikos raises his fists and Umberto jumps back in fear. Then Nikos relaxes and they hug each other.)

CHORUS *(In deep bass)*:
　　Why do I choose this destiny, when I already love myself?

SLURRED VOICE:
　　Careful. Careful.
　　Here comes the Old Man of the Mountains.

HIGH-PITCHED VOICE:
　　Nothing changes.
　　Nothing changes.

(Nikos and Umberto take the blackboards and climb the ladders at the sides of the stage, placing the blackboards behind the blue curtains, as the women pray.)

UMBERTO AND NIKOS: Oh! I'm so tired!

CHORUS *(In deep bass)*:
　　I need tools to accomplish redundant behavior, please.

DEEP BASS VOICE:
　　I need tools to accomplish redundant behavior, please.

(The Mountain People enter with more white balls, which they hand to Nikos and Umberto, who place them in the baskets at the top of the stairs. Buzzers are heard as more Mountain People

arrive with large white screens, which sway to the music. Another pushes a large, rolling phallic stone, six feet tall and covered with flowers, upstage center. Many screens, most white and some striped, rock back and forth to the music as all sing dissonantly. Luminitza moves the cabinet to center stage and opens the doors. Svetlana goes into the cabinet and Luminitza closes the doors on her, but Svetlana opens them. They are closed, they open; they are closed, they open. Then Svetlana steps forward and she and Luminitza, face-to-face, gently press the palms of their hands together.

As the screens drift offstage:)

CHORUS *(In deep bass)*:
Building an entire world from memory.

LUMINITZA *(As Svetlana creeps around the cabinet)*: She dreamt she saw a giant bird, it was a cherry pie.

NIKOS AND UMBERTO *(Whispering, from the ladders)*: Nighty-night, sweet ladies.

(Svetlana pushes the cabinet to the side, revealing the phallic stone which is covered with flowers and has several open books strapped on to it.)

LUMINITZA *(After gently touching the phallus)*: She thought she was a walking stick— *(Presses her nose closed and speaks nasally)* but it was a bloody nose.

(Svetlana rolls on the floor, giggling and kicking her feet in the air.)

(Singing, with her nose still closed) She thought she saw a walking stick.

UMBERTO: Touché!

NIKOS: Please don't bite.

LUMINITZA *(Pointing to Nikos as the Bach prelude plays again)*: Yahhhh! Yahhh! *(Listens to the music. Her mood changes and she shouts out)* OK, boys! Come on down!

(She enters the cabinet, and Svetlana follows her into it. The two men on the ladders reach inside the curtains and pull out two

large stuffed bundles which they throw down to the floor with a crash. Then they climb down the ladders as more bundles are carried onstage, which they seize and throw to the floor.)

DEEP BASS VOICE:

Why do I choose this destiny when I already love myself?

(The music changes, and the women exit from the cabinet and throw confetti at the men. The men are taking the bundles and stuffing them into the cabinet, closing the door tightly as the giggling women leave the stage. Mountain people enter carrying bright floral-print skirts, with which they dress Umberto and Nikos.)

SLURRED VOICE:

We are here now inside the behavioral center.

(Umberto and Nikos whirl about the stage in their new skirts. The music rises and a telephone rings.)

DEEP BASS VOICE:

This is my private collection of lost ideas. And the whole world feeds itself with my vanity, OK?

(Two Mountain People carry on miniature houses, each on top of a six-foot-long pole. One house is painted white and the other is a glorious gingerbread house with ice-cream cones for chimneys. The music turns soft and the two men nervously approach the two houses, looking inside the little windows. Then Umberto backs away and turns toward the audience.)

UMBERTO: Hmmmmm. Let's all join . . .

(A ping—then silence.)

DEEP BASS VOICE:

Let's not stop here because our mental baggage isn't full.

(Music rises again as Svetlana and Luminitza go to Umberto and Nikos. They lift the men's skirts from behind and, one after the

other, thrust their hips forward against the men's asses. Both men give a little "Ow!" of surprise or pain.)

SLURRED VOICE:
>Not yet!
>Not yet!

(Nikos and Umberto turn to the women, slowly put their hands over the women's crotches, and, one after the other, suddenly pull hard, causing Svetlana and Luminitza to double over in pain.)

DEEP BASS VOICE:
>Unless this house tumbles—
>Then I can choose my own private direction.

(Nikos and Umberto take pages from a book strapped to the phallus. They read to themselves and laugh. The women grab the pages from them and begin to read.)

LUMINITZA *(Reading from the page)*: "Even while Martin was talking to her—"

(The two men come over, and each looks at a page over one woman's shoulder.)

"—he already had her in his bed, her legs spread apart . . ."
SVETLANA *(Softly)*: Me, too.

(The men cover the women's eyes from behind. The women tear the pages to bits and let them flutter to the floor—and the men immediately drop to the floor, trying to fit the pieces together. The women climb on the men's backs as if to ride them, but after spanking the men once they immediately jump off.)

DEEP BASS VOICE:
>Let's not stop here because our mental baggage is not full.

LUMINITZA *(As if counting petals on a daisy)*: She loves me. She loves me not. She loves me, she loves me not.

SVETLANA *(Overlapping)*: She loves me, she loves me not. She loves me . . . She loves me not.

(The telephone rings, and the two women each grab a knife with which they slice their male companions once across the back. The men cry out in pain and collapse again to the floor. The women take the ice-cream cone chimneys from the house and begin licking the ice cream.)

DEEP BASS VOICE:
Unless this house tumbles, then I can choose my own private destination.

LUMINITZA: Sugar and spice. *(The two women look at each other and intone a soft "Yahhh")* Everything nice.

DEEP BASS VOICE:
Have I ever not fooled myself on purpose in order to maintain mental health?

SVETLANA *(Sings, as she pulls taut a string from one of the little houses)*: Where are you?
LUMINITZA *(Licking two cones at once)*: What I say is—

(The men are rising from the floor and laughing, as she sings:)

Right! Here! Now!
NIKOS *(Laughing and mockingly imitating Luminitza)*: "What I say is—Right here, now! Right here, now!" Right over here, lady!
SVETLANA *(Singing)*: Where are you?

(Svetlana drops her ice cream with a crash. Nikos ducks under what has become a network of taut string running from the little houses, picks up the dropped ice-cream cone and starts to lick it.)

UMBERTO: Dirty, dirty!
NIKOS: OK by me. Lickin' up leftovers.

(Umberto grabs the ice cream from Nikos and starts licking it himself.)

LUMINITZA: Dirty, dirty boys. Dirty— *(Begins singing; Svetlana joins in)* —but I don't care. I don't care. I don't care!

(They slowly turn to Nikos, who has positioned himself so that a string seems to cut his neck, separating his head from his body. He slides along the string as they again sing: "I don't care.")

DEEP BASS VOICE:
 Thank God I found my ticket home.

(Umberto takes off Nikos's hat and wig, revealing a bald Nikos, who is then wrapped in the string running from one of the small houses.)

Let's not stop here because our mental baggage is not full.

(Nikos reaches into the gingerbread house and pulls out a mop of red hair. He looks at it, then throws it to the floor with a crash. Then, as romantic Italian singing is heard, he picks up the hair, puts it on his head and dances slowly over to Svetlana. She touches his hair, which he takes off and studies, then she offers him ice cream, which he pushes out of the way. He slowly places the mop of hair over her crotch, then bends down to languorously lick the hair between Svetlana's legs, rather than the ice cream.)

SLURRED VOICE:
 Not yet!
 Not yet!

(Umberto dances over to look under Luminitza's skirt, but she slaps his hand away, which stops the music. Umberto then goes to Svetlana, and they both raise their ice-cream cones high in the air. The Mountain People carry in a massive, six-foot-tall wedding cake. As the two couples run to the cake and circle it, a howling wolf is heard, accompanied by a Deep Bass Voice repeating: "I was around, I was around, I was around!"

A giant head with bulging eyes and a headdress of skulls appears in the shadows at the rear.)

DEEP BASS VOICE:
> That thing, entering the room, I forget what to name it, but
> I better think fast.

(The Old Man of the Mountains appears again in the sky. The stage is awhirl with activity, as white screens are carried on to completely transform one side of the stage. The head vanishes. Nikos is left alone.)

> Not yet.

(Nikos waits for a moment, then throws himself against a white screen, accompanied by a loud crash. He staggers offstage.)

SLURRED VOICE:
> This play . . .
> This play is the sacred text of a forgotten people.

(Nikos returns carrying the giant wedding cake. He staggers around the stage and re-exits.)

> Everything is inside it.
> Therefore, protect yourself by wearing the transparent blinders
> with which you have been provided.
> Oh! Forgive me! I see you're already wearing them.

(A small golden throne has come down from above, carrying a bright blue baby god wearing a golden crown, who stands with legs apart on the seat of the throne. At the same time, Umberto has come onstage with one of the biscuit platters. Then, in silence, Luminitza returns holding two large white balls connected to each other with a white hose. She drops one ball at a time and each hits the floor with a great crash as Nikos runs in carrying a club. He studies Luminitza. Svetlana creeps up behind him, and he turns to look at her.)

UMBERTO: Let's all join—

(A pause, then a ping.)

—the misfit club.

(Svetlana wipes her hands across Nikos's back, and he falls to the floor with a crash. A six-foot-tall white "X" appears in the rear, as two striped screens with baby heads peering over the top edge are run across the stage by Mountain People.
As the Bach prelude plays:)

DEEP BASS VOICE:
Jesus! If I knew then what I know now, I'd be really aberrant.

(A six-foot-tall "X" made of two giant breadsticks comes waddling slowly onstage to end up in front of the white "X." The breadstick "X" has a skull with red hair at its center, with tubes running from the skull to two tiny skulls at the top ends of the two breadsticks. This ludicrous, yet frightening, "breadstick man" starts rocking back and forth in place.)

That thing, entering the room, I forgot what to name it, but
I better think fast.

(Nikos rises and attacks the breadstick man with his club. Nikos falls to the ground after each hit—but gets up and hits at it again. The Bach prelude gets louder and louder.)

That thing, entering the room, I forgot what to name it, but
I better think fast.

(Over the music a Voice screams: "Right, right, right!!" The others climb the ladders and hold out their hands to focus all energy and attention upon the tableau of Nikos trying to hit the breadstick man with his club.
The lights slowly fade to black.)

THE END

King Cowboy Rufus
Rules the Universe!

PRODUCTION HISTORY

King Cowboy Rufus Rules the Universe! Produced by the Ontological-Hysteric Theater at the Ontological at St. Mark's Theater, New York City. January–April 2004. Written, directed and designed by Richard Foreman.

RUFUS	Jay Smith
BARON DEVOTO	T. Ryder Smith
SUZIE	Juliana Francis Kelly
CREW	Michelle Diaz, Tommy Smith, Joel Israel, Betsy Ware, Suzi Takahashi, Shauna Kelly, Brenda Hattingh

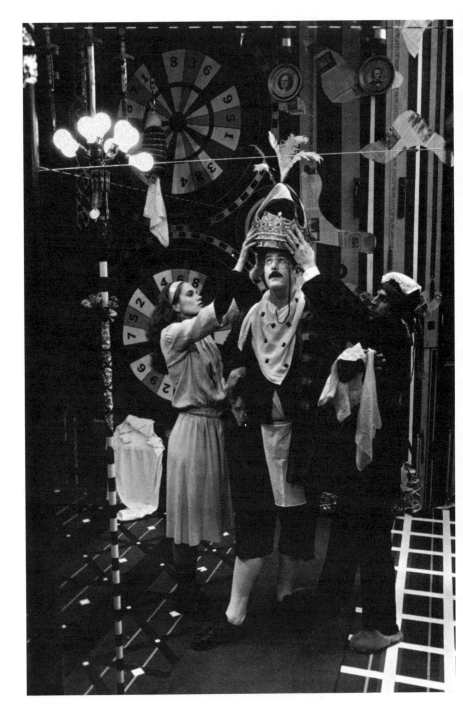

A large room in a restaurant, but with very few tables. Several tall Renaissance-style portraits in heavy gilded frames hang on the walls. A noose of worn rope hangs down from the ceiling in front of each painting. The walls themselves are covered in striped wallpaper and decorated with checkerboards, displayed at an oblique angle and lined up one next to the other to produce several vertical columns of diamond-shaped checkerboards. There is a large bank of fluorescent lights hanging from one part of the ceiling. The floor is painted with white crisscrossing lines and the whole room vibrates with additional bric-a-brac attached to the walls—including tiny flags from different nations and strange, thin, amoeba-like cutout strips of newspaper glued to the walls—as well as the names of American presidents painted on the top edges of the walls in small gold letters.

On one side of the stage, large letters in script spell out LA MAISON ROUGE.

At the front of the stage are thin poles with branching, multiple-bulb light fixtures on top. A few more of these light poles are distributed throughout the first rows of the audience. In addition, a narrow red carpet runs from the back of the stage out into the first few rows of the audience, where arches form a kind of metal cage.

Often, when King Cowboy Rufus advances out into the audience inside this cage, the light poles in the audience become brightly illuminated—but they also turn on at less appropriate moments.

There is music of different styles and periods throughout the play (even more than is indicated in the text), and a high "ping" and a four-note chime tune/punctuate the dialogue at appropriate moments— either mocking what has been said or stopping the action for a moment's reflection.

But now, as the play begins, accordion polka music fills the room.

The Baron Herman DeVoto stands alone on the stage, staring at the audience. He wears a threadbare suit. His chest is covered by a small wooden panel suspended from his neck, upon which are displayed old military medals. He wears an unconvincing black wig, and resting on top of that is a pearl-decorated napkin, making him resemble certain official photographs of Queen Victoria. On his feet he wears oversized, furry pink slippers.

He stands frozen, and then, suddenly, he slaps himself in the face. There is a loud crash and the music lowers. Throughout the play he speaks in a quiet growl, like a nineteenth-century American ruffian.

BARON: You can't know the answer to this riddle.

(He waits, then slaps himself again. There is a crash as the music stops.)

Come to think of it—

(He looks to the side of the stage and watches as Suzie appears and walks slowly to the center of the room. She is a beautiful English coquette, wearing a stylish 1930s cream-colored dress. She speaks with an English accent.)

SUZIE *(Speaking quietly and deliberately)*: My name is Suzie. Remember that name.

BARON *(Staggering upstage)*: I don't even know how to properly formulate this riddle.

HELP ME!
HELP ME!

(Music again rises—someone singing wistfully: "Never again, oh never again." A cigarette girl in a sexy black waitress costume

enters holding a cigarette tray, from which the Baron takes a cigarette. Suzie puts on a blindfold.)

SUZIE: I'm ready.

(The Baron puts the cigarette into Suzie's mouth as the cigarette girl points to a nearby target. The Baron takes a knife and prepares to throw it to displace the cigarette that dangles from Suzie's lip. Then he stops.)

BARON: You know what? The truth is always best. I'm so sorry, my elegant little cigarette girl coquette—but due to economic instability, I suppose—I, Baron Herman DeVoto, I am forced to close my cigarette factory.

(Bright lights switch on, and they are startled.)

You can't see it, of course—because like everybody else, I have my secrets. But you can still smell it. It stinks. It STINKS!

SUZIE *(Still blindfolded)*: Yes. It stinks. But you owe me my wages, Mr. Baron-bastard-whatever-you-call-yourself.

BARON: OK. Maybe you'll have to sing for your supper.

SUZIE: Oh my God—what can I sing?

BARON: Something to cheer us up, obviously.

SUZIE *(Considers, then sings softly)*: Oh—I know—"Mr. Red Red Robin—"

BARON: Ah, that's very uplifting.

SUZIE: "—Comes bob bob bobbin' a—" *(Departs from the real song and sings)* Wake up, wake up, wake up—wake up! *(Removes her blindfold and the "Never again" music stops)*

BARON: I get the picture . . . *(A crash)* During these dark days certain trashy and degenerate people compensate by indulging in certain unhealthy pastimes.

SUZIE: And how is an independent coquette—

(The lights switch suddenly. They look about, nervously but slowly.)

BARON *(Frowning)*: I'm independent, you're independent—so what?

SUZIE: —expected to feed herself—with no gainful employment?

BARON: Remember certain lifesaving truths please.

(In the dark shadows at the rear of the stage, King Cowboy Rufus slowly sneaks onstage. He wears a big ten-gallon hat, a bandanna around his neck and a silver six-shooter strapped about his waist. But, incongruously, he also wears an eighteenth-century frock coat and breeches with white kneesocks and sports a monocle. A lace handkerchief dangles from one hand. His face is powdered white, with one or two prominent beauty marks, and there is light rouge on his cheeks and lips. The others do not yet see him.)

Your close friend—Imitation King Rufus—Imitation Cowboy—

SUZIE: Who?

BARON: Imitation King Rufus Cowboy.

(He has now crept downstage, and they see him, but try not to react. There is a pause.)

SUZIE: I've heard of him—

(The lights, including the light poles in the audience, suddenly snap to bright. Suzie slowly places the blindfold over her eyes, and Rufus, squinting into the light, extracts his gun and slowly lifts it until it points at the rear of the audience. They hold this pose.)

DEEP VOICE: Wake up! *(Pause)* Wake up!

(With an electrical zap, the lights pulsate and Rufus whirls, upset, waving his gun in the air.)

RUFUS: Everybody—out of my way! *(Shooting wildly and noisily in all directions, he runs from the room)*

BARON *(With quiet disgust)*: Thank God I am closing down my dilapidated, stinking tobacco factory—stuffed full of coquettes and whores.

(A bright light makes the Baron shield his eyes with a groan of disgust, and others in black eye masks enter the room and begin to dance.)

I've had enough of this shit world in which I find myself. *(The Baron pushes his way through the dancers and out of the room)* OUT OF MY WAY!!! Whores! . . . Coquettes!

(Rufus runs into the room, shooting his gun in all directions. The music quiets and he points his gun at the now frozen dancers. He speaks with a quiet sneer, in an upper-class English accent.)

RUFUS: Surprise. It's not who you expected. Here I am—the real Rufus. Can you believe it?

(Suzie advances and presses her chest against his extended revolver.)

SUZIE: Are you really an American cowboy hero? Or rather—an old-fashioned English fop harboring impossible dreams of glory?
RUFUS: How dare you ask such an insulting and humiliating question? *(Steps back and fires one shot at the ceiling)*
SUZIE: He shot a powerful bullet . . . into the clear blue sky.

(The others have exited, and Rufus elegantly takes Suzie's hand and begins to count at a stately pace.)

RUFUS: One, two, three, four, five . . .

(A pause. Then, as if on cue, they both run out of the room. There is a pause, then Suzie peeks into the room, and from the other side Rufus peeks in. He waits for a moment, then tiptoes along the wall in her direction.)

SUZIE: Oh, sweet Jesus on tippy-toes!
RUFUS *(After she steps forward shyly to take his hand)*: I wish—I wish I were a real American hero, with the potential, therefore—

(A large, bulldog-like, mustachioed female maître d' in a pin-striped suit and fez sneaks up behind Rufus carrying a crown on a velvet pillow. He turns and sees it. Considers it. He takes off his hat and hands it to Suzie, revealing a wig cap underneath. Then he puts the pillow and crown slowly onto his own head.)

Why the hell not?

(He crouches and moves to the other side of the room, showing off his crown. A Voice sings a repeated phrase from an old jazz recording: "Gimme some of that good tutti-frutti.")

Look at that. Balances perfectly, am I right?

(He whirls and sees that two sexy waitresses have entered with another crown hanging from a tall pole.)

Oh my God—gimme, gimme, gimme that one.

(They drop the new crown onto his head.)

Bravo!

(Behind him the Baron enters escorted by two ruffians in kilts and cowboy hats, who carry a truly giant crown on a large velvet pillow.)

BARON: Look at this one here.
RUFUS: Where?
BARON: Over here. It's bigger. It's better.

(The lights change with an electrical zap, and Rufus whirls and sees the giant crown.)

RUFUS: Oh my God—it's worth the humiliation—down on your hands and knees, Rufus.

(He goes down on his hands and knees and they place the big crown over his head. It has a cloth top with plumes attached. The entire apparatus is so big it rests on his shoulders and his head sticks up into the sack supporting the plumes. His head is totally obscured, as if he were wearing a hood. He crawls across the room.)

Oh, this feels surprisingly bad! My knees hurt—the floor is dirty. Somebody help me to my feet? OK. I can do it by myself.

(He rises unsteadily, inside his crown and hood. The others form a ceremonial line behind him, arms linked, as a German song is heard softly.)

BARON: Congratulations. To commemorate this important occasion— what do we do? How about a wonderful English poem?

(He begins to recite a variation on Lewis Carroll's "The Walrus and the Carpenter":)

> The time has come, the cowboy said,
> To talk of many things.
> Of shoes and ships and sealing wax,
> —And beautiful coquettes like that lady holding that cowboy
> hat,

SUZIE *(Lifting the hat)*: That's me.
BARON: And even old-fashioned kings.
DEEP VOICE: He is in competition with Life.

BARON *(Continuing, as music plays underneath and the others dance in line, with slow kicks first to the left and then to the right)*:
> The sun was shining on the sea.
> Shining with all its might.
> He did his very best to make
> A mighty cowboy
> —Strong as a bull and always in the right.

RUFUS *(Overlapping, under his hood, reaching out toward additional imaginary crowns)*: Mine!—I must possess every last instrument of my expanding power.

(Another removes his crown and carries it upstage, lifted high, as Rufus, the Baron and Suzie join hands and look upstage at the crown.)

DEEP VOICE: The real avoidance mechanism, the power of decision.

(A shot rings out, and the three look back over their shoulders at the audience in fear.)

Hero or Devil?

(They again join hands, facing forward. Rufus clears his throat, preparing to sing. He vocalizes: "Mi-mi-mi . . .")

RUFUS *(Sings)*:
 Dead . . .
 Dead . . .
 Dead . . .

DEEP VOICE *(Overlapping)*: You are now crowned King Cowboy Rufus, with the task of discovering the full meaning of such king-ness, and such cowboy-ness.

(Rufus's last sung "Dead" is interrupted as Rufus falls prey to a fit of coughing, which makes the others drop his hand. He shame-facedly apologizes—"Sorry"—and waits for them to reluctantly take his hand again. Now they sing in unison:)

RUFUS, SUZIE AND BARON:
 Dead people—

(They suddenly pull apart, as if they have each heard a shot the others did not hear. Then Rufus reaches out, and very reluctantly the others take his hands again.)

(Singing, but limited to just two notes)
 —Are never allowed in the same space
 As living people.

(A jeweled, golden Fabergé egg is carried among them.)

SUZIE *(Sings)*: That's why dead people never talk to living people.

BARON *(Sings)*:

> But now, dead people
> Are talking to people who walk, talk
> And say to themselves
> —Is this part of the life's beneficent bargain basement?

> *(He grabs the valuable egg and creeps away with it, counting his steps to safety.)*

> Oh my God—one, two, three, four . . .

RUFUS: Put that back, Baron!

BARON: I'll put it back when I'm damn well ready to put it back.

RUFUS: Oh?

BARON *(Mockingly imitating Rufus's affected upper-class accent)*: "Ohh!"

> *(As a pure tone rises, the Baron slowly offers the egg to Rufus, who waits, then grabs for it. But the Baron eludes him and runs with it out of the room.)*

RUFUS: Slimy bastard!

> *(A large wooden beam, studded with jewels, has been carried onstage. Rufus turns and sees it and is staggered.)*

> Oh my God—at last, at last, at last!

BARON *(Returning)*: What the hell is the matter with you?

RUFUS: Can't you tell? It's the famous American "beam challenge."

DEEP VOICE: Wake up.

RUFUS *(Crossing to the beam)*: Reserved for that real kind of American tough guy who's willing to risk everything—just for the hell of it. Who'll be the first to join me?

BARON *(Shrugs)*: I'll try anything for a laugh.

RUFUS: Of course—you first, Baron.

> *(They lift the beam and place their heads against its two ends, and as they support it between them, the Baron slowly backs Rufus into the audience. Carnival music rises as they alternately count out their steps.)*

(From the middle of the audience) Oh, shut up, Baron.

BARON: You shut up.

RUFUS: I will NOT shut up—you shut up first!

(There is a loud crash and the music stops. While this has been happening, the waitresses have wrapped Suzie in pink tissue paper.)

SUZIE: This is testing me, too, but since I'm just a girl—it's ordinary tissue paper.

(The music begins again, and Rufus begins backing the Baron onto the stage again, step by step.)

RUFUS: Score this big one for Rufus—and another—and another—

(One of the kilted cowboys takes the beam away from them.)

Oh no—I was on the verge of a triumphant success. Goddamn it to hell and beyond!—But I'll have my revenge. *(Aims his revolver over his shoulder—without looking)* One single bullet. I'm that good a shot. *(He shoots. Nothing happens)* Did I hit something?

SUZIE: Klutzy cowboy.

RUFUS: We'll see who's the klutz in this American cowboy story. *(Shoots again)*

SUZIE *(Screams and slowly falls)*: Oh. What a catastrophe. Covered in dirty tissue paper!

BARON *(Trying to help her up)*: Just like me. Total victim.

SUZIE: Keep your filthy hands away from my beautiful bust-out body. All of you! All of you!

RUFUS: No, no! This cowboy never laid a finger, madam. All those bullets were, in fact, an unavoidable mistake.

BARON: I can believe it.

RUFUS: My true feelings have been totally, totally misrepresented.

SUZIE: Your true feelings?

(With an electric zip, the lights alter radically. Rufus is startled and runs downstage to instruct the audience.)

RUFUS: Rhyme things . . . that do not rhyme. *(Runs back upstage)* You understand—words don't come easily to someone trying to be an all-powerful American cowboy.

SUZIE *(Sings, lifting her hands)*: "Wake up, wake up, wake up!" *(Wanders thoughtfully to center stage)* But of course there's more to it than just that. "Suzie Rufus?" Why do those two names conjugate so perfectly? *(Romantic music rises)* "SUZIE RUFUS!" *(She sings softly, almost to herself:)*

> Call it love, in my heart
> In the secret of my soul.
> I close my eyes.
> I see my love.
> And disappear inside his world—
> I'm hiding, I'm hiding
> My broken heart
> —From everyone.
> I'm smiling now
> I don't know how.

(All the others have gathered onstage in the shadows to hear her very sad song. She goes to them.)

RUFUS: Beautiful coquette, I want to help.

SUZIE *(Turning back to him)*: I hate you, Cowboy Rufus.

RUFUS: Hate me? *(He laughs in denial)*

BARON: She hates you, big guy.

RUFUS: Oh—don't believe that "hate" business for one minute, Baron.

BARON *(Sarcastically)*: Oh no, no, no—not me.

(Rufus puts on his cowboy hat again, pulls out a bundle of cash and takes puffs from a long cigarette holder.)

DEEP VOICE: King Rufus Cowboy—deciding to purchase, with his own private funds, the abandoned tobacco factory—previously owned by the Baron Herman DeVoto, his friend.

(Rufus hands over the cash and signs a document as the other women surround him. In addition to the maître d' and the two sexy

waitresses, there is a thin girl in an old-fashioned, long dress wearing a fez, and a scullery maid with a smudged face wearing a white turban. The Baron is counting the money out loud. The women, all together, cough unhealthily from a puff on their cigarettes.)

RUFUS: OK. One more decaying and decrepit tobacco factory— *(The women wheeze painfully)* —mine for the taking. And I shall then have dalliance with these unhealthy, yet strangely attractive, female employees, whom—I believe—are never disinclined to such "adventurism."

(He sees Suzie appear through curtains on the far side of the stage. Everyone else freezes as she slowly approaches Rufus, then turns her head toward the audience and speaks softly, as if in a trance:)

SUZIE: Remember . . . me?
RUFUS: Hello. Again.

(He bows deeply to her. She takes the cigarette holder from his hand and takes a puff. He looks up, startled, and then bows again. She looks, then deliberately burns the palm of his hand with the cigarette. Eighteenth-century dance music plays as Rufus screams in pain. The Baron, still counting money, complains about Rufus's scream.)

BARON: PLEASE! I'm counting money here—

(He continues counting as the music rises. Rufus recovers his poise, takes Suzie's hand and dances her in a formal circle. Now it's his turn to complain about the Baron's distracting counting.)

RUFUS: Oh shut up, Baron!

(The music cuts off, and Suzie backs away, wiggling a finger to beckon Rufus to follow.)

SUZIE: Coochie, coochie, cowboy?
RUFUS: What? Oh no! This justifiably suspicious cowboy has always looked with rigor—before making his "leap," madam.

(Music again rises, and Suzie circles once and then suddenly throws him a powerful, seductive glance, which makes him collapse in shock, backward into the arms of the other women, as the music changes.)

DEEP VOICE: Stroked by a woman's glance!

(Rufus immediately rights himself, but Suzie thrusts her bust forward and glares at him and he again falls backward.)

Stroked! Stroked!

(He recovers and runs across the stage as the music again changes, now to a soft piano tune. The others have followed him, and they indicate Suzie—as if he'd lost track of her.)

RUFUS *(Laughing at himself)*: It's true, I'm being a big baby. I know, I know. *(Steps forward and bows, again removing his cowboy hat so the wig cap is exposed)* Madam. Greetings to you.

(Suzie takes a slow puff from the cigarette holder, and then, looking him up and down, bursts into laughter. Rufus retreats in shock at her rudeness.)

All I said was—"Hello." I see no reason to laugh at a totally honorable cowboy.
BARON: Don't push it, big guy.
SUZIE: Let me make you cry . . . like a baby.

(She laughs at him and runs to sit at a small table, across from the Baron.)

RUFUS: I've never cried in my life. I'm—a "cowboy."

(An electric zap and a sudden light change make Rufus whirl.)

SUZIE: But I love—baby cowboys.

(She takes three big swigs from a whiskey bottle. Rufus is stunned to see such unexpected behavior from the elegant Suzie.)

RUFUS *(Whispering to the Baron as he sits down next to him)*: Well—good God man—tell me about her!
BARON *(Indicating Suzie)*: This one? Sitting across the table from us?
RUFUS: That's the one.
BARON: Her name is Suzie—and her reputation is her beauty, goddamn it.

(She turns and displays herself.)

RUFUS: I see what you mean.
BARON: Though in reality, she is also sometimes sad. *(He and Rufus look at each other)* Look at her.
RUFUS: I am looking at her. *(But he keeps looking at the Baron)*
BARON *(Taken aback)*: OK. Now look at me.
RUFUS: Why should I look at a little worm like you?
BARON *(As accordion chords are heard in the distance)*: Because—I am, of course, the Baron Herman DeVoto, from the fabled isle of . . . Crete. Which means I too am sometimes sad, of course. And therefore a friend of Suzie's.
RUFUS: What kind of friend?

(He looks suspiciously at the Baron as others creep in to watch. As the music gets louder, Rufus slowly rises, then suddenly lunges at the Baron and starts choking him.)

SUZIE *(Screaming)*: STOP IT! STOP IT!

(The music stops and Rufus releases the Baron, ashamed of his sudden outburst.)

BARON: That was unnecessary.
RUFUS: I know but recently I find myself performing . . . "random acts" that just bounce back and forth inside my head like . . . a ferocious game of cowboy ping-pong.
SUZIE: Stupid cowboy.

RUFUS: Oh, it's a man's game, madam, when played full throttle.

DEEP VOICE: Wake up. Wake up. Wake up.

(As the music rises, the two kilted cowboys run forward and fire pistols at Rufus's feet, making him skip and dance. An aggressive German Voice is heard counting out military marching steps as Rufus stumbles over his own feet and falls to the floor. All but Rufus and the Baron run from the stage. After a pause, Rufus sits up on the floor.)

Do they know who I am, Baron?

BARON *(Thinks for a moment)*: Ladies and gentlemen— *(Begins to drum on the table with his hands)*

RUFUS: Stop that.

BARON: The President . . . of the United . . . States.

RUFUS: Really?

BARON: When I say the President of the United States, what I mean is . . . the President of the United . . . States.

RUFUS: But—is that possible?

DEEP VOICE: If it feels good, don't do it.

BARON: Use your imagination.

RUFUS: But goddamn it, Baron—I have no imagination.

BARON: Tough shit.

RUFUS *(Rising from the floor)*: Something is wrong, Baron. Do you know what's wrong?

BARON: I always know what's wrong.

RUFUS: Good, then tell me.

BARON: No.

RUFUS: No? Oh, please Baron—

BARON: NOOOOOO!

(The maître d' rings a gong. A soprano singing a high note is heard.)

RUFUS *(Rising)*: Then goddamn it to hell, I, Rufus, shall climb those heights from which I shall be able to survey—the entire world— primed and ready to fulfill my every desire. *(Climbing up the aisle into the audience)*

BARON: You do just that and guess what. You'll be eating a mouthful of crow pie!

RUFUS: Crow pie?

(As bouncy organ music rises, the waitresses bounce onstage carrying between them a giant pie with half a dozen black crows sitting on it. They are followed by all the others—all wear black terrorist hoods.)

BARON: Everything comes to those who wait!

RUFUS *(Seeing the pie)*: What the hell?

BARON: Rough, crude, elegant Rufus!

RUFUS *(Running back onstage)*: What have we here? Indeed, lots of crows on a big crow pie. I'll take the big one in the middle.

(He laughs happily as the waitresses dip and exclaim: "Ist good! Ist good. Yah!" A Female Voice sings happily in German as Rufus takes the biggest crow, kisses its beak and holds in it in the air. Others seize the smaller crows and come down to hold them up in the air in front of the audience.)

All cowboys love eating crow pie. *(Stops to think)* Wait a minute. Is that true? Yes they do. But fly away, fly away, fly away home. *(Flies the big crow across the stage and straight into a jewel-bedecked grinder box held by the maître d')* Crash! Boom! Sorry about that—grind it to pieces. Faster! Faster, madam!—grind up that crow, GRIND IT! One-two-three-four-five-six-seven-eight-nine . . .

BARON *(Pouring whiskey into the grinder)*: A little extra flavor—that's all—

(He turns, sees the giant pie placed on the floor behind him, and swoons, falling on top of the pie.)

Oh my God!—

DEEP VOICE: If it feels good, don't do it. Wake up. Wake up.

BARON *(Lying on his back, on the pie)*: Please tell me the poet's cry of anguish is not unheard, when he tearfully demands—

RUFUS: I don't trust poets.

BARON *(Quoting a mangled version of Rilke)*:
Oh—if these very same birds cried out to heaven
Who amongst the host
Of angelic cowboy heroes
Would hear them?

RUFUS: I would hear them. And then— *(Takes out his six-shooter)* I'd shoot them down one by one, with my trusty Mr. Silverado.

BARON: Get me off this crow pie! Help me, help me, help me— *(The waitresses lift him to his feet)* I'm a friend of the birdies. And I'm going to follow those birds in my furry slippers, all the way to my lonely mountaintop—feeding them the same music that goes round and round in the head of the Baron Herman DeVoto—from Crete. *(Turns to an audience member)* You know Crete?—it's a tiny place—far away from this rotten world of cowboys and whores.

(The giant pie has been lifted in the air, and Rufus is hiding behind it.)

Come out from behind that giant pie, King Cowboy Rufus.

RUFUS *(Peeking out)*: I hide behind no pie!

BARON *(As the masked terrorists carry their birds toward the pie)*: Here they come, here come the little cuties—go get him!

(Music rises as the birds attack Rufus, and he pushes through them into the clear.)

DEEP VOICE: What happens to traitors! Tell us—what happens to traitors?

RUFUS: I'm no traitor! And I'll prove it, easily—with my subsequent violent behavior.

(He fires at the birds with his six-shooter. Then, exhausted, he is handed the grinder that contains the big crow. He looks sadly into the grinder.)

Innocent bird. Victimized in this grinder worth—well—hundreds of dollars, I'm sure. It can't be helped.

(There is an electrical zap as the lights change and all whirl, frightened.)

BARON: Hey! Show a little respect for a dead bird.

RUFUS: I always do. I shall therefore—lay you, little birdie, to rest, way up—where? *(Looks out into the audience)*

BARON: Stay away from Crete.

RUFUS: I've got bigger fish to fry—and birdies to grind into mince meat.

(He steps off the stage and begins to climb into the audience, but his first step off the stage seems to send a shock through his body and he pulls back, frightened. A high vocal tone rises:)

Oh my God. Courage. The American kind, my friends—that takes me—higher and higher—straight up towards—

(Still fearful—but courageous—he advances into the audience, then stops. As the tone rises, he is frozen in terror and hisses loudly:)

Help me back onstage, my God help me, help me, help me!

(The others reach out and drag him back onstage. He wipes his brow in relief.)

Ah! Back to the safety of a pretend world, over which I have total control. *(The maître d' takes the grinder from him)* Thank you, madam.

(An invisible force suddenly throws him against the back wall. He is frozen, his face ashen. The others watch him in silence.)

SUZIE: Are you all right?

RUFUS: Yes—I'm fine. *(Pulls away from the wall and shudders once. He seems to recompose himself)* I—King Rufus Cowboy—

(They bow deeply to him. This startles him; he turns to look at them all, suspiciously. Then turns back out to the audience, heroically:)

A man who works—like a horse! And then—sleeps—like a big, fat, dirty log.

(He advances boldly into the audience, counting out his steps as rumba-like music rises:)

One-two-three-four-five-SIX! *(On "six"—the others put up their left hands, with fingers spread, hiding their faces)* Seven-eight-NINE! *(On "nine" the others run from the stage. Rufus surveys the empty stage from his arched perch in the audience)* Look at that, look at them scurry away! I've wiped the stage clean as a cowboy's wooden whistle. *(Turns to make eye contact with the audience around him)* And me—way up here. From the vantage point of honest-to-God, ordinary Human Beings—just like you, and you, and you—and ME! Join me? *(Sings in triumph:)*

> YIP YIP YIP!
> GET ALONG LITTLE DOGIES—
> YIP, YIP, YIP!
> GET ALONG, GET ALO-ONG—

(Runs back onto the stage) Alone on that dangerous stage where I kick up my heels.

> Yippie-ki-o! Woo hoo!!
> Get along little dogies!

(The rest of the cast runs back onstage one by one, each slapping at Rufus's face—like a series of gunshots. He counts as they slap him:)

One dead cowboy—two dead cowboys—three—a big three—four and more—five dead cowboys— *(Now he is irritated at the continuing slaps)* —All right, that's enough. Enough, goddamn it!

(From the ceiling, strange baby bundles slowly descend. The babies hang upside down, wrapped in black cocoons with thin ropes of diamonds winding around each cocoon. Rufus, Suzie and the Baron all see them and are awestruck.)

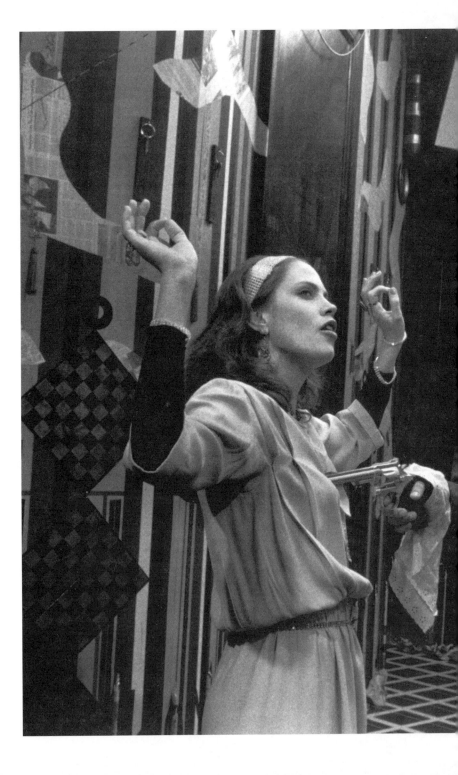

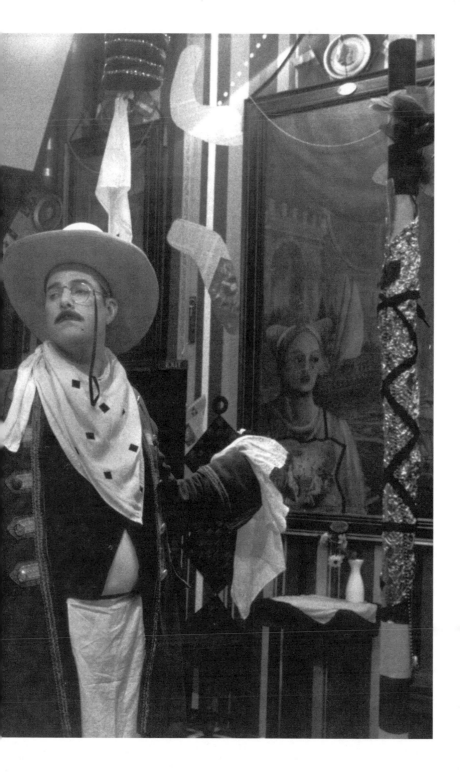

Oh my God! *(Reaches up to touch a baby, then pulls away suddenly)* That damn baby bit my finger!

SUZIE *(Singing, as a panel with targets closes behind them)*: Liar! I don't like liars!

RUFUS: Up yours, with your pretentious coquette behavior, madam.

(The others enter in a conga line, without their hoods, and approach Rufus—the first in line carrying a velvet pillow on which is placed a ceremonial fez. A Voice sings out a marching count, military style, in German, as Rufus puts the fez on his head as if crowning himself.)

SUZIE: Babies don't do such things. LIAR, LIAR, LIAR!

RUFUS *(Raising a finger to instruct the audience)*: "Rhyme things . . . that do not rhyme." Who am I?

BARON: Ladies and gentlemen, here is a man whose deepest wish is to embrace the entire world inside his loving—

RUFUS: Yes, yes, yes—all very nice—but here's something even more important about me—

BARON: More important?

RUFUS *(Glancing up at the babies)*: In spite of some recent bad experiences with relatively young people, I do love tiny little babies—

(An electrical zap, and the lights change. All whirl, startled.)

Which of those little bastards did that? *(The others regard his outburst with shock)* Must I prove my love?

BARON: Use your imagination.

RUFUS: AGAIN?—goddamn it. *(He crosses to one of the suspended babies, holds out his arms to it and sings:)*

Baby face—
You've got the cutest little
Baby face.
I love your tiny little
Baby face.

(As he sings, blindfolds are placed over his face, the Baron's and Suzie's. The German Voice is again heard singing out military marching numbers.)

My little heart is thumping.
You sure have started something—

(The three are given a sudden push forward by the others, and the music and counting breaks off.)

BARON: Hey! Watch that push—

RUFUS: Something is wrong. —Who is the most important person in this room?

BARON: Me.

SUZIE: Me.

RUFUS: Wrong! It's ME! Why? Because I love— *(Gestures as if wiping a window, hissing: "Zip-zip-zip")*

SUZIE: Careful please.

RUFUS: —wiping the slate clean.

SUZIE: The world knows me as a humble coquette. But I disguise myself, because— *(A tone rises)*

BARON: Baron Herman DeVoto. Me. Who do I love? Myself. That's quite enough.

(Still blindfolded, they begin to orate to the world, stumbling about the stage, speaking simultaneously.)

Others see the surface of things but I look deep enough to know—this is Hell. This is really Hell!

SUZIE *(Overlapping)*: I'm the one person who feels at home—here, this is where I belong. I belong here.

RUFUS *(Overlapping)*: But I can truly say after years and years of experience—this is Paradise. Pure Paradise. This is really Paradise—

(He smashes accidentally into a wall. The target panel is pulled away, revealing a cart of the sort that carried people to the guillotine. A girl with feathers and a chicken beak is on the cart, pecking away at an ice-cream popsicle she holds in her hand.)

BARON: You wanna change the future? OK.

(He runs across the room and mounts a chair to begin reciting a mutilated version of Vachel Lindsay's poem "General William Booth Enters into Heaven." The three are still blindfolded. A melancholy piano phrase is repeating.)

King Cowboy Rufus led boldly with his big bass drum—

SUZIE: Are we washed in the Blood of the Lamb?

RUFUS *(Having run out into the audience)*: Rufus—at the very top of his game!

BARON: The Saints smiled gravely and they said: "Here he comes—"

SUZIE: Wash us all in the Blood of the Lamb!

RUFUS *(Running back to the stage)*: Here I come, with a ferocious thrust—back on the stage, where— *(Stops)* But my friends all know—I never believe in the sincerity of poets.

SUZIE: Oh frigid man—I recognize the sneer inside that cowboy voice.

RUFUS: How does one recognize the voice that has never truly spoken for itself?

SUZIE: Tag, you're it.

DEEP VOICE: Behind my back, ice cold, I recognize you behind my back.

RUFUS: Something's wrong here.

(There is a pause. Then they all whirl and shriek in pain, from some invisible source. They recover.)

BARON *(Indicating the wagon carrying the chicken)*: I get it—looks like dirty chickens get a free ride when nobody's guarding the chicken coop.

SUZIE: Amazing—I can see through my so-called "blindfold."

BARON: Damaged goods, par for the course—

RUFUS *(As waitresses enter with drinks)*: I'd like a drink, and then I'd like to try this remarkable "Wagon of Death" on for size—

BARON: I'll get rid of this chicken for you.

RUFUS *(Joining the Baron in the wagon)*: A chicken! . . . Oh, thank you so much. I shall remember this, Baron, when the next world rolls around— *(They giggle between themselves)*

SUZIE: May I join you?

RUFUS *(To the Baron)*: Any day now, right? *(They laugh uproariously)*

SUZIE: Let me climb on board—like a lady—

RUFUS: My God, coquettes are always welcome—but don't push— *(She climbs on, squeezing against them)* Hey! Don't push! Don't push!

(They all discover straight barber's razors attached to the railing of the wagon. They each take a razor and a bloody napkin.)

BARON: What's this stuff?

SUZIE *(Examining it through her blindfold)*: I don't know, I'm not a chicken—I'm just a coquette. Nothing more, nothing less.

(They all slice their throats with the razors, and scream. There is a pause.)

BARON: Try it again.

RUFUS: No, I don't want to wake up.

BARON: Try it again!

DEEP VOICE *(As a tone rises)*: If it feels good, don't do it.

(They re-slice their throats, and scream.)

RUFUS *(As piano music plays)*: What made me do that? STUPID, stupid, stupid. —Do something—sing, goddamn it!

SUZIE *(Singing to the music)*:
> Lost my head, must be dead.
> Never fear—
> One last year.

(The waitresses do an elegant gavotte to the music. The maître d' takes large swigs from a champagne bottle.)

BARON *(Singing)*:
> Hurts to die, I will try.
> Smile and show,
> Brave—you know?

(They slice again, and scream. A man under a big white veil slowly crosses the front of the stage, carrying the jeweled, golden Fabergé egg with a white dove perched on top high in the air.)

RUFUS:
> Blood is red, when I'm dead
> Then I fear—
> Its color disappears.

SUZIE: No. Don't say that.

ALL *(Singing)*:
> No one's fault,
> Total hero, total hero.

(The cart is rolled to the side, and a waitress helps the three step off. A tall, thin revolving mirror is placed on the cart and begins to spin, flashing bright reflected light over the stage.)

DEEP VOICE: Total hero, total hero. Honorable men and women exist here—blind.

ALL *(Singing)*: Blind, blind, blind, blind!

(Rufus tears off his blindfold. The light from the large spinning mirror blinds him. He retreats. All take off their blindfolds. A Voice is heard singing the 1950s rock-and-roll song "Gimme Some of That Good Tutti-Frutti." The singing gets louder and louder and frightens Rufus offstage. The music disappears. The Baron looks out the door after Rufus, then turns to the audience:)

BARON: Tutti-frutti? It sometimes does happen that a cowboy like Rufus—remember that tutti-frutti? Well, I remember him. *(Wipes his hands clean of blood)* A man who claims he has no desire to leave his own neighborhood— *(Slaps himself in the face)* Bastard! . . . Nevertheless, pushes himself—now "King Cowboy"—into an unsuspecting psychic environment. I'll prove it. *(Gestures to Suzie, who waits at the side)* You! Get over here.

SUZIE *(Crosses slowly and stops mid-stage)*: Remember me? Suzie.

(She blindfolds herself. The Baron puts a cigarette, delivered by a waitress with the cigarette tray, between her lips as the target panel slides in behind them.)

BARON: Sorry about this— *(Suddenly struck by the memory of—? He sings:)*

> It seems we stood and talked like this before,
> We looked at each other in the same way then—

(Rufus enters with a drawn pistol, wearing his ten-gallon hat again. The Baron takes the cigarette out of Suzie's mouth and she leans toward Rufus.)

SUZIE: Now cowboy—don't hurt innocent Suzie.
RUFUS *(Looking out to the audience, aiming his gun at Suzie)*: Tutti-frutti.
BARON *(Urging Rufus to shoot)*: Go on . . . Go on, do it!
RUFUS: I do wish I was a real American hero—with the potential to—well—you know—
SUZIE *(Sings)*: Wake up, wake up, wake up!
DEEP VOICE *(Overlapping)*: Wake up. Wake up. Wake up.

(Suzie removes her blindfold and presses her heart against Rufus's six-shooter. The others rush on to watch. She softly begins singing her love song:)

SUZIE *(Singing)*: Was it love in my heart—
RUFUS: Well I hope so—damn it!

SUZIE:

> In the secret of my soul?
> I close my eyes, I see my love
> And disappear inside his heart.
> I'm hiding, I'm hiding—
> My broken heart from everyone.
> I'm smiling now, I don't know how.

BARON *(Overlapping, drunkenly)*:
> I close my eyes, I see my love
> And disappear inside his heart.
> I'm hiding, I'm hiding,
> My broken heart from everyone.
> I'm smiling now, I don't know how.

(Rufus also sings, overlapping them as the music changes to more dissonant operatic music. All are now bellowing and gesticulating operatically:)

RUFUS:
> Even though your heart is breaking,
> Laugh, cowboy, laugh—

(Suzie and the Baron, while singing, are being dressed in opera capes, top hat and feathered headdress. Rufus breaks the singing angrily.)

Oh rot! I don't get a new outfit?—like everybody else in this shithole? *(A crash)*

DEEP VOICE: What I am, finally—a powerful imagination, entering the world to bring punishment.

(The crew carries on a large metal brace, suggesting the sort of device used in the nineteenth century to train students with bad posture to stand erect. The brace is strapped onto Rufus's back with straps wound around. Others hold his chin in place.)

RUFUS *(As the German counting is heard)*: What the devil is this latest obscenity you have in mind for me? I suppose you think I deserve this degrading humiliation? Bad, bad—wanna be rotten cowboy. Is that the idea?

BARON: "The cowboy who twists things"—is a hero.

(They load his arms with the cocooned babies that have been detached from the ceiling ropes.)

RUFUS: OK. Why are my arms full of so many cute little babies? *(Pause)* Well, say something reassuring. *(Babies start to cry)* Oh my God—

BARON *(Performing another variation on "The Walrus and the Carpenter")*:
>Oh babies, babies, babies—
>Come and play with us,
>The cowboy did beseech.
>A pleasant walk, a pleasant talk,
>—And big shots of whiskey for each innocent little baby.

RUFUS: Do you think I'm crazy? I could go to jail for something like that.
BARON: It seems a shame, the cowboy said—
RUFUS *(Interrupting)*: Take these babies, goddamn it. Take them. This is much too humiliating for an important cowboy like me. I have a better idea. Instead of all this baby stuff— *(The crew gathers and removes the babies)* —away, away, tiny tinkertoys. I'm going to allow— *(Whirls and explodes in irritation)* Will somebody get this thing off of me? I have a better idea—I have a better way of achieving my purposes. Fuck, fuck, fuck, fuck, FUCK!!

(The crew removes his back brace as a panel with gold tiles and, at the top, an amoeba shape with a big staring eye slides in behind them. Others bring a small wooden cabinet onstage. Rufus recovers his composure as a soprano sings repeated notes.)

Now, I'm going to allow this ordinary piece of early American antique furniture to stand in for that fabulous magical object of darkest power I could easily call—my revelatory encounter.

(The cabinet has been set center stage, with stanchions and ropes securing it. He goes and opens a door in the cabinet. A gong rings.)

As might be expected—nobody at home.
BARON *(Taps his head)*: Knock knock, what's up here?
RUFUS *(Pulls open a drawer and pulls out a piece of women's underwear, then a rubber glove)*: Ahh—fresh rubber and old lace. A perfect combination.

BARON *(Quoting T. S. Eliot)*: "April is the cruelest month," they say.

RUFUS *(Pulling out more underwear and throwing it to the floor)*: Another piece of evidence, another one, and another one—now wait a minute. If I were to gallop—out into the street—right now—"clippity-clop, clippity-clop, clippity-clop-clop." *(Freezes, then remembers)* Ah—my old palomino named "Whitey"—the pale-faced pony, remember him? Would it be, then, more likely or less likely—that I might encounter that unimaginable "thing" to genuinely change a cowboy life?

(The maître d' approaches him with a crown.)

For instance: If I once again replace my cowboy chapeau—

(He takes off his hat and the maître d' puts the crown on his head. Soft organ music is heard. He advances toward the audience:)

And then disguise—my second, regal chapeau—

BARON: "April is the cruelest month," Your Highness.

RUFUS: Shut up, Baron! *(Pauses, then lifts his six-gallon cowboy hat above his crown)* —beneath my first—even more powerful— cowboy chapeau?

BARON:

> April is the cruelest month, breeding
> Lilacs out of the dead land, mixing
> Memory and desire, stirring
> Dull roots with . . .

RUFUS *(Overlapping, irritated)*: I know—
> Lilacs out of the dead, dead, dead!—

(The maître d' has covered Suzie in a large, black-and-white checkered sack.)

SUZIE *(From under the sack, interrupting)*: So! Is this your normal cowboy girlfriend outfit? Or a special turn-on for cruel and dirty boys?

BARON: Half and half. Who am I?

RUFUS: For me it's the dirty stuff.
BARON: Who are you?
RUFUS: Rufus.
BARON: Rufus, a perversion of Cowboy Purity.

(Rufus, the Baron and Suzie all scream and whirl, as if hit by a mysterious and painful force.)

RUFUS *(After recovering)*: This "all-American cowboy" perverts no purity.
BARON: What I conceptualize as Cowboy Purity?— Think about it.
RUFUS: Leave my house, Baron. Get out of my house. Out! Out!
BARON: This ain't your house.
RUFUS: No? But I thought . . .
BARON: I'll lend it to you.
SUZIE *(Emerging from her sack)*: Ah, the beautiful "Maison Rouge."
BARON: Think fast!

(The maître d' and the girl in the white dress enter carrying a tray with a champagne bottle and glasses, which they thrust forward at Rufus.)

SUZIE: Of course, wonderful people are always lending me such beautiful things. But me—beautiful Suzie Sitwell . . .
RUFUS *(Studying her for a moment)*: And you do, madam.
SUZIE *(Stops, considers whether this is really a compliment)*: Thank you, Your Highness. *(Lifts a glass and surveys the room)* Amidst the many hours of gaiety and laughter—day after day, after day—here—in this charming little "spot."
RUFUS *(Pause, he sadly remembers)*: I once—had a dog by that name— *(Barks quietly in homage)*
SUZIE: We are all quite miserable, of course.
RUFUS: Oh come, come, come—sad all the time, Miss Sitwell?
SUZIE *(As a tone rises)*: Oh, very much like sharp crystal tears, streaming from the skies.
RUFUS: I will wipe them away—like a true hero.
SUZIE: Stupid cowboy—
RUFUS: I am powerful enough to do that, madam. And more— *(Moves toward her with desire in his eyes)*

SUZIE: Get away from me!

RUFUS *(His hands reaching for her body)*: Please?

SUZIE: Get away from me, you rough— *(There is a crash—everything stops for a moment)* —tough American! *(He moves toward her again and she screams out in an ugly, aggressive voice:)*

Wake up! Wake up! Wake up!

DEEP VOICE *(Overlapping)*:
Wake up. Wake up. Wake up.

(There is a frozen moment. Then Rufus turns away.)

RUFUS: Shit. I'm tired of these pretentious coquettes—if I've turned into a real American at last, then what I want is a real woman. I mean a real woman—

(He grabs a bottle and drinks deeply, simultaneously shooting off his gun. Rhythmic drum music returns and the crowd dances eccentrically back into the room.)

I'm ready for what I'm ready for, and I'm ready for it!

BARON *(Clapping his hands together, dancing and singing)*: Looking for our little dog Spot! Where's Spot? Where's goddamn Spot?

RUFUS *(Puts the bottle in front of a target)*: Back to your home, my little friend, I'll show you what I'm made of.

(As the crowd dances, he repeatedly shoots at the bottle and misses. A pink, blanket-like straitjacket device is rushed toward him.)

Get that nanny blanket out of here! *(Punches at it, but finds himself immediately wrapped inside and constrained)*

BARON *(Removing Rufus's cowboy hat and stamping his forehead with a rubber marker)*: Hold on there, buckaroo—the Brand of the Home Team.

RUFUS *(Drunkenly grabbing a rope through a hole in the blanket)*: A buckaroo at the end of his rope. Gimme my rope, gimme enough rope for a real necktie party, woman. Round and round. *(Winds the rope around his finger)*

BARON: The delirious cowboy wound a string of anticipation round his index finger. And pulled and pulled and pulled!
 Until a door opened.

(Soprano singing rises as the gold panel opens and reveals a giant, castle-like wooden door behind it, topped by a mystical, all-seeing eye enclosed in a white triangle, from which shoot golden rays. The others are all reaching up toward the eye.)

RUFUS *(No longer drunk)*: Many doors open for King Rufus.
BARON: Revealing everything that was taught to certain initiated cowboys. Everything that was understandable to those same cowboys.
RUFUS: None of this does serve this potentially still redeemable cowboy— *(Unwinds the rope from his finger)* Piles and piles of dirty shit, amassed inside my powerful head.

(A magic six-shooter, framed by red roses, rises from the center of the crowd around the door. Rufus steps back in awe.)

What a magnificent six-shooter. Antique weapon of that heroic frontier violence that I've imagined for years inside my Christmas stocking. *(Music rises)* Oh yes—Christmas, in the purest sense—I believe. I still believe. Though contemporaneously realizing this is, unfortunately, the wrong time for me—that's the only conceivable explanation!

(The crew runs and straps the magical gun around Rufus, who is still wrapped in his blanket/straitjacket.)

DEEP VOICE: King Rufus Cowboy, accomplishing his own lack of purpose, because a tree uprooted never forgets itself.

(Rufus holds the gun, which he is able to extract from its holster by reaching his arm through a hole in the blanket.)

RUFUS: A big fat dirty log, never forget that.

(He turns to the onlookers, who pull back from his gun in fear.)

No—don't be afraid—nothing to fear—out of my way, Christmas on earth!

(The "Death Cart" appears, halfway onto the stage at the side of the room. Rufus runs onto the cart, aims the gun at his head and fires. The cart moves so that he repeatedly bangs his head against a pillow on the wall over the entry. At the same time he fires again and shouts: "CHRISTMAS ON EARTH!" This happens three times in a row.)

DEEP VOICE *(Overlapping)*: Hit the brick wall. Hit the brick wall. Hit the brick wall.

(Rufus stumbles off the cart. Suzie runs for a small target, which she places under Rufus's arm.)

SUZIE: No, no, no, King Rufus Cowboy. You will never be . . . a proper target.
RUFUS *(Slowly, as he looks out over the target)*: I know what's being proposed. Some kind of "FINAL ADVENTURE," eliminating the very world itself—named "Rebellious—Rotten—Planet"— on which I find myself.
SUZIE *(Slowly offering him the Fabergé egg)*: Rough, tough Boffo Rufus—

(The others re-hook the babies onto ropes from above, and the babies slowly rise to heaven.)

Please—take this—oh-so-beautiful gift, babies. Take it to heaven— where it belongs— *(They keep rising)* Please! Come back. Come back!
RUFUS: No such luck.
SUZIE *(Suddenly angry)*: Stupid babies. *(Slowly presents the egg to Rufus again)* What choice am I left with—but you, Mr. Rufus.
RUFUS *(Flabbergasted; then he finally finds words)*: Thank you.
SUZIE *(Her mood switches like lightning; she points at him angrily and shouts)*: OH NO!

(There is a crash and the lights change radically. After a pause Suzie is calm, and she again offers the jeweled, golden egg:)

From dead people . . . to lots of "wannabe dead people."

RUFUS *(Totally confused)*: "Dead" people?

SUZIE: But just this once—dead people are allowed to say—"Please? Please?"

(Music rises. The Baron runs forward, takes the gun belt off Rufus and puts it around his own neck.)

Pleaaase?

BARON: Thank God you have come to your senses, King Rufus Cowboy.

RUFUS: Guaranteed?

(They whirl as the lights click on brightly, and Rufus puts his head against a jeweled halo that has been lifted behind him.)

DEEP VOICE *(After a pause)*: If it feels good, don't do it.

BARON: Ah—with the possible exception of the undeniable desirability of the beautiful coquette—

SUZIE *(Posing with the egg)*: Yes, yes, yes—guaranteed!

DEEP VOICE: Wake up.

BARON *(After a pause, points the gun at his forehead)*: Nothing is guaranteed, my friend.

(The Baron shoots himself, but doesn't fall. Rhythmic drum music begins as two waitresses wearing frog heads run in carrying a large envelope embossed with a red wax seal. Rufus discards his blanket and runs to see the envelope. He backs away hesitantly and looks to Suzie for encouragement.)

SUZIE: King Rufus—Hero or Devil?

RUFUS *(Thinks; then, excitedly)*: Let's find out.

(He runs over to the envelope, opens it and pulls out a giant piece of paper. He unfolds it and finds it blank.)

It doesn't say.

SUZIE *(Exiting the room)*: Know this in fact—I too have never been happy.

RUFUS: But me—me! I have always tried to create that kind of happiness, have I not? Through being the kind of cowboy—fuck! Why do I use that disgusting affectation?

(Organ music returns. He pulls a letter from his pocket.)

I have written myself a letter—as a personal reminder. Primitive in grammar and punctuation, perhaps. But full of hints—so many hints. Hints that wind the string of powerful anticipation around my index finger. *(Seizes another rope and winds it around his finger)*

SUZIE *(Peeking in at the door)*: Remember, I too have never been happy.

RUFUS: The end of this painful string tied to a doorknob in some invisible room, waiting for that terrible door to open!

(Frightening carnival music rises. Two large, wild Bears with skulls on their heads and white aprons around their waists run into the room, closely followed by white screens. There is a crash, followed by changing music, and the Bears and screens spin and run from the room as Rufus runs downstage.)

Dangerous invasion of uncivilized beasts! Away! Away, cursed subhuman animals! —Make ready the real stage where real things happen. Where the flash of recognizable bodies makes me realize—

(Rufus and the Baron run to touch the wooden door and retreat with a scream as it seems to burn their hands.)

Goddamn it! This is the wrong time for me—and my rapturous presence here on earth has been a terrible miscalculation.

BARON: I will never repeat myself again. *(Points to Rufus, who then exits)* This bastard's in deep shit.

(A crash and the music rises again as a Bear reenters upstage, lifting a polished sword. A feathered emblem is held behind the Bear's head, and Suzie runs forward.)

SUZIE: Protect us all from the return of that ferocious bear that brings three nightmares piled up on top of each other.

(Rufus runs in from offstage, followed by two waitresses, carrying large targets, and the scullery maid, who carries a bucket that she lowers over her head.)

RUFUS: Have I lost my mind? Or is it suddenly very dark—

(An electrical zip and the lights change, making everyone whirl.)

Oh God—inside this strange yet familiar "Maison Rouge"?

(A crash.)

BARON *(Reaching out from behind the targets)*: Let me out of here! *(Crash)* Wrong! Let me back inside! Please!

SUZIE *(Taking rocks out of the scullery maid's bucket)*: Tick tock.

RUFUS: I will never be fooled again, because this darkness is not my darkness. *(Takes the rocks from Suzie)* And I am still blind inside my own adventurousness. *(Presses the rocks against his eyes and screams)* In this lurch toward beneficent mistake—I do burn! *(Drops the rocks into the bucket)* Careful—careful! Lost inside this private vestibule of private fantasy—the whole world reaps unjustifiable benefit.

BARON *(Leading a Bear downstage)*: What we got here is a ferocious bear for the ages. *(Starts spinning the Bear)* Speed Bear—Power Bear—Brain Bear.

DEEP VOICE: Don't you get it, my friend? Stories hide the truth. Stories hide the truth.

(A large stone urn has been carried to center stage by the scullery maid. Suzie runs to it and pulls out small stuffed dolls, which she throws to the floor. Then out comes a blindfold, which someone else grabs and uses to cover Rufus's eyes as Suzie extracts a knife from the urn.)

RUFUS: Stroked by a woman's glance.

233

(Suzie is rehearsing a series of stabs to his heart.)

Stroked, stroked, stroked!

(She throws away the knife as Rufus holds his head and turns away.)

Ow!—my brain!

(She runs and scrapes his back with her fingernails.)

Owww!!

(He turns and holds her head.)

DEEP VOICE: Strum the brain strings. Just strumming the brain strings.

RUFUS *(Squeezing Suzie's head between his hands)*:
 Power Bear!
 Speed Bear!
 Brain Bear!

(He releases her and she spins upstage and off. Rufus, still wearing the blindfold, is alone as the music becomes very soft. There is a pause.)

Am I now one hundred percent—alone at last?

(He is still wearing the blindfold. Others tiptoe in and clear the remaining furniture. Meanwhile, in an alcove upstage, the two Bears tiptoe into view, side by side, each holding a sword in the air with one hand and a large, white, mystical egg in the other hand.)

Then why—why—why do I hear footsteps, without knowing whether it be friend or foe—man or terrible beast—to be conquered again—and again!

(On the other side, the waitresses slowly enter carrying a device that looks like a bloody miter box, and with it, a bloody double-handed saw, the type used to cut through large logs.)

But—I do now choose to remove this blindfold. Thereby acquiring knowledge—sufficient to allow—bold acts of lucid determination. *(As he slowly removes the blindfold)* Oh, dear Rufus, remind yourself one last time that you fear nothing that exists on God's greatest planet. *(Turns and sees the bloody saw; retreats in fear)* But—who would not fear—such dark thoughts . . . inside one's vulnerable brain—

(He turns and sees the Bears. He snatches the two eggs, which he holds up into the light. There is a crashing sound. He speaks with great difficulty.)

So very hard—to—con-con-cep-tu-al-ize.

(He collapses facedown on the floor. The target panel closes behind him.)

DEEP VOICE: CON-CEP-TU-AL-IZE.

(The miter box is placed over Rufus's head, and the saw is fixed into its groove. Rufus's body is covered with a white sheet as a baby is heard crying. The two waitresses strike a sexy pose, each holding one side of the saw, ready to start sawing through Rufus's head. Organ music rises and then softens as Suzie studies the tableau. She then turns to the audience and speaks quietly:)

SUZIE: Oh my goodness—this is almost frightening. Does this not suggest that—what is most fragile in life, is the necessary belief—

(The waitresses pull the saw once, and Rufus screams as if they were cutting into his head. The lights change abruptly.)

—that all important things are indeed—

(She bends over Rufus, first putting her hands together in prayer, and then holding her arms out slowly, like the wings of a gentle dove. She begins to sing:)

Very opaque things.
Very hard things,

(Her "dove wings" begin to flap faster.)

Hard, hard things.

(The waitresses begin to saw continually, and Rufus twitches and screams.)

DEEP VOICE: Expect not happiness. Happiness is inevitable.

(Suzie bends down and lifts the edge of the cloth that is covering Rufus as the Baron advances slowly with a long pole. He is wearing Rufus's ten-gallon hat. He gently slides the pole under the cloth and into Rufus's ass.)

BARON: Mr. Opaque?—
RUFUS *(Screaming out)*: Me!
BARON: Mr. Hard-to-Penetrate?—
RUFUS: That's MEEE!
BARON *(Bellowing over organ music)*: Who rules the Universe?
RUFUS: ME! ME! ME!
BARON: Who loves babies?
RUFUS: ME! ME! I love babies—I love babies—I love babies!

(He comes out from under the cloth as the music lowers. Holding a bloody towel over his face, he goes and looks up at one of the suspended babies.)

BARON *(Quiet now, leaning on his pole)*: OK—then you got no problem. In my opinion—anyone who loves babies—they're OK.
RUFUS: I do. I love them.
BARON: You love babies? You want to rule the whole goddamned universe? —That's OK with me.

(There is the loud sound of a whip cracking, and the lights flick on bright.)

DEEP VOICE: Wake up. Wake up.

SUZIE *(Singing, overlapping)*: Wake up, wake up, wake up. *(Slowly covers her eyes)*

RUFUS: Thinking about it. And more and more thinking about it— makes me realize—

(He senses something behind him and whirls. Suzie slowly takes her hands off her eyes and meets his gaze. He turns away from her and comes back to the Baron.)

There's just one thing that I'm missing at the moment.

BARON: Oh yeah?

RUFUS *(Bending close)*: You may laugh at this—but— *(His eyes travel to the top of the Baron's head)* —it's my big hat.

BARON *(After a moment)*: Oh, of course. Take the big hat.

(Rufus takes the hat off the Baron's head and puts it on his own. Carnival organ music rises. All the others run onstage carrying globes painted to look like various planets, each with a slightly different design in gold. Each globe has a decorative knob on top and strange unreadable letters embossed on it. They make the globes bounce lightly to the organ music.)

Follow the bouncing balls, my friend. Pick a lucky target, for King Cowboy.

RUFUS *(Taking out his six-shooter)*: My God, Baron—there are so many to choose from.

BARON: That's Cowboy Heaven, isn't it? *(The music rises as Rufus shoots at many different globes)*

SUZIE: Please, don't hurt me. *(The music stops)*

RUFUS: Good God, I would never hurt you, beautiful lady—because you have nothing real to offer me. What I really want is that big, round one, hiding behind me in the shadows. With its promise of a whole world, subdued and renamed with my great name—Planet Rufus.

(The Voice sings out the numbers of a marching rhythm in German. Rufus runs to the one oversized globe and spins with it.)

Great Planet Rufus!

(Everyone whirls as the German singing increases. Then a gong sounds and the music stops.)

Planet Rufus. What a wonderful kind of "music" to that wonderful name. *(Lifts the globe high in the air. There is a silent pause)*
DEEP VOICE *(Slowly)*: If it feels good, don't do it.

(Before the Deep Voice has finished, the counting in German has begun again. As its volume increases and the music rises, all march offstage. Rufus exits last of all, carrying his globe high in the air.)

Ladies and gentlemen, we do pay homage to the irony of asking you to seemingly applaud a man such as King Rufus Cowboy. *(A gong sounds and happy music begins)* Do remember, however, that art is not quite life, and in the theater, therefore, your gentle applause is always welcome.

THE END

RICHARD FOREMAN is the founder and artistic director of the not-for-profit Ontological-Hysteric Theater in New York City (founded 1968). Foreman has written, directed and designed more than fifty of his own plays, both in New York City and abroad. He has received numerous awards and citations, including OBIE awards for Directing, Best Play, and Sustained Achievement; an Annual Literature Award from the American Academy of Arts and Letters; a Lifetime Achievement in the Theater Award from the National Endowment for the Arts; the PEN/Laura Pels Foundation Master American Dramatist Award; a MacArthur "Genius" Fellowship; the Edwin Booth Award for Theatrical Achievement; a Ford Foundation play development grant; a Rockefeller Foundation playwrights grant and a Guggenheim Fellowship for Playwriting. In 2004, he was elected Officer of the Order of Arts and Letters of France. Since the early 1970s, his work and company have been funded by the NEA and NYSCA, in addition to many other foundations and private individuals.

His archives and work materials have recently been acquired by the Bobst Library at NYU.

The Ontological-Hysteric Theater is currently located in the historic St. Mark's Church-in-the-Bowery, in New York City's East Village neighborhood, and serves as a home to Foreman's annual productions as well as to other local and international artists.

In the early 1980s a branch of the theater was established in Paris and funded by the French government.

Foreman's plays have been co-produced by such organizations as New York's Public Theater/New York Shakespeare Festival, La MaMa, The Wooster Group, the Festival d'automne in Paris and the Vienna Festival. He has collaborated (as librettist and stage director) with composer Stanley Silverman on eight music-theater pieces produced by the Music-Theater Group and the New York City Opera. He

wrote and directed the opera *What to Wear* (music by Michael Gordon), which was produced in 2006 at CalArts's REDCAT Theatre in Los Angeles. He has also directed and designed many productions with major theaters around the world, including *The Threepenny Opera*, *The Golem* and plays by Václav Havel, Botho Strauss and Suzan-Lori Parks for The Public Theater/New York Shakespeare Festival; *Die Fledermaus* for the Paris Opera; *Don Giovanni* for the Opera de Lille; Philip Glass's *Fall of the House of Usher* for American Repertory Theatre and the Maggio Musicale in Florence; *Woyzeck* at Hartford Stage; *Don Juan* at the Gutherie theater and The Public Theater/New York Shakespeare Festival; Kathy Acker's *The Birth of the Poet* at the Brooklyn Academy of Music and the RO Theater in Rotterdam; and Gertrude Stein's *Doctor Faustus Lights the Lights* at the Autumn festivals in Berlin and Paris.

He wrote and directed the feature film *Strong Medicine*.

He holds degrees from Brown University (BA, Magna Cum Laude, Phi Beta Kappa) 1959; Yale School of Drama (MFA, Playwriting) 1962; and an Honorary Doctorate from Brown University, 1993. He was born in New York City on June 10, 1937.

There are numerous collections of Foreman's plays, and books that study his work. Works by Foreman include: *Love & Science: Selected Music-Theatre Texts* (TCG, 1991); *My Head Was a Sledge-hammer: Six Plays* (The Overlook Press, 1995); *No-Body: A Novel in Parts* (The Overlook Press, 1996); *Paradise Hotel and Other Plays* (The Overlook Press, 2001); *Unbalancing Acts: Foundations for a Theatre* (Pantheon Press, 1992; TCG, 1994); *Reverberation Machines: The Later Plays and Essays* (Station Hill Press, 1986); and *Richard Foreman: Plays and Manifestos* (New York University Press, 1976).

Books that devote their entirety or a chapter to Richard Foreman and his work include: *ABCDery of Richard Foreman*, Anne Berevo-litch (Editions du Sud, Paris, 1999); *Die Bühne als Szene Denkens*, Markus Wessendorf (Alexander Verlag, Berlin, 1998); *Directors in Rehearsal: A Hidden World*, Susan Letzler Cole (Routledge, 1992); *The Directors Voice: Twenty-One Interviews*, Arthur Bartow (TCG, 1988); *In Their Own Words: Contemporary American Playwrights*, David Savran (TCG, 1988); *The Other American Drama*, Marc Robinson (The Johns Hopkins University Press, 1994); *Postmodernism and Performance*, Nick Kaye (Macmillian, 1994); *Richard Foreman*, edited

by Gerald Rabkin (PAF Books: Art + Performance/The Johns Hopkins University Press, 1999); *Richard Foreman and the Ontological-Hysteric Theater*, Kate Davy (UMI Research Press, 1981); *Theater at the Margins: Texts for a Post-Structured Stage*, Erik MacDonald (University of Michigan Press, 1993); and *Tradizione e Ricerca*, Franco Quadri (Giulio Einaudi, Editore, 1982).